TIME AND THE IMAGE

MANCHESTER
UNIVERSITY PRESS

THE BARBER INSTITUTE'S
CRITICAL PERSPECTIVES
IN ART HISTORY SERIES

SERIES EDITORS
Tim Barringer, Nicola Bown
and Shearer West

EDITORIAL CONSULTANTS
John House, John Onians,
Marcia Pointon, Alan Wallach
and Evelyn Welch

Time and the image

EDITED BY

CAROLYN BAILEY GILL

Manchester University Press
Manchester and New York

distributed exclusively in the USA by St. Martin's Press

Published by Manchester University Press
Oxford Road, Manchester M13 9NR, UK
and Room 400, 175 Fifth Avenue, New York, NY 10010, USA
http://www.manchesteruniversitypress.co.uk

Distributed exclusively in the USA by
St. Martin's Press, Inc., 175 Fifth Avenue, New York,
NY 10010, USA

Distributed exclusively in Canada by
UBC Press, University of British Columbia, 2029 West Mall,
Vancouver, BC, Canada V6T 1Z2

British Library Cataloguing-in-Publication Data
A catalogue record for this book is available from the British Library

Library of Congress Cataloging-in-Publication Data applied for

ISBN 0 7190 5813 9 *hardback*
 0 7190 5814 7 *paperback*

First published 2000

07 06 05 04 03 02 01 00 10 9 8 7 6 5 4 3 2 1

Typeset by
D R Bungay Associates, Burghfield, Berks

Printed in Great Britain
by The Alden Press, Oxford

For Paul, Kerry and Jamie

Contents

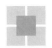

Illustrations

Figures

Colour plates

colour plates 1–8 appear between pages 66 and 67

Contributors

Parveen Adams is Senior Lecturer in Human Sciences and Convenor of the MA in Psychoanalytic Studies at Brunel University. She was co-founder and co-editor of the feminist journal *m/f* from 1978–86. She guest-edited a special issue of *October* on psychoanalysis and art in 1991. Her collection of essays on psychoanalysis and representation *The Emptiness of the Image* was published in 1996.

Mieke Bal is Director of the Amsterdam School of Cultural Analysis (ASCA) at the University of Amsterdam. Her most recent books are *Reading Rembrandt: Beyond the Word-Image Opposition* (1991) and *The Mottled Screen: Reading Proust Visually* (1997).

Sylvie Blocher is a French multi-media artist who has produced a number of video installations exploring relations between camera technology, authority and address. Over the past decade her work has been included in many significant international exhibitions such as *Feminin/Masculin* (Centre Georges Pompidou, 1995), the inaugural exhibition of PS1, New York (1997), *Heaven* (Kunshalle Dusseldorf, 1999) and *Video View Points* (MOMA, New York, 1999).

Howard Caygill is Professor of Cultural History at Goldsmiths College, University of London and the author of *Art of Judgement* (1989), *A Kant Dictionary* (1995) and *Walter Benjamin: the Colour of Experience* (1997).

Joan Copjec teaches in the departments of English, Comparative Literature, and Media Study at the University of Buffalo, where she is also Director of the Center for the Study of Psychoanalysis and Culture. She is the author of *Read My Desire: Lacan against the Historicists* (1994) and of the forthcoming *The Ethics of the Absolute All: Sex, Body, Sublimation*.

Mark Cousins is Head of the General Studies Programme at the Architectural Association, London, and has lectured widely in the United Kingdom and abroad on the relationship between psychoanalysis, architecture and the visual arts.

Thierry de Duve is a freelance art historian and has written extensively on modern and contemporary art, with an emphasis on the work of Marcel Duchamp and its theoretical implications. His most recent books are *Kant after Duchamp* (1996) and *Clement Greenberg between the Lines* (1996).

Alexander García Düttmann is Professor of Modern European Philosophy at Middlesex University. He is the author of *The Gift of Language. Memory and Promise in Adorno, Benjamin, Heidegger and Rosenzweig* (1989, 2000), *The Memory of Thought. An Essay on Heidegger and Adorno* (1991, 2000), *At Odds with Aids* (1993, 1996), *What is Called Love in all the Languages and Silences of This World. Nietzsche Contingency Genealogy* (1996) and *Between Cultures. Tensions in the Struggle for Recognition* (1997, 1999).

Briony Fer is Reader in History of Art at University College London. She has written widely on twentieth-century art, and is especially interested in the relationship between art and psychoanalysis. She also writes on the work of contemporary artists. Her book *On Abstract Art* was published in 1997.

Patrick ffrench is Reader in the Department of French, King's College London and is the author of *The Time of Theory* (1995) and a forthcoming monograph on Bataille. He is also co-editor of *The Tel Quel Reader* (1998).

Carolyn Bailey Gill teaches Critical Theory at Birkbeck College, University of London and is the editor of *Bataille: Writing the Sacred* (1995) and *Maurice Blanchot. The Demand of Writing* (1996).

Timothy Mathews is Professor of French at University College London. He is the author of *Reading Apollinaire: Theories of Poetic Language* (1990) and his *The Pleasures of Decay: Essays in French Modernism* is currently in production with Cambridge University Press. He is also co-editor of *Blood Axe Contemporary French Poets*.

Laura Mulvey is Professor of Film and Media Studies, Birkbeck College, University of London. She is the author of two collections of essays: *Visual and Other Pleasures* (1989) and *Fetishism and Curiosity* (1996). She is also a film-maker and has taught at various universities in the United Kingdom and the United States.

John Sallis is Liberal Arts Professor of Philosophy at The Pennsylvania State University and the author of ten books, including most recently: *Shades – Of Painting at the Limit, Double Truth, Stone* and *Crossings: Nietzsche and the Space of Tragedy*.

Peter Wollen is Chair of the Department of Film and Television at the University of California, Los Angeles. He is currently researching a book on the history of fashion.

Preface and acknowledgements

The sheer complexity of the relations between the notions of time and of the image in current thought is daunting; yet the need to rethink the connection has been increasingly evident in large bodies of theory and in a wide variety of contemporary artistic practices. The emphasis on process from Modernism onwards has resulted, among other things, in an interest in the meanings of a work which only emerge in later encounters between the spectator (or reader) and the artwork. Works have appeared which blur the moment when an artwork begins and when it ends: works, for instance of open duration, or those subject to change over time. If the contemporary art practices addressed in this volume, which include video and installation art, performance art, still photography, sculpture, painting, the cinema, and literature, have something to say to theory, theory too has perhaps something to say to them.

The authors chosen for this volume do not belong to a single discipline nor even work within the same conceptual framework. Moreover, the remit given to the authors did not define, in advance, the meaning of the image. Nor did it restrict the notion of time to any one of its variants. The book is intended to be exploratory, and to encourage speculation on possible new ways of configuring the relation between the image however construed and issues of time.

Yet all the chapters, it is fair to say, in one way or another, question the old orthodoxies of the image as a formalist object. Mark Cousins, in his Introduction, points to what he sees as a *weakening* of the traditional Modernist notion of the image and the aesthetics on on which it is based. I think this is right. It was inevitable that new senses of the image in contemporary thought would bear critically on issues of temporality, and such is the case here.

The chapters in this book have been structured to suggest new directions and movement in ongoing debates. For instance, the encounter within these pages between the art critic Thierry de Duve and the artist Sylvie Blocher, whose work is the subject of Chapter 9, echoes an earlier encounter between them which took place at the Tate Gallery during the International Conference on Time and the Image (in which incidentally all the authors in this volume participated though sometimes with different papers than those published here). But the terms of their debate have changed and moved into entirely new territory. In fact, agreements and disagreements are everywhere played out in the book, and this has been my aim.

Chapters are presented in order to play one position off against another and capi-
talise on the respective energies of each. It is hoped that readers will gain from the
sequencing of the chapters and the juxtapositions of different positions and argu-
ments one against another.

Because this volume has been the result of an interest developed over a number
of years, and linked to various occasions and projects, there are many whom I
should thank. I am particularly grateful to all those – too numerous to name – who
contributed to the International Conference on Time and the Image which took
place in London in May 1997. I would particularly like to thank Timothy Mathews
of the French Department of University College London, who co-organised the
Conference, Malcolm Bowie of All Soul's College Oxford, Michael Newman of
Central-St Martin's School of Art, London, Andrew Brighton of the Tate Gallery,
London; Anthony Lumley of the Visual Arts Department of the Arts Council of
England and René Lacombe of the *Institut français*, London.

I also owe a large debt to members of my class on *Time and the Image*, over the
past four years, in the Faculty of Continuing Education, Birkbeck College and
especially to Tim Gough. The work done in those classes has been sustaining and
helped to cristalise ideas and deepen understanding.

I acknowledge finally the work of my editor, Vanessa Graham of Manchester
University Press and Louise Edwards, who helped on the book during Vanessa's
absence. It has been a pleasure to work with them. I thank as well the Friends of
University College London whose generous help made the colour section of the
book possible.

<div align="right">

Carolyn Bailey Gill
London

</div>

Introduction

Mark Cousins

These chapters perhaps bid farewell to the formal and modern condition of the image. If by image is meant a special type of object, which is constructed, which is looked at in a certain way, which claims certain types of social and legal privilege, whose connection with the world may be discussed in terms of 'representation' (but not in terms of copying) – then it is the weakening hold of this category which is manifest in the papers. The bid does not complete its farewell. Somewhere between leave taking and taking leave of the category of the image, much is said that weakens a certain conception of the image and aesthetics that supports it. It is in this context of a certain abandonment of the complex of issues of image, representation and aesthetics that the ostensible topic of time intervenes. The issues of time which are advanced as relevant to the question of the image are no longer the conventional topics for discussion.

The modern intellectual condition of the image allows it to be thought of as manifesting two possible relations to time, one internal and one external. The first somehow is thought to concern the image 'as such'. This might include such traditional questions of the status of time itself *as* an image, an issue which has an ancient philosophical heritage. But it will also include how the image might represent or signify temporal relations. Likewise it includes the relation between the image and its consumption, raising the status of such formulae as that images unfold in space, texts in time. The external conditions by comparison centre upon the relation to the image as an object. How does its status as an image change with age and decay? How might the intervention of 'restoration' be conceived? These external questions involve not just time as temporality and duration or even age, but broach an externality which feeds history. The list could be extended. But the point is that this syllabus of questions, which is aligned both with the aesthetic and the art-historical, is not what is here. Without any manifesto and without any theoretical convergence, the chapters have all seemed in their different ways to address the topic from at least the direction of how one might consider some issues of time within the *weakening* of a clear, modern and formal definition of the image.

This is given the most candid assertion in Chapter 9 by Thierry de Duve on a video work by Sylvie Blocher, *L'annonce amoureuse*. This work is part of a

continuing project with the generic title *Living Pictures*, and with the motto '*Rendre la parole aux images*'. Thirteen actors and actresses, chosen not by her but as nominees for the Michel Simon prize for acting, were asked by Blocher to address the camera and make an '*annonce amoureuse*'. De Duve writes of the project: 'The ethical endeavour in *L'annonce amoureuse* is the grounding of a new, radically non-religious legitimacy for those images called art.' For him and for what he might say about the project, a new condition is required. The traditional field of art is bankrupt because of 'what' it represented more than its pretence to represent. This field now includes abstract art which has lost its critical role. At the same time the new dispensation of technical development, from photography to virtual reality, offers no alternative. On the one hand it is governed by the production of semblances of representation as old as Renaissance perspective, while on the other it has no legitimate claim to 'represent' anyone.

This opening on to a sudden field of who can represent whom, as a question at the same level of how representations can be made, directly re-opens the relation of mimesis to a political dimension. How can people be represented? The exhaustion of epistemological and critical issues of representation passes here into the other side of representing, as an action. This agonistic conception of making work is explicitly avowed by him; he calls 'for a destiny of images beyond Christianity … for radically atheistic and fatherless time'. It seems from his account that there is something which exceeds the capacity of modernism to meet, something which needs to force the image from its modern constraint, something which responds to 'a new radically non-religious legitimacy for those images called art.' The strange element here, and it finds echoes in other contributions, is that while a line of militant atheism is demanded, the situation which de Duve describes is none the less full of Christian words. For him it stretches out a post-Christian world of the image, but it is uncanny that the passage to it frees the image from an excessive rationalised formalisation through the love and agony of an early Christian language about images.

Perhaps this should not be surprising. The abstract theories of images within aesthetics and formalism both rest upon and have repressed the religious passion which drove the history of the image in the West before the image was robbed of its attendant violence. Perhaps now the role of images, insofar as it escapes the narrative of form which was implicit in Kant long before Greenberg, will itself have to rehearse some aspects of Christian historiography as a godless experiment. Something of this thought runs through the contribution of Howard Caygill. The opposition to modern aesthetic treatments of the image leads to the suggestion that we need, or that we are offered, elements of a new baroque. He associates the work of Orlan with an issue of time which requires a 'baroque' framework to interpret their relation. He deploys the *reliquary* as a means to elucidate the history of what is left over, in his discussion of Orlan's work from the *mesurages* 1976–84 to the series of operations starting in the 1990s. 'Orlan's work is unique in achieving a baroque poise between transgressive hybridity and the desire to insulate these

delicate objects from the effects of time by encasing them in the reliquary'. As such it stands outside the platonic/aesthetic investments in the image as art. 'The art object as reliquary is not the visual envelope of an eternal truth but the receptacle of sacred matter.' At the same time Orlan's work as a history is confronted with the 'finitude, decay and ruination insinuated in them by the temporal series.'

What reference to the reliquary makes possible is to directly address something that the representational character of discussions of imagery suppresses. For Caygill it is approached in an essay in 1948 by Levinas, 'Reality and its Shadow'. Instead of discussing the relation of representation in terms of mimesis, or in terms of the capacity of the image to participate in an idea, Levinas insists that the effective relation contained within representation is *absence*. 'Spots of colour, chunks of marble and bronze. These elements do not serve as symbols, but by their presence insist on its [the object's] absence. They occupy its place fully to mark its removal, as though the represented object died, were degraded, were disincarnated in its own reflection'. Caygill suggests that although Levinas has remained just within the limits of representation, Levinas' description of the work of art is one of a reliquary without a relic.

These two different appeals to Christian objects are anything but an opening to religion. It is the rejection of a world of the image which is felt by turns to be platonic, representational, aesthetic. Since across the range of papers part of that rejection lies in the repressive character of the art/image couple, it is not surprising that it involves historical as well as logical experiments, such as the claim that we should find our 'baroque' bearings. This has a temporal and a philosophical dimension. The temporal claim is that if in a certain era of aesthetics repression of the image starts with Baumgarten and Kant, then we must go back before this in order to move on. This points to the same place or rather person as the philosophical dimension – which is that *now* we should recognise the superiority of Leibniz over Descartes. Descartes as a philosophical phantasy is made to originate or license all the major philosophical thoughts which are complicit with the 'repression' involved in anything from self-consciousness to the problem of essences.

The exception here is Lacanian theory. Joan Copjec's chapter has a different set of conditions. She has no sympathy with the abstractions of the formalist account of the image; her argument goes in a different direction. Her starting point might be shared by most contributors to the volume – what would it mean to think about an embodied spectator in contrast to 1970s film theory's attempt to analyse vision as a signifying practice that produced 'a subject that no body could be: a monocular subject of pure abstract seeing, who occupied no space, was subject to no temporal fluctuations, and laid claim to no sexual identity, except – notoriously – by default'. This abstraction has always been contested on the grounds that it functions as a pseudo-universalism. Scholars have wanted to divide spectators ultimately by gender, by class, wherever the claims of particularity can challenge the false generalisation of an abstraction. Others have sought to locate visuality as itself

a complex historical construction which combines distinctive regimes of subjec-
tivity with technical arrangements which do not just confront the body but inter-
vene within its field. Jonathan Crary's text, *Techniques of the Observer*, has usually
been taken in such a way as a means of describing an observational system which
abandoned the abstract generalities of vision for the embodied, and historically
specific, technique. Copjec has her own reasons for wanting to contest this, not
least the wish to preserve the *cogito* as a material level of human subjectivity, albeit
one whose relation to causality takes on imaginary form. At the same time, in the
name of conceiving of an embodied subject, she wishes to oppose Crary on the
grounds that it is *he* not *she* who repeats the terms of a Cartesian dualism. For her
the theoretical situation is that only a psychoanalytic monism can provide the
means to understand, as a fundamental singularity, the embodied subject. Her
argument is that Crary's invocation of the body is as a 'bodiless body'. But at the
same time the structure of the Cartesian *cogito*, like the 'truth' of geometrical per-
spective, must be retained for each correctly describes genuine subjective states. It
is as if the *form* of error describes truthfully the mechanism of illusion.

Each of these arguments has implications for time and the image, but they pro-
ceed, largely, through questions of identity and space. In Caygill's baroque han-
dling of Orlan and the reliquary he uses the Leibnizean notion of series to replace
that of essences, including time. He wishes to see the time over which, or under
which, Orlan has sacrificed and saved herself, as a series. The reliquary is a kind of
loop which suspends the progression of the temporal series. The image tradition-
ally required a meditation upon its timelessness as an image-as-such, while pro-
viding a meditation upon the effects of age, and of mortality, in terms of the
image-as-object. This binary opposition of the image is now subject to re-arrange-
ment of the opposition: the reliquary exemplified the neutralisation of time in art as
something never finished, still enduring – something inhuman and monstrous.
Orlan's operation is between two positions – the perfect reliquary of a monumental
past that will never pass and the monster of its passing. Perhaps the question of
time now becomes the question of *times* and the image, according to the relations
with which the image is caught up.

It may also be that the resources of formalism are not exhausted. I shall use as an
example a recent photographic experiment and work by Eyal Weizman, which
were concerned literally and materially with the internal relation of time and the
image.[1] The normal relation between time and the photographic image established
itself both phenomenologically and historically as a relation between a *then* and a
now. The idea of a *then* was exteriorised in the nineteenth century onto photo-
graphic paper which I gaze at now. Two circuits of time are set up, for this *then* can
outlast me in *now* when I am no longer. At a collective level, this contrast between
then and now embodied in the photograph established itself as a popular reflection
upon the passage of time. The indexicality, as it is called, of the image bequeathed
internal life with a new, if readily understood, medium of loss.

In order to play this role photography must exhibit a fundamental stillness – a stillness which evacuates time from the internal relations of the photograph. What does that mean? Of course photography involves the exposure of film to light for a precise period. But this duration belongs to the order of technique rather than to the order of the experience of photography. That experience is dominated by a moment, by a minimum unit of time, to support the category of event. We experience it not as time but as the 'click' of the camera, a vanishing point of duration, an event which occurs in time but is not represented by time. Rather the stillness of the photographic image to which I am referring is related to the draining away of time from the image in order that the image be exclusively the representation. What we call the 'moment' which the photograph captures is space, and it captures it in a piercing way, a way which the harassed business of visual perception can rarely do. The stillness of the image is an effect of a particular distribution of space and time. The image, as exemplifying a moment, may be a cross-section of time but it does not embody time but space. If the image tends towards the character of still life this is *not* because time is a motionless character in the scene but because time has been exteriorised, away from the image and towards the spectator. Indeed one could extend this idea of stillness to the movies. Movies may represent time but they do so through the space of the image and its sequence. Each image is a cross section of time, which empties the image of duration. The movie takes time, may represent time, but does so through a sequence of images which are based upon the fundamental stillness of space, in which even movement appears as a series of images which are stilled by their exhaustion in space. The question is not how time and space are represented in images, but how do spatially organised images – for it is these that we are used to – represent time?

This raises the question of how the relations between time and space might be reversed. If the stillness of the image is the result of the spatialisation of time, what, within an image, would the temporalisation of space look like? Christian Nicolas and Eyal Weizman adapted a camera so that it had an open slot of one millimetre as its aperture. Behind this the film is run in a single exposure over a set time, that is, at a set speed, usually about fifteen to forty seconds. The camera is still, only the film moves. How should one describe the result? In one sense a millimetre of space is spread out the length of the film – where length refers to time. Space is expelled from the image which can be thought of as the opposite of a panorama. *What* is photographed is the space which is opened by the millimetre aperture – that is all that is photographed, but it is not still. The bodies which appear along the length of the image are not like those that we are used to reading, spread across the image because they occupy different places in space. For in fact all bodies in the image are in the *same place,* but they are in the same place at different times. What appears as *spacing,* indeed what is spacing in the image, is the flow of time. Time is not now a cross-section, but is the movement of the film itself, the time which is embodied in the image. It is as if time provides a cross-section of space, that is, the same space analysed by a passage of time.

If this procedure, which was developed from the technique used in sports to register the winner of races, seems to upturn the relations between time and space in the photographic image, then we should not be surprised at how difficult it is to incorporate its results. Looking at the photographs will evoke a sense of puzzlement and regression, which attempts to reintegrate them in the previous model of the 'spatial image'. Of course it cannot be done, they will not fit. But even the most elementary effects of this technique unsettle our habitual literacy in respect of the photograph. Imagine that something within the visual field of the aperture would register as a stationary dot; here it registers itself as a continuous line that runs for the length (of time) of the image. By extension (of time) a vertical line turns into a surface, manifesting a temporal rather than spatial solidity. It follows from this that the scale of an object is related not to its volume but to its speed. A thin body and a stretched body in the image refer to a quick body and a slow body. All these effects pose problems to an eye trained to read the image in spatial terms, leading to incomprehension. It is possible to speak of an unconscious 'resistance'; even when one understands the image intellectually one can be overtaken by a sudden affective refusal to understand, an emotional insistence on reading in the old way. This should alert us to the fact that this technique harbours a certain horror in its capacity to render time internal to the image.

This capacity is pushed to the extreme in one of the effects of this photographic technique. When positioned on London Bridge with pedestrians walking in opposite directions or by a dual carriageway with cars speeding both ways, the camera produces the following result: all the bodies (or cars) are represented as travelling in the same direction. The bodies and cars that are travelling in the 'opposite' direction are folded into the image and appear to have their direction reversed. This effect is a tribute to the tenacity of our way of reading the image as the spatial image, in which directionality is a constitutive element. We have the feeling that some fundamental level of reality has been travestied, that the truth is in fact quite simple, or rather it can be simply put, even though it remains hard to grasp. When we speak of this technique of 'direction', the direction in question must be the direction in which the film is moving through the camera. It is the moving film that creates the singular direction which can only be measured in units of time. If a body is moving in the same direction as the film is travelling, say from left to right, there is no counter-intuitive effect. But if a body is travelling in the opposite direction to the film, its own direction will be erased in the following way: imagine that the first element of the body exposed to the film is the nose; by the time the next element, the eye, is exposed, the film will have travelled, and if the eye is represented *after* the nose, the before and after refer *only* to one direction, that is the direction in which the film is travelling. Another way of putting this is that we are used to thinking of direction as necessarily involving two directions, say left and right. It seems a primordial fact about the world and about images that there is a left and right, just as there was for Aristotle, together with a below and an above, a before and a behind. The orientation of the body, and likewise the legibility of the image, both seem to

demand these dimensions. But this image of London Bridge has only one direction, that of time, and it is time which determines the space of the image. This technique renders time internal to the image where it re-orders the space. This is where the horror is. Is everyone walking in the same direction if I stand on London Bridge? That depends. Spatially they are not: but if the only dimension of measurement is that of time, then they are. But where are they going, all in the same direction?

In the traditional photographic image the question of time is attached to the image but is absent from it as a 'moment of space'. The temporal relations in which the image is caught up belong to the order of the spectator, to the melancholy passage of time between the point of original exposure and the point of its viewing. It speaks of death in the form of mortality, of human finiteness measured against the image whose youth increases each year. Death here is related to the passing of time. But in this other technique, where time determines the image, death erupts in the order of the spacing of the image itself. They are all going in the same direction, herded together, trekking to what can only be death. We already know in premonition that such a cowed march of massed humans travelling together in the same direction has a single, if secret, destination. Dragooned by the military authority of time, they exhibit the passive demeanour of fatality. If, in the image, time does indeed become an arrow, we fall back appalled by its speed, by the inflexible accuracy of its trajectory, and by the lethal singularity of its target – death. No one escapes, and, as befits a technique borrowed from the photo-finish of races, everyone is a winner as the subject who is first past the post when it comes to death.

Mortality in fact is not an extraneous supplement to the experience of the image. It relates also to the birth and death of media and its constitutive elements. Peter Wollen, in *Time, Image and Terror* (Chapter 11) and Laura Mulvey, in *The Index and the Uncanny* (Chapter 12), relate to the joined problems of births and deaths within the ensemble of film. Peter Wollen's chapter starts from Goethe's 'Observations on the Laocoon' in which Schiller's aesthetic reading is replaced with one which is concerned to reintegrate the sculpture back into a temporality of scenes, of before and after. In this reading the temporal structures of reactions of fear, suspense and anxiety become relevant. In effect Wollen's chapter argues that Goethe identifies in the sculpture a set of cinematic effects *avant la lettre*. This significantly adds to our now complex picture of the origin of cinema as the product of a range of 'births', cultural as well as technical. When taken with Goethe's concern with the flickering effects of alternating light and darkness, the text can be taken as the baptism of certain effects for a medium which is not yet born. In Laura Mulvey's chapter the perspective is reversed. Recalling the work of Bazin and Barthes on the indexical character of the photograph, she points out that the indexicality of film changes its character when, for an example, a star has died. Now the film harbours an indexicality which relates a human alive to a human dead. This gives rise to a psychic uncertainty which is characteristic of the uncanny. Suddenly

a certain indexicality becomes an animated necropolis. This final gift of stardom, of indexicality after life, once belonged only to Zeus. Both these chapters disrupt a certain modernist narrative, in which History acts as an external pressure upon a medium to clarify its formal character. They both show how time, birth and death ceaselessly reformulate the medium from within.

THE IMAGE OF TIME

Time and image

John Sallis

I am going to begin with some questions. Even though, here, now, in order to mark this beginning I have already violated it, not begun with some questions, but deferred that beginning so that it can be, at best, only another beginning. By simulating the deferral of the questions, I want to signal in advance that something always comes in advance of the questions, provoking them into response, as response. Especially if one would begin to question about time, the questioning would already, from the beginning, have been entangled in precisely that which it would question, even in marking itself as a beginning.

The questions with which I am going to begin are indeed about time, and the very possibility of developing these questions in any but the most formal way presupposes as operative in deed precisely that which is asked about in the questions. These questions about time constitute in a sense only one question, elaborate the sense of that question. It is a question of sense, and it is time to formulate the question and its elaboration.

What is the sense of time? How does one sense time? Where is it to be found? Where is time present in such a way that one can sense it, that one can sense its presence, that one can sense it in its presence?

Only for a moment could one overlook the enigma harboured by these questions. Only for a moment could one restrain the doublings they release. First of all, the doubling and redoubling of *sense*, which spans the gigantic difference that philosophy, from its beginning, has laid out between intelligible and sensible. But also, more specifically, the folding of the question of time back upon the question of its *where*, its place, as if there were a kind of space of time. Or, at least, whatever would be required in order for time to be present, as if being present, presence, could be determined other than by reference to time.

One might, then, reformulate the question in a more rigorous way. One might reformulate it in the way required by phenomenology in its adherence to the injunction '*zu den Sachen selbst*'. Then one would ask: How does time show itself? How does it show itself from itself, that is, in a showing that proceeds from time itself (assuming that time has an itself), in a showing to which one would merely

attend, as if one were a Socratic midwife assisting at the birth of truth, in a showing no longer simply reducible to presence.

How, then, does time show itself? Most assuredly not in the way that ordinary, perceptible things show themselves. Not, for instance, as a stone shows itself, protruding from the earth into brilliant sunlight. One never sees or hears time itself as one sees and hears things, even though it seems that time somehow haunts all the things one sees and hears.

Yet the stone, protruding from the earth into brilliant sunlight, can show itself otherwise than simply as itself. One can make a drawing of the stone or a photograph; and when later the stone is out of sight, one can see it still in the drawing or the photograph. In this case one sees it through the image; that is, through the perception of the picture one intends that which is pictured in it, the stone itself. Can one also sense time in such a manner? Is there an image of time, an imaging of time through which time itself shows itself from itself, even if not quite as itself?

Or is time not itself an image? Has it not at least been determined as an image from the beginning, from the beginning of what we, from a certain end-point in time, call metaphysics, even while leaving the word suspended between singular and plural? Does the determination of time as an image not still retain a certain force? Especially if one sets aside the endless repetitions of the formula that is supposed to have been drawn from Plato's *Timaeus*, the formula by which time would be the moving image of eternity. Especially if one reopens the text of the *Timaeus* at the very spot from which this formula is supposed to have been drawn. Especially if, now, one rereads the celebrated passage on time along with a few others from this part of the dialogue that belong within its orbit. Especially if one attempts, as Heidegger demanded for the texts of Aristotle, to translate these passages back into Greek, to let their Greek sense shine through all that the course of time has layered over them.

The passage on time occurs near the middle of the first of the three discourses in which Timaeus tells of the generation of the cosmos and of the other living beings within it. According to his account, the cosmos is itself a living being animated by an invisible soul and fashioned in the image of the noetic paradigm of living being. It is made by an artisan god who looks to the paradigm so as to fabricate the cosmos in the image of the paradigm, as an image of the paradigm. Thus from fire, air, water and earth he fashions the body of the cosmos; and from a mixture (the precise composition of which has been debated since the early Academy) he forms the cosmic soul, first by shaping the mixture into two circular bands, one of them, the circle of the different, obliquely inclined to the other, the circle of the same, and by then splitting the circle of the different into seven concentric circles. Though as constituting soul all the circles are invisible, the circle of the same turns in a movement that will become that of the fixed stars, while the other seven circles will become the orbits of the sun, the moon, and the planets.

Before there is any mention of time, the body and the soul of the cosmos have been made and the soul has been set into the body, the two being joined centre to

centre. The completion of the work issues, for the artisan god, in a time of delight. Yet as he takes delight in his work, a thought comes over him: the thought of making the cosmos even more like its paradigm, while realising still that the eternal nature of the paradigm prevents the image from ever measuring up to it entirely. It is this thought and the deed to which it gives rise that are expressed in the celebrated passage on time.

The translation that I offer of the passage draws not only from a reading of the entire first discourse but also from recent historical-philological work on this particular passage.[1] Here, then, is the passage: 'The thought occurred to him of making a moving image of eternity; and in ordering the heaven he makes the heaven as an image of the eternity that abides in unity, an image moving according to eternal number, that which we call time.'[2]

There are various features of the passage that will make one hesitate merely to substitute for it the traditional formula declaring that time is the moving image of eternity. To be sure, the initial clause mentions the god's intention of making a moving image of eternity, but without yet identifying this image with time.

What is one to understand here by the word translated as *eternity*, the word αἰών? The word can signify one's age or a lifetime or a time of indefinite length such as an age or a generation; though this last sense can be extended so that the word comes to mean something like what one might understand as eternity, nothing in the word itself compels one to assume this extension, much less merely to equate αἰών with *eternity* as such. In reading the passage on time the most appropriate way of determining the sense of the word is by adhering rigorously to the indication that this passage itself provides: according to what the passage says, it is a matter of the αἰών that 'abides in unity [μόνοντος . . . ἐν ἑνί].' In other words, αἰών is determined as an abiding in unity, as remaining within oneness, as something's remaining one and the same with itself, its being perpetually selfsame. If one agrees to retain the traditional translation of αἰών as *eternity*, one will need to insist that the word means – and only means – perpetual selfsameness. It is this sense alone that links the word to the noetic or intelligible. Most emphatically, one will need to keep the sense of αἰών distinct from that which *aeternitas* comes to have, for instance, with Augustine, that of a present that never passes, of eternal presence.

The passage refers to two activities on the part of the artisan god: an *ordering*, a setting in order (διακοσμέω), and a *making* (ποιέω). The traditional construal took these two activities as having distinct objects, even though they occur together, at the same time (ἅμα): what is set in order is the heaven, and what is made is the image of eternity, that is, time. But recent research has shown that a more natural construal of this portion of the passage would be to take both activities as having the same object, namely, the heaven.[3] Thus it would say: in ordering the heaven, in setting it in order, the god makes the heaven. Most significantly, such a construal implies that what the god makes is the heaven and not some image distinct from the heaven, not a distinct image that would then be identified as time. The word *image*

is not the direct object of the making but rather is set in apposition with *heaven*, that is, it explicates the character of the heaven as the god makes it.

What, then, is the heaven that the god orders and makes? Though the word οὐρανός has more than one sense in the dialogue, a careful examination shows that in the passage on time it has its ordinary meaning: the heavenly vault, the sky, the heaven as distinct from the earth. In the passage on time, οὐρανός designates the sky considered especially as the region in which the movements of the heavenly bodies occur, the starry heaven.

This, then, is what the god makes at this stage: the starry heaven. In this production he takes over what has already been set in place: the body of the cosmos, especially its fiery part, which belongs to the upper region, and the soul of the cosmos with its still invisible circles that have been set revolving. To make the starry heaven the god has then only to form the heavenly bodies, to set them in the orbits already determined by the circles in the cosmic soul, and to set them moving in these orderly movements. Thus it is that in one and the same act the god both makes the heaven and sets it in order.

The moving image that the god makes is nothing other than the starry heaven, the stars (including also sun, moon, and planets) in their ordered movement. By setting the stars in the various orbits determined by the revolutions in the cosmic soul, the god makes a visible image of the ordered revolutions in the soul; by making those revolutions visible, he, in turn, makes a moving, visible image of the noetic order that has been set into the soul. But, as noetic, as intelligible, that order is itself perpetually selfsame. Thus, in making the starry heaven, the god makes a moving image of eternity, of the eternity that abides in unity. As ordered, the movement of this moving image is a movement according to number.

It is time to come back to the passage on time, to reread it, first, in the translation already given and then in a more expansive, explicative translation. Here again is the passage: 'The thought occurred to him of making a moving image of eternity; and in ordering the heaven he makes the heaven as an image of the eternity that abides in unity, an image moving according to eternal number, that which we call time.' And here is the explicative translation, in three parts: (1) the artisan god makes/orders the starry heaven by fashioning the stars and setting them in motion in the orbits already determined for them by the revolving circles in the cosmic soul; (2) thus he makes the heaven as an image of the eternity that abides in unity, that consists in perpetual selfsameness, an image moving according to number; (3) the heaven thus made as an image is that which we call time.

But what, then, is time? Granted the appositional structure of the passage, one can say: time is the same as the image, which is the same as the starry heaven. Hence, it is not a matter simply of rejecting the traditional formula that time is a moving image of eternity; rather, what is required is that the formula be linked to the appositional structure, which identifies time with the image and both with the starry heaven. As the moving image of eternity, time is nothing other than the starry heaven.

Yet how, more precisely, is the apposition to be understood? How is it that time is the same as the starry heaven? For, even as one affirms their sameness, a differenti- ation – marked by the two names – will have been at work.

Following the celebrated passage, Timaeus says that time was generated along with the heaven (μετ 'οὐρανοῦ), that they were generated at the same time (ἅμα). Here is his account of this double fabrication, the word ἅμα continuing to mark this simultaneity that would first make possible ordinary temporal simultaneity: 'For there were no days and nights and months and years before the generation of the heaven; but he contrived that they should come to be at the same time [ἅμα] that the heaven was composed. All these are parts of time [μέρη χρόνου]' (37d-e). Thus, in making the heaven, the god made, at the same time, the parts of time: days, nights, months, years. He made these parts of time precisely by making the heavenly bodies and setting them in their respective orbital movements, the movements that visibly measure out the parts of time. As Timaeus explains: 'In order that time be generated, the sun and moon and five other stars – wanderers [πλανητά], as they are called – were generated for the determination and guarding of the numbers of time. And when the god had made the bodies of each of them, he placed them in the orbits along which the revolution of the different was moving, seven orbits for the seven bodies' (38c-d). The revolutions of these seven bodies together with that of the fixed stars turning in the circle of the same measure out the parts of time. This is why Timaeus calls the stars the instruments of time (ὄργανα χρόνου) (42d; cf. 41e). The revolu- tion of the fixed stars generates day and night, the revolution of the moon measures out months, and that of the sun determines year. Timaeus notes that the revolutions of the other heavenly bodies also measure out parts of time, though men have not dis- covered them and thus have no names for them.

Yet still, again, the question: What, then, is time? Timaeus addresses this ques- tion most directly in the passage in which he refers to those revolutions of which men are unaware, those parts of time for which they have no names. He says: 'They do not know that the wanderings [πλάναι] of these bodies is time' (39d). What decisively determines time – these wanderings – as a moving image of eternity is not just that the measuring out of time exemplifies certain arithmetic orders that are themselves noetic. Rather, what is decisive is, as Timaeus openly declares, that time 'imitates eternity and circles around according to number' (38a). Time involves circling around to the same, as the sun circles around the earth each day but also, more decisively, as it returns annually, in its circling, to identically the same circle (so that what the sun preeminently measures out is the year). Whereas the eternal is perpetually the same and eternity (αἰών) is this remaining always the same, the heavenly bodies always *circle back to the same* and time is these circlings, these wanderings.

This is what time is. Or this is the closest the *Timaeus* comes to an answer to the question: What is time? If this answer seems still insufficient, merely identifying time with the stellar wanderings from which, nonetheless, one would also somehow have to distinguish it, this insufficiency may be taken to indicate the insufficiency,

even the inappropriateness, of the question. For in asking 'What is time?' one asks about the proper of time without asking also whether time is such as to have a proper, an itself. Or, translating back into Greek, the question 'What is time?' presupposes that time is such as to have a *what*, an εἶδος. Does time have an εἶδος, as a stone may be said to have an εἶδος, a look, that shines through it, in it, from it, when, for instance, it shows itself protruding from the earth into brilliant sunlight? Or does the name *time* not serve to say how the starry heaven is an image, not just of some εἶδος or other, but of the eternity, the perpetual selfsameness, that belongs to every εἶδος as such? Does the name *time* not then say how the starry heaven is, in precisely this sense, the image of all images: that it is such by means of the visible circlings that measure out the parts of time, even if never time itself? Like the name Χώρα the name *time* (Χρόνος) would say something about the possibility of images rather than designating an εἶδος of which certain things would be images.

To be sure, the traditional translation and interpretation of the Timaean passage on time was quite different, at least the interpretation that originated in Middle Platonism and gained definitiveness in Plotinus,[4] though there are virtually no earlier traces of this interpretation.[5] It is only recently that the traditional interpretation has been seriously challenged along with the traditional construal and translations of the passage. Since time has perhaps never been thought in Western philosophy without at least tacit reference back to the Timaean passage and the formula that the traditional interpretation extracted from it, it would be difficult to overestimate the stakes involved in the reading and interpretation of the passage.

In the traditional reading the most decisive difference lies in the direct objects assigned to the verbs that express the god's activities of ordering and of making, respectively. What the god is regarded as ordering is the heaven, but what he is regarded as making is the moving image of eternity, which is identified with time. The construal of the sentence in this way is possible, though, among other things, it requires taking the verb ποιεῖ (he makes) to have as its direct object a word (εἰκόνα, image) that not only follows it but that is separated from it by eight other words. For this and other reasons Brague considers the traditional construal difficult and highly unnatural; he concludes that the ancient readers who codified the interpretation in the formula 'Time is the moving image of eternity' chose a less natural construction in order to be able to find in the text what they already supposed it to contain.[6]

If the passage is construed in the traditional manner, then the two simultaneous activities carried out by the god will be regarded as utterly distinct. On the one hand, the god set the heaven in order, while simultaneously he made time, the moving image of eternity. Thus construed, the sentence lacks the full appositional structure that would identify the heaven with the image of eternity and with time. As a result – the most decisive result – time is separated from the starry heaven, kept utterly distinct as such from it, despite the bonds that other related passages forge between them. Thus time, not the heaven, is the moving image of eternity,

even if it remains exceedingly difficult to understand how time, thus set apart, can have the character of an image.

In turn, it is the separation of time from the starry heaven that prepares the way for an unmistakable shift that occurs in Middle Platonism, that by which time comes to be regarded as belonging to the domain, not of cosmology, but of psychology. Once time is no longer taken to be inextricably connected to the starry heaven, once time is set apart from those circlings in the heaven made visible by the fiery nature of the stars and by the light that the sun spreads throughout the heaven, once time is made distinct from the sensible cosmos, the basis will have been prepared for situating time within the soul. Whereas, otherwise, aside from the traditional construal, the *Timaeus* is not to be read as assigning time simply to the cosmic soul but rather as declaring that the making of time requires precisely that visible bodies, the fiery stars, be placed in the orbits determined in the soul, rendering the circlings visible.

In this shift that commences in Middle Platonism, it is a question of the *where*, the place, of time, of the region of beings where time is shown forth or sheltered. The question of time will already have been folded back upon the question of its where, the question of the place where time is present. What occurs in the shift is a withdrawing of time from the heaven into the soul.

This shift is utterly decisive for the subsequent history of metaphysics. For Plotinus time is the spreading-out of life (διάστασις . . . ζωῆς), of the life of the soul in its passage from one way of life to another.[7] For Augustine the drawing of time into the soul provides the only means by which to shelter time from the threat of non-being. Since the past is no longer and the future is not yet and the present has no extent, no space (*spatium*), time as such can *be* only if it is somewhere where these three parts of time are sheltered from non-being by being secured in their presence. For Augustine it is the soul that provides such a place for time, for within the soul each part of time can be made present: through memory there is constituted a presence of the past, through expectation a presence of the future, and through attentiveness a presence, that is, an extent or space, of the present. Hence, through these operations of the soul each of the parts of time is doubled by a form of presence within the soul. Only thus is time sheltered from non-being, for, as Augustine writes, referring to the parts of time, 'Wherever they are and whatever they are, it is only by being present that they are.'[8] This is why – granted that being is presence – they must be in the soul; this is why, in Augustine's words, 'some such different times do exist in the soul, but nowhere else that I can see.'[9] Little wonder that when Augustine translates the Plotinian διάστασις into *distentio* and determines time as distention he begins, as he says, 'to wonder whether it is a distention of the soul itself.'[10]

One cannot but be struck by how remote all of this is from the *Timaeus*: whereas the Platonic text identifies time with the circlings in the starry heaven by which days, nights, months, years are measured out, for Augustine time is withdrawn – on pain of not being at all – into the human soul and is regarded even as *of* the soul, as

its distention. Platonic cosmology with its uranic time, its time of the starry heaven, comes to be replaced by a psychology for which time is not only buried in the soul but is, as such, *of* the soul. Platonic physics, for which time belongs to nature (φύσις), is replaced by a metaphysics of time, for which time is determined as regards its place by the metaphysical demand for presence, which, in turn, inseparable from time, determines that very metaphysics. This metaphysics of time involves the double determination expressed by the double genitive: time is determined by metaphysics, by its predetermination of being as presence; but, precisely through this predetermination, metaphysics is itself determined by reference to time.

Much of the history of this metaphysics of time remains to be told. One would need to tell how, for instance, it comes to be transformed in Kant's thought when time is taken as the very form of sense, how the absolute precedence of time as form over the sensible manifold radicalises the withdrawal of time from the sensible, the shift prepared by the traditional reading – or rather, misreading – of the Timaean passage on time. Not to mention transcendental schematism in which are constituted determinations of time that, were they not absolutely anterior to everything sensible, could almost be called images of time.

Yet it is not with the intricacies of this history that I want to conclude but rather with some indications as to how, today, in what we call our time, one might begin to think time and the image at the limit, even beyond the limit of the metaphysics of time. So then: three indications, little more than questions, developed all too briefly. (1) It is Heidegger who has radicalized to the limit the sheltering of time within the soul, its being *of* the soul, *of* the subject. In his 1924 lecture 'The Concept of Time', in which he first outlined the project of *Being and Time*, Heidegger begins with the question 'What is time?' In the course of the lecture he displaces the question, replacing it, first, with the question 'Who is time?' and, then, with the question 'Am I my time?' In conjunction with this shifting of the question, Heidegger arrives also at an answer, one that radicalizes to the limit the placement of time in the soul. Displacing also the traditional determination of that being that we ourselves are, Heidegger redetermines it as Dasein. What, then, is time? Heidegger says: 'Time is Dasein.'[11]

In a certain respect this answer remains intact in *Being and Time*. And yet, Heidegger also expands the mere identification so that it comes to read: time is the meaning of the Being of Dasein. The identification becomes then the locus of a decisive tension: on the one hand, *Being and Time* reaffirms – indeed at its most profound level of analysis – that time is Dasein, that time, originarily understood, is precisely what Dasein most originarily *is*; while, on the other hand, as the meaning of the Being of Dasein, time is beyond Being, ἐπέκεινα τῆς οὐσίας, in the Platonic phrase that Heidegger cites in this regard in his lectures.[12] The tension is evident: How can time be both identical with a being, Dasein, and yet beyond Being?

That he lets such tensions develop rather than covering them with some sham resolution testifies to Heidegger's persistence in thinking. And even if this and

other tensions of comparable scope do not, in *Being and Time*, develop to the point where they would distort the entire project and force it into another channel entirely, there are indications that a reversal is being prepared. For instance, near the end of *Being and Time*, the remarkable passage about the sun and the day. Heidegger writes: 'In its thrownness Dasein is delivered over to the changes of day and night. Day with its brightness gives the possibility of sight; night takes this away.' For this reason sunrise and sunset, granting and withdrawing the sight-bestowing light demarcate, as Heidegger says, 'the "most natural" measure of time, the day.'[13] Even the further division of the day remains, in the first instance, says Heidegger, bound to the sunlight, to its progression and to the progression of the sun across the heaven.

Even if there are also, from Heidegger, gestures toward an originary time that would remain anterior, the time of which he writes in this remarkable passage is not a time buried in the depths of the soul; it is a time of light, of the sun, of the heaven.

(2) This time is not, then, so very remote from time as determined in the *Timaeus*. In both instances time is linked to the heaven and is measured out by certain heavenly bodies. Such uranic time is given by the heaven, by the circlings in the heaven, which give out days, months, season, and years.

The question is whether it is not something like this uranic time that imposes itself today, in our time, whether it is not to something like uranic time that we – the *we* of today, of the present time – are both impelled and brought, a future and a past of time that are perhaps, in the end, almost indistinguishable.

Then, time would be given by the heaven, the sky; it would be given in such a way that things could sometimes even image time, letting it show itself from them as from an image. As a stone protruding from the earth into sunlight measures the progression of light, from twilight on through the successive times of day, letting the time of day show itself by way of the brilliance and configuration of light on the lithic surface as well as by the shadows it casts on the otherwise illuminated earth around it.

(3) Yet the uranic gift of time, showing itself from things, becomes most manifest, it seems to me, neither through philosophical theory (even as phenomenology) nor through an attentive engagement directly with nature. It becomes most manifest, so it seems to me, in art or, at least, in certain paintings.

Let me mention only – and all too briefly – Monet's series paintings; specifically, the series of paintings of wheatstacks – some thirty paintings of what appear to be the very same wheatstacks – that Monet executed in Giverny in 1890–91. Monet himself wrote of having sought to render the most fugitive effects,[14] aspects of nature almost as fleeting as time itself is said to be, aspects whose fleeting is perhaps hardly distinguishable from that of time. Stories abound about Monet setting up multiple easels before the same object so as to work on several paintings of it in quick succession as the time of day and thus the appearance of the object changed. And yet, there can be no question but that the object's contribution to the force of the painting as such is very limited – so much so that when Kandinsky first saw one

of the *Wheatstacks* in 1896 in Moscow, he had, as he says, 'a dull feeling that the object was lacking in this picture',[15] that is, the very force of the painting was linked to a certain retreat of the object.

In an interview during the 1891 exhibition at the Durand-Ruel Gallery in which fifteen *Wheatstacks* were shown, Monet said: 'For me it is only the suroundings [*les alentours*] that give true value to the subjects.'[16] By surroundings he means of course not primarily other objects as such but the sourrounding light and atmosphere, that is, in the words of a letter written to Geffroy during the very time Monet was painting the *Wheatstack* series: 'The envelope, the same light spread over everything'[17] (Plate 1). What Monet paints is this singular spread of light in the surrounding atmosphere, its spread over the wheatstack precisely as it is gathered around the wheatstack. The painting renders visible the spread of illumination in which the wheatstack becomes visible; the painting lets one see the light itself, the shining that endows the wheatstack with visibility. Indeed in some of the *Wheatstack* paintings virtually everything else is dissolved into the shining – that is, the shining is rendered visible precisely at the cost of rendering almost invisible the houses, trees, and hills in the distance. Monet literally paints the shining over things so as to produce a reversal of the ordinary relation in which one sees the things without seeing the shining that lets one see them.

Yet shining is inseparable from a certain time, from a certain uranic time, inseparable in the most concrete sense. Even in those *Wheatstack* paintings that fail to name in a subtitle a certain time of day or time of year, these times will be manifest in the paintings themselves. It is not just that the shining is determined in its specificity by these times but that the shining gathered around the wheatstacks renders these times visible, lends time a certain visibility: in the painting itself one *sees* that it is late afternoon on a late summer day (Plate 2). Or one sees that it is near sunset, sees it in seeing the intense light along the conical edge of the wheatstack. One sees not only the times of the day and the seasons of the year, these times that come and go – circling around – according to number; one sees also the alternation between bright sunlit times and overcast days, a coming and going that is perhaps not unlike those parts of time that Timaeus says are given by wanderers in a way that eludes discovery and names.

In these paintings seen in series, various times – times of day, times of year, and other perhaps unnamed parts of time – are shown forth in and through the spread of light around the wheatstacks. In these paintings Monet has painted things imaging time – a time of sky and earth – in and through the gathering of light around these things, in and through their shining. It is perhaps in the vision offered by such works, in the silent opening of vision to what is shown forth from them, that one can – in the most poetic yet elemental way – be given a sense of time.

3

Lifeline and self-portrait

Alexander García Düttmann

Translated by Humphrey Bower

> Someone succeeded in lifting the veil of the Goddess Isis. But what did he
> see? He saw – wonder of wonders – himself. Novalis

To form a picture which would assemble the various views I acquired of myself
and my life during its course, I would have to trust the record and testimony of
others; I would have to rely on a third person for confirmation. Perhaps, however,
there are certain times of my life during which I had no views of myself, not on
account of an omission, but because of an incompatibility. Is there not a belief that
one is most true to oneself when one renounces the attempt to represent one's
own life? Such a belief seems to be sustained by a contradiction, and pays heed to
the ban on images.

Nevertheless, it is scarcely conceivable that one might get by without any views
and images at all, whether it be a view that captures the course of one's life in retro-
spect, or an image that projects it into the future. If I wished to depict my life, I
would trace the trajectory of a double line. One line would run along the periphery
of things. It would correspond to the conduct of one who is dazed because he is
overwhelmed by the very distance at which he keeps himself. The inability to react
other than spontaneously, the involuntary and irrepressible surrender of restraint
and circumspection, the relinquishing of strategy and tactic seem to be dictated by
just such an irreducible distance. Or do these reactions themselves create the dis-
tance? The other line would indicate the trajectory of a driving force and would run
right through the middle of things, as if it were drawn by a blind search for the
centre.

This doubling of lines reveals a disparity of perspectives. There is the imma-
nent perspective of a burrow whose tunnels connect the places where opposing
forces have clashed. And there is the transcendent perspective of a mute and
intransigent observer who remains immovable and entranced, as if caught in an
imperceptible process of self-destruction which is both infinitely delayed and infi-
nitely accelerated. To encounter myself, to recognise myself in a self-portrait, I
would have to construct the intersection of these two lifelines. I would have to be

able to discern the point where immanence and transcendence converge. It is such a point of convergence that provides a diary with its focus. On 12 August 1948 Julien Green notes in his diary: 'A diary in which one could say everything would be neither the diary of the body up in arms against the soul, nor the diary of the soul repressing the body, but the diary of both, the diary of a human being reconciled with itself at the end.'[1]

Does not the question of the trajectory of a lifeline pre-suppose something which it leaves unquestioned? Does it not pre-suppose a linear conception of time which rests upon a continuous sequence of instants and takes these instants to be moments of presence? Does not the question of a self-portrait in which one is meant to recognise oneself also pre-suppose something which it leaves unquestioned? Does it not pre-suppose the idea of a representation which is linked to the possibility of forming a picture? In what follows, the notion of a lifeline will be used to designate that which persists and is characteristic of an individual and his particular nature. An individual keeps stumbling over different obstacles in the same way because his particular nature prevents him from encountering what does not belong to this nature. The notion of a self-portrait will be used in the sense of *a release of what is peculiar to an individual*, of a release which indicates both a concentration and a redemption.

But there is a dilemma here. Is the doubling of lifelines a feature of self-portraits, or is it the symptom of the particular nature of a specific individual? In the first case, the hyperbolic and contradictory rule followed by a reader who takes pleasure in texts, a rule to which Roland Barthes alludes,[2] would also apply to self-portraits. It would trigger the doubling of lifelines. A reader cannot be bound by rules, for a pleasure prescribed in advance can only be experienced in the form of a perversion. Hence, the peculiarity and singularity of a reading experience must be measured by the resistance it opposes to its identification. In the end, singularity and anonymity seem to coincide. This hyperbolic and contradictory rule can also be formulated in terms of the doubling of perspectives revealed by the doubling of lifelines. The more the immanent perspective becomes predominant and the more a particular nature asserts itself, the more the gaze which corresponds to this perspective is deflected and the more the self-assertion of a particular nature is undermined. What is peculiar to an individual will divide and double his lifeline, submit his life to the forces of Eros and Thanatos, and engender an eccentric movement. Reflecting upon this movement from a transcendent perspective amounts to a final subjective turn. Consequently, the dilemma lies in the difficulty of deciding whether one should conceptualise the temporality of the self-portrait in general in terms of a doubling of lifelines, or whether one should consider the doubling of lifelines in terms of the temporality of a particular self-portrait.

The doubling of lifelines or perspectives is essentially aporetical. For the standpoints pre-supposed and disclosed by the perspective of immanence and the

perspective of transcendence are adopted simultaneously whilst excluding each other. The fact that both standpoints cannot be adopted at the same time shows that one cannot simply observe oneself and that there is no pure introspection. Since the object of observation would be my own self, I cannot entirely observe myself. A non-coincidence separates self-observation from what it observes. It is therefore necessary to distinguish between the transcendence of a distance which enables self-observation, and the transcendence of a distance which disenables it. The bedazzlement and speechlessness of an individual who not only distances himself from himself, but also allows himself to be overwhelmed by this distance, is not an enabling condition for self-observation and never consolidates into a stable point of view, just as the vanishing-line of an immanent search which is driven by an unknown force transgresses the limits of a theoretical position. It cannot be confined within the field of vision opened up by a specific perspective. When an individual relates to himself from a transcendent *perspective*, some form of self-observation is always involved. However, something within self-observation remains forever unobserved, something self-observation cannot capture and represent. Pure self-observation would be an observation which would not depend on a presupposition and which would be totally transparent. A determinate intuition or a reflection effected by pure self-observation would render the observed object completely intelligible. Such observation would have to produce that which it observes and give it to itself in an act of self-affection. It would have to be productive. Productive observation, however, destroys itself. Without the resistance derived from the non-coincidence of observer and observed, all observing dissolves in the mere tautology of a productive and self-referential observation, an observation which would create its own object. To the extent that self-observation has to pre-suppose what it observes, to the extent that the observed cannot observe itself and hence provokes self-observation, to the extent that self-observation aims at the very blindness which brought it into existence, it can become pure self-observation and transform itself into a self-determining intelligence only at the cost of destroying the observed object and thereby itself. Pure self-observation is ultimately self-destructive.

What the self of self-observation observes is always a photograph or a death-mask, a likeness or a replica of itself, an image in which it cannot recognise itself fully. In the second version of his transcendental deduction, Kant writes: 'Accordingly I have no knowledge of myself as I am but merely as I appear to myself. To be conscious and aware of oneself is thus very far from knowing oneself.'[3] The bare consciousness of the fact *that* I exist is purely conceptual, an act of thought rather than an item of knowledge. It becomes an item of knowledge and a 'determination of existence' by means of intuition alone, of 'the special mode' in which the manifold, once combined and synthesised, is given in inner intuition, or time. Kant defines time as the 'pure image' of all the 'objects of the senses'. Schematism, the sensualisation which mediates between pure concepts and experience, is a process of figuration and temporalisation. In his book on Kant,

Heidegger refers to it as the 'formation of an aspect' and as the 'acquisition of an image'.[4] Schematism pre-supposes a possible relation to something which presents itself in experience. The 'that-ness' of what presents itself in experience cannot be deduced, determined or known. Against Descartes, Kant maintains that the 'that-ness' is contained in the logical unity of self-consciousness. Existence, the positing of being, does not follow from the pure act of thought, for it is 'something real that is given, given indeed to thought in general, and so not as appearance'.[5] In order to elucidate this insight, Kant says that 'without some empirical representation to supply the material for thought, the act 'I think' would not take place'. There would be no thought and it would be impossible to speak of a logical unity without a possible relation to something that presents itself in experience and that is empirically given. Sensation and receptivity lie 'at the base' of the existential proposition.[6] Hence, if the self recognises itself as something which appears and which can be experienced, and if it is thought alone that can relate to the self as something which does not belong to the world of appearances; if the self cannot be recognised in itself, and if self-consciousness does not simply coincide with a recognition and a knowledge of the self, then each image of the self, each unity into which the imagination synthesises the manifold of intuition, is marked by the blind spot of a 'that-ness' which is prior to knowledge, determination, representation and observation. 'Image' is the name conferred upon a blindness which is constitutive of finite cognition. This blindness, the blind spot of knowledge, indicates the unbridgeable gap which separates the 'how' from the 'that'. It separates self-observation from its object and triggers the doubling of lifelines.

In his diaries, Julien Green repeatedly reflects on the experience of a doubling which occurs in the process of writing. It is not he who writes his books, but rather the other of whom he knows nothing. This experience can be generalised, for a writer who could observe himself while writing and do so without interference, would not be able to write at all. He would apply rules. Such an awareness of the non-coincidence which both creates and destroys the link between the subject and the object of observation may well denote a kind of intensified self-observation. But this kind of self-observation, too, remains dependent on something unobserved that calls for self-observation and that turns it into an observation commanded by alterity. The self observes itself as if it were a stranger. That it does so before it can even distinguish between what belongs to it and what does not, is the passion and the trauma of self-observation. Thus self-observation never achieves the construction of an intersection of lifelines. It cannot discern the vanishing-point where immanence and transcendence converge, or paint the self-portrait in which the self recognises itself.

The fact that I cannot observe myself straightforwardly and hence observe myself all the more closely explains why observations which stem from others startle and wound me. I either reject them as one-sided and unjust, or accept them blindly as shocking revelations which cannot be gainsaid, and which for this reason I crave. But if someone keeps his observations to himself and reveals them much

later during a quarrel, he does not act as a friend and turns my blindness into an instrument of power which he uses against me. Whoever claims to be finally revealing the truth about the other in the course of a fight affects to be an honest man, but proves to be a culprit. Conversely, whoever continues to keep his observations to himself, allows his silence to turn into a betrayal. That I cannot observe myself straightforwardly and hence observe myself all the more closely not only explains why the happy and the unhappy live in incomparable worlds, but also why even the unhappy live in different worlds. The non-coincidence which marks self-observation and which results from the simultaneity of mutually exclusive perspectives frustrates all attempts at comparing one's own unhappiness with the unhappiness of others. I keep observing and measuring my unhappiness because I can observe it only partially. Hence I keep experiencing it as an incomparable and inescapable unhappiness, as the greatest that can be, regardless of the efforts I make to be an objective observer. My willingness to acknowledge an existing disparity, my concessions and admissions, my impulses of pity and compassion, my offerings of friendship, my loving devotion change nothing about the way in which I experience my unhappiness. The despairing 'What for?' is the sign, the symptom, the scar of an unavoidable breach in communication.

The self's encounter with itself appears to be paradoxical because it is not caused by self-observation but must consist in a transformation. As a concentration and a redemption, the release of what is characteristic of an individual has the paradoxical form of a transformation which amounts to a self-encounter. Were one to understand this transformation as a transition from one state of affairs to another, as a specific and purposeful substitution, or as a reification, one would confuse the self-encounter with a result and consequently with self-observation. For self-observation aims at a self-encounter which results from it and absorbs the transforming process. The moment a transformation is reified and turned into a result, the moment it is considered to be a settled and established condition, the concentration effected by the self-encounter is separated from its redeeming force. The individual who has been transformed is condemned to hell and perdition because his transformation is reduced to a fateful repetition and ceases to be redemptive. Perhaps the self's fear to encounter itself and its flight from the self-portrait have their origin in just such a separation, in just such a violent untying of the paradox. Walter Benjamin writes that the figures in Green's novels encounter themselves in their very gestures and attitudes, but are oblivious to this encounter: 'Their demeanour would be just so and no different even if they had to live through the same moments once more beyond the grave. In the desolate stereotype of all truly fateful moments, they stand before the reader like the figures in Dante's Inferno – as if marked by the irrevocability of an existence after the Last Judgement. This stereotype is the sign that we have reached hell.'[7] The self's encounter with itself is, on the other hand, a transformation which coincides with itself. It is a pure event, a transformation that is nothing but a transformation.

In his late book on photography *Camera Lucida*, Roland Barthes defines the photographic image in terms of a contingent occasion or encounter which does not claim anything.[8] Hence, the sovereignty of the contingency which characterises a photographic image derives from its independence of interpretation. The contingent occasion or encounter has a purely deictic value. It merely seems to say: 'There it is', or 'That's how it is'. The event which resides in the capture of something real, objective and given, in the exhibition of a reality which assumes the form of an image both temporal and atemporal, never transcends itself in order to refer to anything outside of the encounter. If the photographic image allows for a return of the dead, of that which existed in the past and is now irretrievably lost, then this return consists in nothing more than the endurance and persistence of a unique and therefore contingent encounter which will not recur. However, the persisting encounter is never a self-encounter. Barthes notes that the self diverges from its portrait or its image, even and especially in the photograph. The difference which brings about this divergence, the difference between the image and what it portrays, is the difference between the vital flow of the lifeline and its irrevocable interruption by death. The image is closer to death than to life. It is only within the flow of time that the sound of the camera can induce an awakening which, as Barthes stresses, releases the stiffness of a deliberate pose. It is only within the flow of time that an awakening may occur which excludes the possibility of a self-encounter in an image, at least to the extent that the image captures the awakening, turning it into something unique and thereby condemning it to ghostly recurrence.

The photographic image thus frustrates the self-encounter that takes place by virtue of the recognition of a resemblance. The referent of such a recognition is the equivocal referent of myth, of the mythical view that I have of myself. But as an image which frustrates recognition, the photograph has the power of authentication. This power places it in contrast to language. An image cannot support or articulate what it presents to our gaze, but it can attest to what it shows. By transforming itself into a self-encounter it transcends the perception which must run up against the temporality of the encounter, against the recurrence of the irretrievable. Barthes interprets the self-encounter within the image as an authentication which is rendered possible by the paradoxical temporality of the photograph. Only from such a point of view can the relationship between a photographic image and the awakening of a resurrection be clarified. Since authentication is not a perception of something given, since what is attested to cannot be perceived as such, the self-encounter Barthes seems to be preoccupied with is not the result of a perception and recognition of oneself in a self-portrait. Of course such recognition is already thwarted by the mythical and equivocal nature of resemblance, and by the reification of that which is portrayed. The self-portrait is the pure event of an authentication which, according to Barthes, cannot be conceived without the existence of photography. To the extent that it is defined as authentication, the photographic image transforms the encounter into a self-encounter. Thus, the photograph is not a depiction or representation of a resemblance. It is not the medium of a transition

which would lead from an original and hidden self, from a self that does not yet resemble itself, to a transformed and manifest self, to a self that finally resembles itself. Rather, it constitutes an authentication, a self-encounter which amounts to the pure event of a transformation.

The fact that this authentication requires the gaze of a third party, that one cannot authenticate oneself, or can do so only in an involuntary and self-oblivious fashion, and that Barthes does not seek a self-portrait or a photograph of himself, but an image of his dead mother, simply expresses the paradox of the self-encounter. The self-encounter is neither a self-perception nor a self-observation, it is a pure event, a transformation which coincides with itself; as such, it involves a forgetting which is no longer opposed to memory, and a death which is no longer opposed to life.

In his essay 'The Two Versions of the Imaginary', published in 1955, Maurice Blanchot defines the image as something which addresses itself to us.[9] It speaks to us in order to speak of us, and to do so in the most intimate way. An image creates an intimacy in which it reveals to us something about ourselves. It is only later in the text that Blanchot explains how the image speaks to us so as to appear as a self-portrait. The intimacy, the close relationship established by the image is not to be confused with a subjective inwardness, for the address of the image marks precisely a rupture, a division of interiority. The image, a mere trail and thus different to what it represents, maintains itself on the verge of indeterminacy and designates the limit of nothingness. Its equivocality which gives rise to the two versions of the imaginary, to an identification of the image with a sustaining ideality and with an arbitrary dissolution, stems from this extreme position. Hence, an image proves to be independent of the object it represents because it is not simply determined by the nature of this object. We must in no way constrain ourselves to a literal understanding of the imaginary, reducing it to figural representations. Beckett's play *That Time*,[10] for instance, features different voices and an almost expressionless face which are imaginary in the sense intended by Blanchot. The face is the face of a listener whose slow and regular breathing accompanies the voices. It is as if the transformation into the imaginary achieved by Beckett in his plays proved the point that there are 'infinitely many degrees of consciousness, down to vanishing'.[11]

But Blanchot does not just assert that the image addresses us. He claims that, at the very limit of nothingness, it addresses only us and speaks only of us – without ever speaking of us and without actually speaking to us: 'Thus the image addresses us and, when speaking of a thing, it speaks of less than a thing, it speaks of us. But speaking of us, it speaks of what is less than nothing, for it speaks of what remains when nothing is left.'[12] The breach of inwardness which is caused by the self-portrait, by the address of an image that speaks to us most intimately, affects us and transports us into a twilight world where we are neither mere thing nor living being. It is in this peculiar intermediate space that a self-encounter occurs. The self-encounter occurs in a place where the self is transformed into a pure image, a pure likeness, a corpse: 'When this moment has come, the corpse appears in the

strangeness of its solitude as that which has disdainfully withdrawn from us. Then the feeling of a relation between humans is shattered, and our mourning, the care we take of the dead and all the prerogatives of our former passions are returned to us – they fall back on us since they can no longer know their direction. It is striking that at this very moment, when the cadaverous presence is the presence of the unknown before us, the mourned deceased begins *to resemble himself*.'[13] Because the corpse is the image of all images, is pure resemblance, an image always addresses us and always speaks of us; because the living human being can never resemble himself, because he always resembles a different human being and remains entangled in the equivocality of the mythical which Barthes rejects, one cannot encounter oneself without undergoing a transformation: the image speaks always to us and speaks always of us without actually speaking to us and without ever speaking to us. The self-encounter in the self-portrait is the event of a resemblance. Resemblance itself becomes an event[14] because the self-encounter reveals itself to be a pure transformation, a transformation which results neither in being nor in nothingness.[15]

In his essay on the storyteller, Walter Benjamin states that, while it is possible to transmit a man's knowledge and wisdom, the object of transmission is 'above all his lived life'.[16] However, one can infer from the final pages of the essay that the life which is transmissible, or which can be transmitted in and as a story, is always the life of the wise man. Benjamin seems to be more interested in transmissibility itself than in the distinction between knowledge, wisdom and life. To establish these distinctions would mean to analyse a historical dynamics, rather than to describe a static relationship. Since life becomes transmissible only once it has been lived, transmission pre-supposes the completed life experience that transcends birth, and depends on the experience of the dying man. The experience of the dying man is still an experience, and even particularly so because far from exhausting itself in the violent severance of the lifeline, the suddenness of death, it creates a continuity. The origin of storytelling, of an activity which always aims at narrating a whole life and life as a whole, lies neither in life nor in death. If one takes Benjamin at his word, this origin lies in an incredible reversal which makes it impossible to establish a clear and simple distinction between beginning and ending: 'A sequence of images is set in motion inside a man as his life comes to an end. They represent different aspects and views of him. In some of them, he has come face-to-face with himself without being aware of it. But suddenly the unforgettable emerges from his gestures and glances and imparts to everything that concerned him an authority which even the poorest wretch in dying possesses for the living around him. This authority is at the very source of the story.'[17] Life spreads out into images as if it were a fan. The movement of these images reproduces the external course of events on an internal screen, inscribing each image in a cinematographic continuity. However, both the continuity of the inner succession of images and the continuity of the external course of events is brought about only at the end, at the moment life expires and its views unfold quickly before the eyes of the dying man. The self-encounter of the man who, oblivious of himself, fails to internalise it, the creation of

a resemblance in a self-portrait which a man does not recognise as such, have always already occurred when the unforgettable appears to this same man and becomes apparent on his face. It is not in verbal communication that the unforgettable is expressed, but in the externality of an expression. A former self-encounter has always already prepared and enabled the dying man's encounter with himself. For what authority could the unforgettable confer upon the story if not the authority of a self-encounter? The name 'wisdom' is given to a self-encounter which is the origin of storytelling and communicability. But in founding the continuity of the external course of events and of the inner succession of images, the self-encounter of the dying man has the retroactive effect of making his former self-encounter possible. This self-encounter could never have happened in a condition of mere discontinuity. According to Benjamin, the self-encounter takes place in the precipitous agitation of that which happens 'suddenly'. Is not this suddenness, this caesura of expression which allows the unforgettable to express itself, the suddenness of a repetition that prevents us from clearly determining which self-encounter occurs first?

There is an uncertainty which haunts the distinction between beginning and ending, life and death, continuity and discontinuity. Consequently, the self-encounter Benjamin refers to cannot be an event which one identifies as such and distinguishes from other events that form the context of life. The self-encounter once again proves to be a pure event or a pure transformation.

In 'Gaps' [Lücken], an aphorism or fragment from *Minima Moralia* written in 1944, Adorno describes lifelines as deflected, distorted and disappointing 'with regard to [their] premises'.[18] Yet it is only in following such an erratic course and in 'being less than [they] should be' that they 'represent an unregulated experience.' A lifeline is never a straight line, for life never orientates itself towards a conclusion which could be deduced from its premises. Life transgresses its own law, misses its vocation and destination, thwarts the potential it pre-supposes. Its line runs between expectation and disappointment. Life disappoints because it does not fulfil the yearnings and expectations it arouses; at the same time, though, it fulfils these expectations precisely because it does not fulfil them. It is as if the missing fulfilment rescued the expectation left unfulfilled.[19] Adorno radicalises his thought when he claims that a life which fulfilled 'its vocation directly' could not help missing it. The terse exposition of this idea stands in the context of an analogy. For Adorno uses the image of a lifeline and its diverted trajectory in order to illustrate the process of thought itself. Life and thought form two parallel lines which finally intersect each other, as one can gauge from the last sentence of the aphorism or fragment. The line of thought resembles the course of life in that it is not linear. Thought must break the promise it holds out by assuming the 'form of a judgment', a form without which there would be no thought. But the promise inherent in thought is kept precisely because it resists its own fulfilment,[20] just as the expectation life arouses is fulfilled when it renounces everything that legitimates it and that relates it to a vocation, a destination, a goal. In both cases, fulfilment lies in indebtedness, and success in

failure. Thought counts as thought only insofar as it 'forgoes the full transparency of its logical genesis' and ceases to seek the integration of its genesis and its validity in a conceptual unity: 'Knowledge comes to us through a network of prejudices, opinions, innervations, self-corrections, pre-suppositions and exaggerations, in short through the dense, firmly-founded and by no means uniformly transparent medium of experience.'[21] From the perspective of Adorno's analogy, experience is not transparent because the trajectory of a lifeline cannot be construed in advance and according to geometrical progression, or because existence cannot be regulated. However, if the gaps of which Adorno speaks are indeed to be gaps, rather than something which can be filled, then one must conclude from this anti-discourse on method[22] that every act of thought could also have produced a different thought, and that every thought is surrounded and intrinsically determined by such virtuality. In his fourth untimely meditation, Nietzsche recalls the attempt 'to consider the evolution of the greatest artists as deriving from inner constraints or gaps'. Inhibited and interrupted, Wagner developed his 'natural talent for acting' into the form of the *Gesamtkunstwerk*.[23]

This lack of regulation of all existence and all thought is reflected in the line of thought itself. For insofar as Adorno maintains that the irregular trajectory of lifelines represents an unregulated experience and that this representative function is a negative reflection of present historical circumstances, he appears to qualify his argument historically. But insofar as, in what follows, he maintains that only a life which misses its vocation is capable of doing justice to itself, he seems to make a general point and to suspend the historical premiss of his argument. This juxtaposition of unmediated and almost contradictory claims is a gesture characteristic of Adorno's philosophy.[24] Doubtless, the unregulated aspect of a line of thought which is not unified and which is at odds with itself should not be taken as a sign of arbitrariness. For the lack of mediation points to two irreconcilable demands thought has to take into account if it is not to renounce itself, if it is to resist both the reification which results from a continuous repetition of familiar patterns, and the confusion which results from the entanglement with its object. The historical qualification of the argument means to take into account the dependency of thought on experience, whilst the formulation of the argument in terms of a universal claim seeks to correspond to the form of a judgment, raising thought above history and the temporal limitations which constantly divide, suspend and illuminate our judgments and force us to revise them. If one places oneself within the perspective of the historically qualified argument, the question arises whether, despite the overt insistence upon deflection and distortion, the very idea of fulfilment does not, after all, dissimulate the suddenness, blindness and violence of interruptions which mark recent historical events and which disrupt the temporality of individual biographies. Are the concepts of the self-encounter and the self-portrait not also deceptive? Twenty years after writing *Minima Moralia*, Adorno denounced a certain usage of the word 'encounter', a usage which transformed it into one of the ideological keywords of the jargon of authenticity.

The 'present circumstances' of history and historical experience allow and call for an anticipatory substitution. An unregulated life is to represent a future unregulated life. Does not such a representation turn the unregulated life into a model? Does not a life which proves to be unregulated when measured against 'present circumstances' function as the negative of an unregulated life that transcends these circumstances? Is the same not true of thought, at least to the extent that its line runs parallel to the lifeline? Does not the transformation of an unregulated way of thinking into a paradigm revoke its being-not-one and its being-not-at-one? To be critical and even dismissive of Adorno by answering these questions too hastily in the affirmative would perhaps amount to a misconstrual. One would overlook the fact that an unregulated life is affected by its unavoidable exposure to a regulated life, and that the substitutive representation must therefore reveal itself to be a representation without representation.

But is there then such a thing as an unregulated life opposed to a regulated one? At the beginning of his aphorism or fragment, Adorno says that thought depends on its distance from familiar patterns. Does it not also remain exposed to such patterns? Insofar as it is intrinsically linked to the 'form of a judgment', thought must aim to justify itself, to provide a legitimation which allows it to recognise itself and to become recognisable. The tension between the discontinuity of gaps and the continuity of the familiar connects and constitutes thought. But this tension which results from the unbridgeable distance between the blind spots of thought and its recognisable patterns, contains within itself the possibility and the risk of its own dissolution. Such a dissolution would lead to an irrevocable negation of thought. In some sense, however, it also belongs to the very experience of thinking. What cannot be reconciled co-exists in thought, for thought is a conjunction of irreducible opacity and flawless legitimation, a conjunction of a conjunction and its possible negation.

The fact that lifelines are being drawn, no matter how distorted or interrupted, indicates an absence and an expectation. The self-encounter, the concentration and redemption which release the particular nature of an individual, the pure event of a transformation, have not taken place as yet. But lifelines would not be drawn at all, and life would coincide with death or with a form of paralysis, if existence and experience were regulated, and if there were no gaps in life and thought. To the extent that the fulfilment of the expectation inherent in both must depend on the failure of such a fulfilment, or, to be more precise, on 'the remembrance of what was missed and neglected', it cannot be interpreted as the recovery of a transparent and coherent totality without disavowing the forgetting caused by the gaps. Adorno refers to the 'remembrance of what was missed and neglected' in the last sentence of his aphorism or fragment. He speaks of it with the necessary sobriety, but he also invokes it with distinct messianic overtones. What he has in mind is a 'teaching' [Lehre] which would go beyond the conditions of possibility of an existence regulated by categories.[25] One must, in order not to betray the unregulated thought of the aphorism or fragment, conceive of the self-encounter which remembrance is to

achieve in terms of a pure event, of the transformation itself rather than its result. The expected transformation of thought into a 'teaching' is by no means to be confused with its transformation into a specific teaching, a positive doctrine, or a fixed content. The prospect of such a transformation would once again suggest that life and thought can indeed reach their goal by following a 'straight line'. The final turn Adorno contemplates points to the paradox of the self-encounter, to the simultaneity of concentration and redemption which characterises the release of the particular nature of an individual. The transformation of thought into a 'teaching' signifies the concentration of thought; that this transformation must be a transformation into a pure event signifies the redemption of thought. A pure event can never become the content or the object of a 'teaching' and eludes teachings which aim at objects and contents. Hence the transformation into a 'teaching' or, as Adorno writes, '*the* teaching' [die Lehre] is to be understood literally – as a transformation into that which makes something teachable, not as a transformation into a content which can be taught.

To recognise a transformation means to recognise other transformations which it provokes before or after it has occurred. Thus, Kafka's famous story 'Metamorphosis' pre-supposes the event of a transformation. It turns this event into its premiss and deals with it in the only possible manner – by referring to the transformations which it causes, and by describing the ongoing and irreversible process of absorption which removes the person who wakes up transformed from his former life. Perhaps it could even be said that the story fails to convince its readers precisely because Kafka so successfully keeps to the meticulous description and portrayal of what can alone be described and portrayed. 'Metamorphosis' does not only begin, but it also ends with a transformation. This last transformation depends entirely on the preceding transformation, on the expulsion which it triggers and which leads to the death of the character who has been transformed: 'While they were thus conversing, it struck both Mr. and Mrs. Samsa, almost at the same moment, as they became aware of their daughter's mounting excitement, that in spite of all the sorrow of recent times, which had made her cheeks pale, she had blossomed into a pretty girl with a good figure.'[26] The difference between a preceding transformation, a transformation which has effected a transition to a new state of affairs and which, as such, cannot be brought into presence, and a transformation which is a pure event, consists in that a preceding transformation gives rise to further transformations, while a pure event does not initiate anything and provokes no changes at all. Thus, the intention to encounter oneself, interrupted by the paradox of the self-encounter, does not aim at causing something to happen, or at producing an effect. Rather, it seeks to enter the very interruption of causation, the ceasing of all effectuation and effectiveness.

TEMPORALITY
AND BODY IMAGE

4

The strut of vision: seeing's corporeal support

Joan Copjec

If anything has stirred American academics in the last several years, it is the much-trumpeted observation that bodies matter. This observation has produced a veritable cornucopia of corporeal kinds: volumes have been written and compiled on all sorts of bodies, categorised by function, differentiated by class, race and gender, meticulously scrutinised in all the nooks and crannies of their differences from some abstract, idealised form. This *un*airbrushing and proliferation of bodily forms harbours the belief that it was a misguided focus on the signifier that led us down the ideologically retrograde path of decorporealisation. Analysis of our world as a system of signifying relations yielded, we are told, merely ideal subjects: absolutely abstract, detached from bodies and all their powers, limitations, and demands.

The current revenge of the body, or of interest in the body, is seen as a revenge against the soma-denying power of the signifier, and as such has taken two forms: either it condemns the semiotic project by turning away from it toward biological sciences or it extends the project by adding the body to the list of the signifier's effects. As the recent barrage of books on embodiment testifies, however, neither this simple condemnation nor this simple addition is capable of producing any real knowledge of the body as component of our human existence. The reason for this, I would argue, is that rather than forcing a fundamental rethinking of the nature and operation of the signifier, the introduction of the body into current discourse has left the signifier undisturbed, whether it has rejected it or put it to a new use. Simply stating that 'bodies matter' – as though one need only revenge or answer their neglect, these studies have so far buried the crucial *question*: 'What is the matter of bodies?' Why do they suppurate (for that is the word for it) so much trouble for themselves? Why does human embodiment manifest itself as a pitched battle between our bodies and our biology, such that it would be a mistake to take them as synonymous? To be embodied means, of course, that we are not just anybody, but *this* body *here*. But why is it that our corporeal particularity displays itself in such peculiar cravings: why do we find ourselves constantly overeating or

starving ourselves, cutting up other bodies into little pieces or prostrating our-
selves at another's feet? In other words, why, even in their 'basic' pursuits of nour-
ishment and sex, are human bodies given to compulsion, inhibition, sadism,
idealisation? Animals have bodies, too, but not such exotic pleasures, such per-
verse tastes. Their instincts, like our drives, are a kind of non-conscious know-
ledge of what they must do. The difference is that instincts, which suits animals
for survival, are determined by nature, while drives, which are determined neither
by nature nor culture, often jeopardise survival. Yet, it would be a mistake to con-
fuse drive with will or whim, since drive does not appear to be at the disposal of
the conscious subject; on the contrary, it exerts an unrelenting, internal pressure
which mere will is unable to oppose and the body is unable to escape.

Though the concept of drive pays heed to what is often called the human
body's *perversion* or deviance from the natural order, only bad faith would prevent
us from admitting that the notion of a non-natural body is a contradiction in terms
and therefore untenable. A body is clearly a part of nature. If one wants to hold onto
the notion of drive (and psychoanalysis has given us many reasons why we should),
the only way to avoid contradiction is to assume that the notion implies not an over-
riding so much as a redefinition of nature. Which is precisely why, of all Freud's
notions, that of the drive has had the least success in attracting supporters; it
obliges a kind of rethinking that only the boldest of thinkers would dare to under-
take. The question one must ask is: how does drive determine human embodiment
as both a freedom from nature and a part of it? In sum, the conviction that bodies
matter does not exonerate us from having to ask this fundamental question, 'What
is a body?'

However much we have learned about the body in recent years, we have learned
next to nothing that would lead us to pose, let alone answer, such a question, nothing
that would cast light on the 'perversions' of human embodiment.[1] Let us settle on
one example of this problem, that provided by the notion of the embodied *observer*.
In the late 1970s, it is true, the film theoretical attempt to analyse vision as a signi-
fying practice did produce a subject that no body could be: a monocular subject of
pure, abstract seeing, who occupied no space, was subject to no temporal fluxuations,
and laid claim to no sexual identity, except – notoriously – by default. In *Techniques of
the Observer*, Jonathan Crary challenges this description of the film spectator by
mounting a historically-informed argument against it. At the end of the nineteenth
century, he tells us, the observer suddenly acquired a body, one that took up space,
changed over time, and could be examined in all its contingency by empirical sci-
ence. Unlike the earlier, abstract observer – which was configured and instantiated
by the camera obscura and the geometry that informed it – this corporealised
observer had more than a merely ideal existence. The aberrant perceptions of its all
too human eyes – retinal afterimages, light distortions, blurring, and the like – that is,
perceptions constituted *by the body itself*, were no longer dismissed as carnal errors
requiring rational correction, but were instead taken seriously as positive phe-
nomena in their own right – the better to be put to use by a developing capitalism.

While the argument for such a shift from an anti-optical or geometrical model of vision to an optical or physiological one is amply documented, there is more than sufficient reason to doubt its fundamental soundness. Let us begin with the general argument that the transition from a geometrical to a physiological model signals a transition from an abstract to a corporealised observer. The support given for this argument is mainly of the following commonsensical sort: since the camera obscura was constructed around a single point of projection while the stereoscope was constructed around two, the first must have been aimed at the mind's eye and the second at the actual eyes of the embodied subject. Or: since geometry is an abstract science, it supposes an abstract subject, while physiology, which studies the body, supposes a carnal observer. Now, from these sorts of assumptions a guess as to what Crary means by embodiment is a simple affair. In the Cartesian vocabulary that Crary cites, it means that the observer is *res extensa* and not merely *res cogitans*, that is, the observer is extended substance rather than a purely thinking or seeing thing, a cogito; in nontechnical language, the observer, whatever else it may be, *is* matter, a bounded, finite thing interposed between other things, and as matter it impinges necessarily and meaningfully on vision in ways that can be physiologically studied and manipulated. I do not doubt that physiological science held such a notion of the body, what I doubt is its veracity. Additionally, I would question the broad assumption that this notion represented a more materialist account of vision; in fact, it can be easily shown that it is decidedly more *abstract* than the geometrical account.[2] Anyone who needs convincing should treat himself to reading about the wild shenanigans of these physiologists, who kept coming up – despite themselves, one imagines – with reasons for embracing the blindman as the only proper subject of their experiments, and constantly found themselves in cahoots with spiritualists, vitalists, and other such positivist dupes. In any case, what is most striking about these experiments is their incapacity and unwillingness to distinguish the facts of human and animal embodiment.

Crary does not blink, one notices, when he cites the passage from the *La dioptrique* where Descartes, in the process of describing the construction of a camera obscura, asks his readers to imagine an eye – it could be the eye of an ox, he adds parenthetically – at the lenticular[3] entrance to the darkened chamber. To this off-hand remark Crary off-handedly responds, 'this only indicates that for Descartes the images observed within the camera obscura are formed by means of a cyclopean eye, detached from the observer, possibly not even a human eye.'[4] That is, since the eye at issue here is not a physical one – insofar as it is the cogito, pure seeing or thinking that counts – the eye's actual characteristics are irrelevant. The problem is, however, that when Crary later examines the physiological model of vision, we cannot help recalling this passage from the *La dioptrique*, and its Bunuelian sleight of hand. For, in the later optical experiments, all indications are that the human eye which was the object of its study might just as well have been the eye of an ox.

One of the conditions of the possibility, and greatest errors, of the 'life sciences' introduced in the nineteenth century was their improper equation of stimuli which

had radically different origins and natures. It was psychoanalysis, rising up to take issue with these sciences, that would eventually untangle them for us. To this end Freud would complain, 'a dryness of the mucous membrane of the pharynx or an irritation of the mucuous membrane of the stomach,' that is, the physical manifestations of thirst and hunger in the human body, are treated by these sciences on the model of 'a strong light fall[ing] on the eye,'[5] even though the pangs of human hunger and thirst need have nothing to do with the presence or absence of food in the stomach or moisture in the mouth, and how well one sees may have nothing to do with the intensity of available light. These two types of stimuli – those with a purely physiological source and those that originate in the drive – cannot, however, be distinguished merely by determining whether they originate externally or internally; what differentiates them rather are the concepts of cause required to account for them. While physiological stimuli and the responses to them are governed by simple scientific laws, or regularities, drive stimuli provoke responses not calculable in advance. This is not to say that the latter do not enter into causal relations, but that these relations are 'more complex', as Freud said; or, as Lacan would later argue, in the drive cause and effect are not welded together to form one principle as is the case with the fixed and stable relations that bind stimulus to response.[6] While the latter are governed by scientific law, drive stimuli arise there where a gap in the law is to be found. To illustrate, Lacan invokes an image of the crushed body of a suicide lying on the pavement. This image would undoubtedly prompt different causal explanations from a physiologist and a psychoanalyst. That it is only a human body which is ever suicided would not enter into the considerations of the physiologist, whose explanation would most likely give more weight to the force of gravity than to the pressure of the drive, though the latter is surely the more relevant fact of this suicide's embodiment.

The fundamental error of *Techniques of the Observer* is, I am arguing, its unthinking acceptance of the mind/body dualism of Cartesian philosophy. It is this dualism that grounds the distinction Crary makes between the geometrical model of vision, which supposedly disregards the body entirely in favor of abstract consciousness, and the physiological model, which reduces the body to its empiricist definition. This history presents us with a false choice between no body at all and what we might call an 'abstract body', since it lacks both generic (that is, human) and individual specificity. This choice precludes the possibility of Crary's coming to terms with the corporealised vision of a human subject, insofar as this subject constitutes a direct challenge to that dualism. But if his initial error ultimately leads him to misjudge the nature of the corporeal observer, it also causes other problems along the way, including a throughgoing misrepresention of that geometry which informs Renaissance perspective and its 'universalist' claims.

This is not to say that this misrepresentation originates with Crary. Since the point of his argument is not to challenge film theory's analysis of Renaissance perspective as that which set in place an abstract observer, but to question the hegemony of this model of vision beyond the late eighteenth century, he accepts

without question film theory's analysis and mistakes. As is known, film theory attempted to prop up its notion of cinematic visuality on the analysis of the gaze that Lacan offers in *Seminar XI*, though the reading of Lacan it produced was so severely flawed that it ended up taking a position completely at odds with his. Where film theory and Lacan diverge, Crary follows the former, often strengthening its argument. This is the case, for example, on the question of the observer/spectator's placement vis-à-vis the visual field. Crary works diligently to secure a rigorous separation of the observer from the observed. Essentially he argues that the geometrisation of vision places the observer not only *outside* the body, but *outside* the visible world, as well; whereas, the physiological model places the observer *within* the world and *within* his body. Relying on these 'age-old assumptions'[7] regarding the simple exteriority of body and world, Crary interprets ideologically the textbook argument which states that Renaissance painting introduced a visual objectivity that quickly displaced the subjectivity of medieval painting. He and film theory interpret this objectivity as a *mis*recognition fostered by the belief that the observer could indeed transcend his/her body and world and thus truthfully comprehend it.

Lacan does not dispute the textbook argument concerning the Renaissance invention of painterly objectivity; but he interprets objectivity in a different way. This difference is plain in statements such as this: 'the geometral dimension enables us to glimpse how the subject who concerns us is *caught … in the field of vision*.' (FFC, 92) That is to say, Lacan argues that Renaissance painting places the spectator *within the image*, not outside it, as Crary contends. Giving full weight to the name by which this model of vision is known, Lacan argues that it shows that all we see, we see from a certain *perspective*. In fact, the relevance of his lengthy discussion of anamorphosis is to focus attention on the *impurity* of the painting's visual field insofar as it consists not only of *what the spectator sees*, but something more: the vanishing point, which is nothing other than *that which the spectator contributes to what she sees*.[8] This does not mean that quattrocento painting rendered the spectator visible or transparent to herself in the manner in which Descartes' ideal observer became transparent to herself. If the spectator is pictured there in the painting, she is not grasped as coincident with the thought she has of herself, but as someone who is looked at from a place other than the one from which she or he sees.

That Lacan's extended disavowal of the supposed similarity between Descartes's abstract observer and the observer of Renaissance painting should have fallen on such deaf ears among film theorists, is no surprise. The missed encounter can perhaps be chalked up to the fact that film theorists mistook anamorphosis for an occasional rather than a structurally necessary phenomenon, or, more generally, to the notorious difficulty of Lacan's paratactical style. But if the particulars of his argument were not immediately clear, its context is unmistakeable and this alone should have sent up warning flares to those intent on nailing down the Cartesian lineage of his observer. For, these sessions on the gaze are no diversionary foray into

the territory of art criticism; they are, rather, an attempt to develop one of psycho-analysis's fundamental concepts: that of the drive. Lacan proposes that Renaissance perspective provides the exact formula of the *scopic drive*, that is, it gives us the formula not of abstract vision, but of embodied seeing. As I noted above, the concept of the drive is the vehicle by which Freud collided head-on with Cartesian dualism, the means by which he strove to account for the facts of an incarnate subjectivity. Listen once more to the definition he gives of the drive in his essay, 'Instincts and their Vicissitudes': '[drive] appears to us as a concept on the frontier between the mental and somatic, ... as a measure of the demand upon the mind for work in consequence of its connection with the body.'⁹ This demand (which is precisely *demand* in the Lacanian sense) is that call for a more complex response from the corporeal subject (which is to say, the subject as such of psycho-analysis) than any that could be accommodated within a physiological, stimulus-response model of investigation.

But what is it that *justifies* this argument? What allows one to state that geomet-rical perspective provides a formula for the the relation of the *corporeal* subject (not the purely rational subject) to the visual field? To answer this question, it is first necessary to distinguish *artificial perspective*, which emerged in the sixteenth cen-tury out of a revolution in geometry, from its predecessor, *natural perspective*. Whenever this distinction is overlooked, confusion results, as happens in Crary's and film theory's account of Renaissance perspective.

> What is that thing which does not give itself, and which if it were to give itself
> would not exist? It is the infinite! Leonardo da Vinci

It is a commonplace to say that Renaissance painting introduced infinity into the visible world. But one needs to specify, beyond this platitude, which infinity it introduced.¹⁰ Without explicitly saying so, and while seldom using the word infinity, Crary seems to assume that what is at issue in paintings of the quattrocento is *potential infinity*. Citing two paintings by Vermeer, *The Astronomer* (1668) and *The Geographer* (1668–69) as paradigmatic illustrations of Renaissance perspective, Crary argues that the two observers depicted in them 'engage in a common enter-prise of observing aspects of a single *indivisible* exterior. Both ... are figures ... for the autonomous individual ego that has appropriated to itself the capacity for intel-lectual mastery of the *infinite extension* of bodies in space' (pp. 42–3, emphasis mine). Missing the point of the paintings and of Renaissance perspective, Crary here describes not an infinite, but a finite space. Why do I say so?

By referring to the space surveyed by the geographer and astronomer as a 'single indivisible exterior,' Crary declares it to be an irreducible, an uncomposed, contin-uous whole rather than an aggregate built up of parts. He cannot claim then that the surveyable space itself is infinitely extended or actually limitless; conceived as indivisible, as incapable of being enlarged by the addition of parts, it is necessarily limited, finite. The notion of infinity is introduced into this finite space only

through the operation of measuring or surveying it. Since these operations are indefinitely repeatable, *ad infinitum* – a point Zeno's paradoxes exploited – it is they, and not the space itself, which is unlimited. Measuring and surveying, as processes that cannot be brought to an end, inscribe a negative sort of infinity, which is often called *potential*, though Hegel employs the more obviously derogatory term *spurious*. For, rather than manifesting the *grandeur* of thought (or, in Crary's phrase, the 'autonomous individual ego['s] … capacity for intellectual mastery'), it is evidence rather of a 'superstition of the understanding,' or *deficiency* of thought: an incapacity to come to any conclusion.

If measurement must be considered here a fundamentally incompletable process, implying an indeterminateness rather than a clarity of knowledge, this is because Crary supposes that the truth of Renaissance perspective is provided by the classical, or Euclidean, geometry which informed the construction of the camera obscura. This geometry – which was exclusively concerned with the size and shape of figures, not with space – dealt only with finite points and finite and flat spaces, never with infinity, which notion it regarded with open disdain. Since the Good was conceived by the Greeks as finite and definite, being infinite could only be seen by them as the mark of *privation*, as the absence of a limit or a lack of definition, rather than as a perfection. Infinity was not something *actual*, but a measure of our ever deferred encounter with it. Indeed, even the notion of potential infinity was accepted begrudgingly, as a way of protecting both geometry and philosophy from having to accommodate infinity as a positive notion referring to an actually existing entity.[11]

Renaissance perspective was not based, however, on the classical geometry of the camera obscura, but on projective geometry, whose principles are largely set out in a twelve-page treatise by Girard Desargues, published in 1636. The title of this treatise is immediately revealing: *Example of one of S.G.D.L.'s general methods concerning drawing in perspective without using any third point, a distance point or any other kind, which lies outside the picture field*.[12] Plainly, and contrary to what Crary and film theory have argued, this method operates without referring to any point outside the picture plane; it does not depend on the eye of some supposed external observer, placed at a measurable distance from it. Instead, the field is organised soley around an internal point, the point of infinity.

The lack of reference to an external observer is not the only difference separating projective geometry from its predecessor. A discussion of some of the others will enable us to account for Renaissance painting's repositioning of the spectator inside the frame. In the older, Euclidean geometry, parallel lines are defined in a negative way as *lines that do not meet*. Under certain circumstances, of course, when an object is looked at from a distance, they *appear* to meet, but this appearance is read as an illusion created by distance and not confused with fact. Thus, both in its definition of parallel lines and in its correction of optical illusion, this geometry remains tied to our basic intuition about such lines, to the way we ordinarily picture or represent them to ourselves. Projective geometry, on the other hand, jettisons

intuition the moment it redefines parallel lines positively as *lines that meet at infinity*. For, not only does this defintion cause infinity to come into being as an actual location (rather than a kind of 'and-so-on,' indicating that the drawing of parallel lines has to be carried on indefinitely), it also causes the distinction between parallel lines and all others to disappear. It can now be said of *all* lines that they intersect another line at one and only one point. This new parity between parallel and all other lines has a surprising result: lines and points suddenly lose their hierarchical relation (in classical geometry, a point is a more basic unit than a line, since a line is defined as being made up of points) and become, for the first time, equal. The principle that posits this equality, called the 'principle of duality,' states that it is possible to substitute *point* for *line*, and vice versa, in *any* valid statement regarding their relation, without altering the validity of that statement.

The principle of duality has revolutionary consequences for geometry, but what needs to be noted for our purposes is simply this: projective geometry represents a break – or, better, liberation – from the intuition that grounds classical geometry. Beginning with its positing of an actual infinity – a point which can be neither experienced nor constructed, but which is nevertheless supposed *actually* to exist – projective geometry established itself as radically anti-intuitionist. Unlike the earlier geometry, this one never conceived itself as a method for mapping the visible world, that which it was possible to see; as a result it became a method for revealing the existence of what it was impossible to see, what vision necessarily veils. The purpose of classical geometry was to assist in the drawing of objects on a two-dimensional surface with as little visual distortion as possible; it was intent on preserving the object's *resemblance*, or visual similarity in the drawing. Projective geometry, on the other hand, studied the transformation of objects under projection in order to determine what remained the same throughout the process; it sought to preserve the consistency of the object, not similarities. Parallelism is not one of the properties that is preserved under projection, since deployment of this method results in the intersection of *all* lines at a point, called in painting the *vanishing point*, and the formation of a line across the painting, called the *horizon*.

Now, to imagine that this point and this line mark places where parallel lines *appear* to intersect is entirely to disregard the method of their production, to efface once again all the differences between Euclidean and projective geometry. As stated above, since this method does not investigate the visual properties of objects, the vanishing point and horizon line that emerge in these paintings are not to be taken as illusions of perception, as objects we mistakenly but actually see. They are rather objects that could not be seen except through projection. Though they present to view a surplus of objects beyond those ordinarily visible, Renaissance paintings are nevertheless not inconsistent with the world we see. Paintings and world remain equivalent, despite their lack of resemblance.

But if the vanishing point – or *gaze*, as Lacan will call it – is not something available to sight, what is it? It is the position *from which we see*. This explains why we do not see it in everyday life; for if we are positioned as subjects *at* the vanishing point

(or point of the gaze), then this point lies not before us but 'at the back of our heads,' as it were. This ought to alter our reception of Alberti's famous contention that Renaissance painting offers a 'window on the world.' For, projective geometry forces us to conceive this window as flush not with the picture plane, but with the vanishing point or gaze located in the interior of the picture. The structure of Renaissance painting also needs to be rethought accordingly, because if the spectator is included within the world he or she sees, then the space of the painting must be shaped like a *torus* that folds over on itself (to include in its interior that which would otherwise be considered exterior), rather than – as is commonly imagined – like a *conical section* or visual pyramid receding from its base, or frame, to its apex at the vanishing point. The torus-structure describes then not the visible world but the path of the drive to see or the drive tout court.

In *Seminar XIII: The Object of Psychoanalysis*, Lacan again takes up the problem of the spectator to which he devoted so much attention two years earlier, in *Seminar XI: The Four Fundamental Concepts of Psychoanalysis*, where Renaissance perspective is still represented two-dimensionally as the intersection of two visual pyramids. In the later seminar, Lacan abandons the last vestiges of geometrical intuition to which his earlier discussion still remained minimally indebted. Taking note of the dependence of Renaissance perspective on projective geometry, he describes the latter as 'logically prior to the physiology of the eye and even to optics' (that is, to the problem of resemblance) and states categorically that this later geometry gives us 'the exact form ... of what is involved in the relation of the subject to extension.'[13]

Rectifying the common misconception that Renaissance perspective poses a spectator outside and thus transcendent to the field of vision, one already begins to rectify the assumption that this spectator has merely an ideal existence. But here Lacan makes the issue of the viewing subject's corporeality even more explicit through reference to that subject's *extension*,[14] which is the term Descartes uses to refer to material substance (including the body) in contrast to thought. The thought/extension dichotomy was supposed to guarantee the independence of each term (pure thinking on one side, corporeality on the other), but Lacan argues that the Cartesian notion of extension has thought's fingerprints all over it. That is: material substance is thought as homologous with thought, which means that the former, scarcely independent from the latter, is endowed by Descartes with a covert ideality. Moreover, Lacan argues, if thought is able to think material substance, including the body, as homologous with it, this is because thought already thinks itself as having the finite, limited form of the body, and thus a kind of extension. This does not indicate that thinking is corporealised in any real sense, it indicates rather that the the body, extension, amounts in Descartes to nothing more than an *image* of the body. The Euclidean geometry (which is metrical) that informs Descartes's speculations is capable of taking the measure of only an *imaginarised* body, not the body as such. If we are interested in knowing something about this other relation between the subject and its body, it is to projective geometry that we must turn.

At the beginning of the lectures of *Seminar XIII* devoted to perspective, Lacan poses the fundamental question he wants perspective to help answer; 'What precisely is this subject, this place necessitated by the constitution of the objective world?' We have determined that this 'place' of the subject is the point of infinity (or vanishing point, or gaze) located within the world. The world takes shapes, coheres, around the subject who constitutes it; and yet, the question suggests, this world is not subjective but *objective*. This apparent paradox does not spring uniquely from Lacan's text. Renaissance painting, we recall, is defined in the same paradoxical way, both as perspectival and as the invention in painting of a visual objectivity. Painting's precocious visual introduction of this paradox would precede by centuries its philosophical exploration. It was only in Kant that the dependency of the objectivity of the world on the subjectivity of the subject would come into philosophical focus. For, notwithstanding the common caricature of his position, Kant did not argue sceptically that we have access only to subjective appearances, but held the more compelling view that through a process he called 'transcendental synthesis', the subject constituted a world that was not arbitrarily or simply subjectively ordered, but objective. Lacan's analysis of Renaissance perspective ought to be taken as an attempt to make sense of Kant's position.

But why should psychoanalysis have anything to say about the philosophical problem of the objectivity of the world? The answer is: because the problem came knocking directly at psychoanalysis's door, without philosophical mediation, initially as the problem of hallucinatory satisfaction, most floridly, as the deliria of psychotics. Freud thus had to be able to explain how the 'objective' thoughts of most subjects differed from the 'subjective' ones, the deliria, of psychotics and newborns, who suffered from a lack of reality. We know that Freud first sought an answer in the agency of the ego and that this answer was expressed in Kantian terms: it was to the *synthetic* function of the ego that he looked to restore objectivity to a psychical system potentially overwhelmed by delirious thoughts. But the ego did not turn out to be up to this task, for as the study of narcissism would reveal, the ego is mired in the same muddy waters it was meant, originally, to titrate. It could not for this reason contribute to the constitution of an objective reality, quite the reverse. At this point Freud turned away from the ego to the drive for an answer to the question of reality.

One of psychoanalysis's deepest insights is that we are born into a world not merely of things that impinge on our senses to form perceptions, but into the world of an antecedent Other; it is not then our relation to the *order of things*, but our relation to the desire of the Other, *das Ding*, that decides the objectivity of our reality or its collapse. Essentially the psychoanalytic meaning of objectivity comes down to the fact that the subjective constitution of reality is dependent on repressing the Other's desire by giving it a signifier; without this, the 'reality principle' malfunctions. Irreducibly enigmatic, the desire of the Other cannot be directly signified; yet Freud is not content to say only that its signifier is to be located negatively in the bumblings and lapses of signification. This desire is designated directly by a quasi-imaginary, object-like entity which Freud invokes under the cumbersome Germanic term

Vorstellungreprasentanz (representative or delegate of representation); Lacan has the good sense to shorten this, renaming it simply *object a*. This new name brings out the fact that what Freud called *Vorstellungreprasentanz* is the drive as object; its nature is as much corporeal as ideational. It exerts a constant pressure on what is thereby conceived as an embodied subject, which pressure compels the subject to organise its fantasy in a certain way. The placement of the object in this fantasy determines the nature of the subject's reality. In addition, the term *object a* refers to the fact that it functions not to *name* the Other's desire, but as an object or obstacle that lodges itself in the hole this desire creates, thus keeping it open.

It is important to note in this context that psychosis, which is precipitated by the foreclosure of the Other's desire (as far as the psychotic is concerned, the Other hasn't the least interest in the goings on of human subjects), results not only in the loss of reality with which we always associate this pathology, but *in the loss of the body* as well. The psychotic, whose corporeal experience is reduced to only two dimensions, has no body to speak of, just a kind of frame. Victor Tausk's brilliant documentation and analysis of the 'influencing machine' delusion prevalent among psychotics showed conclusively that the psychotic's attempts at cure consisted not only in the cursory and delusional 'miracling up' of an ersatz world, but in the 'miracling up' of an ersatz body as well.[15] For, one did not fail without the other.

No doubt Lacan had these wobbily edifices of the psychotic in mind – along with those of the perverts and neurotics, whose tics, paraplegias, catarrhs, and other self-inflicted wounds bore witness to their efforts of construction – when he charged:

> Compared to Freud the idealists of the philosophical tradition are small beer indeed, for in the last analysis they don't seriously contest that famous reality, they merely tame it. Idealism consists in affirming that we are the ones who give shape to reality, and there is no point in looking further. It is a comfortable position. Freud's position, or that of any sensible man … is something different. Reality is precarious. And it is precisely to the extent that … it is so precarious that the commandments which trace its path are so tyrannical.[16]

You might be tempted to think that Freud had the advantage of the clinic, where all these botched bodies and realities presented themselves to view, but Lacan's allusion to 'any sensible man' implies that the precariousness of reality ought to have been visible even to someone whose human commerce was limited to dinner parties in Konigsberg. Freud opened our eyes to the fact that even for the most reasonable of us reality's foundations are necessarily shaky – despite Kant's careful and truly admirable attempt to lay the bricks just so. No transcendental synthesis is capable of locking reality fully into place, a fact at which Kant's very notion itself seems to hint. The problem stems from a point we have already discerned: though it may pacify or 'colonise' its unsettling force somewhat, the drive-object does not resolve the enigma of the Other's desire, which continues to insist as a question. If, as Freud states, the drive *is* repetition, this is because the enigma of the Other is irreducible.

For this reason, it would be incorrect to conclude, as Crary and film theory do, that the gaze – a drive-object – is the point from which an entire reality is supposed to be embraced; the gaze is, on the contrary, precisely an obstacle that prevents reality from ever being totalised. Let us approach this point by way of a slight detour through the philosophy of Merleau-Ponty, who like Lacan also sought to corporealise the look (though Lacan is sympathetic to and admiring of Merleau-Ponty's work, he nevertheless distinguishes his view from that of his friend, going so far as to refer, in the seminar on *Anxiety*, to phenomenolgy's notion of the body as a 'corporealised soul'). Like Lacan, Merleau-Ponty relates the objectivity of vision to a limit that functions to give our view a certain depth. This limit creates a 'behind' not visible from my perspective, but which may be imagined nevertheless as a 'rounding-out' of objects on the basis of what is visible on their front. In Vermeer's *The Geographer*, for example, the geographer's body is turned almost completely toward the viewer. We do not see his back, nor do we see the whole of the armoire in front of which he stands, blocking our view. Yet we read the painting *as if* the geographer had a back and the armoire a base which is simply, owing to our perspective, obscured from sight.

Lacan's position is completely different; for him the impossibility of a fully-achieved reality is more radical. Citing Sartre's discussion in *Being and Nothingness* of the voyeur surprised by the rustling of leaves, Lacan states his own position, which suggests that the gaze of another does not stabilise the dimensions of our reality, but, on the contrary, causes this reality to tremble at its base. Now, the more ominous gaze appearing in this scene brings us to the heart of the matter, primarily because it is the critical element in the primal scene of film theory's misreading of Lacan. Partly because it does seem ominous ('paranoid' in the most impressionistic accounts), film theorists interpreted it as that of an Other positioned at a point transcending that of finite beings and able to fix us and our entire reality in its angle of vision. Our thesis has been all along: not at all; the gaze is on the side of an embodied subject (not a disembodied Other) and it falls within the space of temporal reality (not eternally outside)! But how to get from this primal scene to our reading? If the gaze is on the side of the spectator, it is nevertheless, we said, located 'behind his back', that is, it is unconscious. It is other in this sense and also in the sense that it 'figures' the Other's desire. But in 'figuring' this desire (without naming it), it averts it from the spectator and thus tames or appeases what would otherwise be its voracious relation to the subject – once again: without resolving the enigma of this desire.

The spectator's visual relation to reality is thus erected on this foundation: the gaze as corporeal-ideational drive-object that covers over/holds open the hole introduced by the Other's lack. In brief, it is founded on a hole, but a hole that is buttressed by an object; it is this object that will become the keystone of reality. Sometimes the gaze and other drive-objects are described as elements of the real (in Lacan's sense); this is inaccurate. They are *semblants* of the real. This precision is critical, not least of all because the term itself usefully exposes the intimate relation that exists between these *semblants* and the *imagination* that carries out the

transcendental synthesis by which sensible impressions are made to give rise to objective reality, rather than to hallucinatory or delirious representations. We have been following the steps Freud took while assuming as his own Kant's project to attach the objectivity of the world to the perspective of the individual subject, beginning with the first step, the synthetic function of the ego, which notion he then abandoned in order to turn his attention to the drive. We are now in a position officially to recognise (though Freud never put it this way) the *synthetic function of the drive*. The drive-objects, including the gaze, are the creations of a synthesis that gives rise to objective reality.

And yet these objects are, as Freud always insisted, *partial objects*; they therefore testify to a *separation* or *dismembering* as readily as to any sort of agglutination. But why are they called *partial*? Because, Freud will claim, they are only partially satisfying; they only partially represent a greater, more glorious satisfaction that looms beyond the one they provide. (Note the way ideation maintains its connection to the body, through pleasure.) And yet this greater pleasure radically inaccessible to the subject – or, in a word, repressed – is simply that which the inadequacy of the process of synthesis makes us suspect. That is to say, what I am here baptising the *transcendental synthesis of the drive* is a sword that cuts both ways: it produces a foundation but one that continuously undermines itself.

If reality is precarious and never fully-achieved, this is due to the fact that the drive-object (here: the gaze) presents itself as having been severed from some absolute whole and thereby cuts off some of the very foundation it is supposed to build. The only resolution is then dissolution; the subject must continuously detach itself from the drive-objects. This process of successive attachment and detachment replaces and renders obsolete Kant's dream of establishing objectivity on solid, eternal ideas. It is not simply that the process of attachment and detachment must necessarily take time, more: time itself issues from this process, or from the gap that separates the visible world from that which its visibility occults.

Lacan concludes his discussion of the projective geometry that underwrites Renaissance painting with a lengthy analysis of Velasques's *Las Meninas*. Paying to Foucault, who is seated in the audience, the full respect his brilliant analysis of this same painting deserves, Lacan nevertheless proceeds as though he has something to add. While Foucault views the painting as the moment of the birth of the 'transcendental doublet' of the Kantian subject, Lacan appears to be suggesting that we must seize the subject as a 'triplet' (phenomenal-noumenal-object a) formed by the synthesis of the drive. This is a significant alteration, as I have argued; it introduces time and the body into the discussion of representation.

Reliquary art:
Orlan's serial operation

Howard Caygill

> The aim of this series is to produce as many reliquaries as possible, all presented in the same manner, always with the same text but each time translated into another language, until the body is depleted; each time in a different language until there is no more flesh to put in the centre of the reliquary.

> We all have a feeling of strangeness in front of a mirror; this often becomes more acute as we age. Orlan

One of the most striking and yet strangely inconspicuous features of Orlan's work is its serial character. From the *mesurages* of 1976–84 to the series of operations beginning in 1990, Orlan's serial interventions have generated a parallel series of performances and reliquary objects. Orlan's serial intervention consists not only in the conjuring of the strange events produced by the transgressive meshing of heterogenous series – religious and art objects, art and surgery, the female body and its image – but also in confronting them with the finitude, decay and ruination insinuated by the unfolding of the temporal series. As with the face in the mirror, the uncanniness of the double series of object and reflection is intensified by the implied temporal series manifest in ageing.

Orlan's work is unique in achieving a baroque poise between transgressive hybridity and the desire to insulate the delicate products of transgression from the effects of time by encasing them in a reliquary. The central place occupied by the reliquary in Orlan's work prompts a reflection on this art form that last flourished in the context of the Counter-Reformation. The reliquary calls for an understanding of art removed from the platonic aesthetic investments in the image. The art object as reliquary is not the visual envelope of an eternal truth but the receptacle of sacred matter. As the product of an interference between the sacred and profane orders, sacred matter is vested with contradictory and dangerous properties which require it to be sealed off and insulated from the world. Perhaps the supreme modern example of reliquary art, apart from the work of Orlan, is the sarcophagus at Chernobyl, which encases dangerous matter but which in spite of the

efforts of its makers cannot wholly insulate its contents from the effects of time. Such an object cannot be understood in terms of conventional aesthetics, with its emphases upon representation and visuality, but demands a rethinking of the matter of art itself. The burial of the baroque coincided with the invention of modern aesthetics by the protestant Pietist Baumgarten and the diffusion of a theory that linked sacred and profane through the concept of representation, a manouevre accomplished at the expense of a sacramental economy of multiple, dangerous and unpredictable intersections of sacred and profane matter.

The critique of representational aesthetics proposed by Deleuze and Levinas provides a better understanding of the reliquary, and thus of the serial work of Orlan, than theories that remain invested in representation and the visual. Deleuze's contrast between the icon as the visual representation of the platonic idea and the simulacrum as the intersection of heterogenous series provides an exit from an aesthetics that privileges representation as a privileged site of intersection between diverse series. Levinas's attention to the temporality of art provides a similar service, putting into question the analogues of platonic participation that inform aesthetic theory. Both philosophers attempt to rethink the representational basis of art and thought, seeing nested within them more inclusive sets of relations, above all those located in the heterogeneous series and in alterity.

Among the intellectual origins of the anti-platonism of Deleuze and Levinas is re-negotiation of the heritage of baroque thought from Descartes to Leibniz. The consummate expression of the philosophical baroque in all its contradictions and complexity is to be found in the work of Leibniz. The guiding intuition of this philosophy was the conversion of essences into series, a radical step which Leibniz prosecuted unflinchingly and with consequences that, in spite of Deleuze's work, have yet to be fully realised. In his reply to Burcher de Volder's Cartesian objections to his work Leibniz insisted that the series was not only logical but ontological. He argued against the notion of a fixed individual identity by first drawing out the temporal character of identity in a manner that anticipates Kant's 'Analogies of Experience' and then, in a move vehemently opposed by Kant, converting temporal succession itself into a series. After dissolving the individual thing into a temporal flux by claiming that 'all individual things are successions or are subject to succession' Leibniz then claims the paradox that 'nothing is permanent in things except the law itself which involves a continuous succession'.[1] This 'permanent law' of temporality is then itself revealed as a series: 'I do not say that every series is a temporal succession but only that a temporal succession is a series': thus the thing is understood as a moment of a series that intersects with another, temporal series.

Leibniz's insight into the serial character of being and time provoked the further discovery that intra- and inter-serial relations were inseparably related. This followed from the formal definition of a series as that which has 'the property that the law of the series shows where it must arrive in continuing its progress or in other words, the order in which its terms will proceed when its beginning and the law of

its progression are given, whether that order is a priority of essences only or also one of time'.[2] The series is an ordered whole the relation of whose parts is established by a given law of progression. The most deceptively simple law of progression is the law of iteration applied to the essence of an individual thing to produce the permanent presence of the thing. What appears to be a fixed and unchanging individual thing or substance is for Leibniz the product of the intersection of a moment in an essential series with a law of iteration: hence identity is reliant upon difference – the act of iteration – while the differential act of iteration lies at the origin of the identical and the permanent.

The example of the iterative source of permanent identity shows that series are not autarchic but always already hybrid, combining features of other series. These others include not only uniform series such as those formed by the law of iteration, but also 'series which contain maxima, minima, bend points, etc'.[3] The convergence of series in an individual thing corresponds, furthermore, 'to that law which determines the whole world,' the lesson of the *Monadology* that Deleuze encapsulated in the phrase that for Leibniz 'the world was an infinity of converging series, capable of being extended into each other, around unique points'.[4] Deleuze's work is one of the most single-minded developments of the Leibniz's conversion of essence into series, a movement traceable through the reflections on the series that make up *Difference and Repetition* and *Logic of Sense*. What Deleuze drew out of Leibniz's seriology was the possibility of conversions and intersections between the series without the assumption of divine calculation introduced by Leibniz. In this respect both monad- and nomadologies are serial projects: the former seeking to plumb the eminent, divine source 'outside the sequence or series'[5] the other mapping the superimpositions and intersections of series without privileging the divine source, whose externality is seen as but another serial ploy. Rather than seeing the convergence of series producing the divinely attested best of all possible worlds, Deleuze was alert to the possibility of playful and monstuous intersections between heterogenous series, and above all to those strange unions that involve cross manipulation of the temporal series.

The baroque conversion of essences into series and the production of strange hybrids out of the convergence and intersection of heterogenous series helps to locate the transgressive character of Orlan's operation and some of its limits. For her work moves between a nomadic dissolution of essences into series and the staging of a playful interference between them that produces strange and transgressive objects, all alongside a monadic attempt to establish a definitive synthesis capable of arresting the decay of the temporal series into an eternal, re-iterated present. This movement itself, however, also marks an interference between nomadic and monadic series, producing in its turn blasphemous objects which appropriate the divine licence definitively to combine and manipulate the series and to present their intersections in strange syntheses.

The essences that Orlan converts into series are above all art, religion, gender, property and medicine. The laws for producing the events of one series are

disrupted by mapping them to others to produce hybrid events: thus the sequencing that produces objects corresponding to the 'essence' of art is introduced into other series such as that producing the sequence of events identifiable as medical interventions. Similarly, both medical and aesthetic series can be mapped in complex ways onto the religious series, producing uncanny syntheses and indeed new hybrid sequences.

The series of measurements performed by Orlan between 1976 and 1984 in Nice (1976), Paris (1977), Strasburg (1978), Lyon (1979), New York (1983) and Paris (1984), exemplifies the conjunction of heterogeneous series. Her measuring practice has nested within it a number of sub-series that intersect, conjoin, replicate and interfere with each other. Using her body as a metric, Orlan physically measured already carefully calibrated public spaces. The act of measurement is a classic example of the conjunction of three series, the measure and the measured and their union through a series of iterative acts of measurement. The act of measuring consisted in Orlan laying her body on the ground and marking its position with a chalk line, a line that designated the completion of one act of measurement and the beginning of another. Yet the apparently simple act of measurement involved interfering with a number of dominant and inconspicuous series that already implied measure, measured and the act of measurement.

The choice of a metric has always been the prerogative of sovereignty, which in this way established its presence across the diverse series of appropriations and exchanges making up a given society. The metric forms a master series which is superimposed upon any number of sub-series, providing a seemingly neutral terrain for articulating them with each other. Thus the metre – imposed during the French Revolution in 1791 – can articulate any number of divergent series from the measure of clothing and dwelling to sporting events and the scientific study of the universe. Orlan's choice of her own body as a metric pretended not only to usurp a discrete object or space, but the very series that permitted the comparability and appropriation of the spatial universe and the objects within it. The act of usurpation is compounded by the substitution of what Kate Ince has identified as 'gynometric' for an 'anthropometric' series in the metric position.[6] The usurpation of the metric series by a woman's body reveals not only the abstract sovereign measure but also its investment in a gendered opposition.

Orlan's decision to use her own body as a metric also disrupts another hitherto smooth meshing between the series of art, masculinity and sovereignty. Her use of her body as a metric replicates the use of the perfect male body as a metric in Vitruvius and later in Leonardo and in Corbusier's modulor. The smooth meshing of civil architecture and military engineering in Vitruvius is made possible by a system of proportions based on the male body, thus not only investing power with the dimensions of the male body but also the male body with an intelligible power derived from geometry. Orlan's apparent replication of this series, but with a female body, disrupts the smooth meshing of artistic perfection, masculinity and power, although without necessarily substituting for it a tightly meshed system of

gynometry. Rather, it replicates a series in parallel to the 'original' that erodes the latter's 'originality' and produces the sense of the uncanny that Orlan repeatedly finds in serial reflective doubling.

The disruption of the metric series extends from the realm of measure to that of the measured. The metric does not only chart what is given, but to a large degree constitutes givenness. The space to which Orlan applies her measure has already been given its measure, whether as ecclesiastical or public architecture. In a sense it has already been surveyed and appropriated, and to remeasure it is to disrupt this appropriation, and, once again, to establish a parallel series that reveals the original as a simulacrum.

Whatever the results of Orlan's interventions in the series of measure and measured, it would seem as if the most radical moment of her performance emerged in the act of measurement itself. In the original system of measurement the act of measurement is strikingly clean and timeless, suspicious given that measure involves the repeated violence of adapting the different to the same. Vitruvian man to serve as a metric must be fresh from the bath – clean and naked – while the metre rod must be made of pure platinum; in addition to the purity of the metric, the act of applying it must be accomplished instantaneously without apparent effort or residue, producing a purely ideal result. Without these conditions the neutrality of the act of measure would be undermined, revealing the violence of equating the different. Orlan's *mesurage* intervenes at all these levels, disrupting the very act of measurement itself by showing it to be physical, time consuming and dirty.

Orlan's metric is her own ritually clothed body and the act of measurement – the performance – is shown to take time and effort. The physicality of the performance consists in the repeated laying down of the artist's body, the soiling of her clothes from the physical effort and from the environment that is being measured, and the scribbled chalk marks that calibrate the acts of measurement. The involvement of time, physical effort and dirt in the act of measurement produces yet another parallel series – this time of the intelligible, timeless act of measurement beside the physical and timebound act of *mesurage*.

The outcome of the series of operations making up the act of measurement is very different in the two cases. The intelligible series results in a pure measure without residue while Orlan's series certainly delivers a measure in terms of 'Orlans' but this is secondary to the main result of a material residue. The physical traces of the act of measurement which are usually filtered out and cancelled are made by Orlan into the main outcome of the measurement. After a performance Orlan would wash the clothing used during the performance and then collect the water before transferring it to wax sealed containers where the residues of measurement were conserved as 'relics'. With this inversion of the result of measurement Orlan makes the final translation, this time between the artistic and the religious series. Instead of purifying the result of measurment of its temporal traces, the temporal traces are themselves physically removed from time by their incorporation in a reliquary.

By preserving the residues in the form of 'relics' Orlan adapted a complex and contested religious series to her own purposes. The relic is the material residue of a sacred event, whether this be the body of a saint or an object associated with a religious act, such as the nails used in the crucifixion. The two species of relic are historically and doctrinally distinct, the former being the older form in which the body of a holy person is venerated out of respect for its sanctity while the latter, predominant after the Crusades, preserves the material traces of a singular religious event. The relic, thus poised between the sacred and the profane, also testifies to a desire to insulate the singular event from the passage of time: the body of the saint or the traces of an act are suspended in a time that is neither properly temporal not eternal. The body of the saint has died, their soul is in heaven, but their material traces live on, invested with a strange power. The work of suspension or insulation was achieved by recourse to art in the form of the reliquary which provided the envelope and protective barrier for the object against the effects of time.

The reliquary attempts to neutralise the temporal series by introducing an eddy or loop into the progressive series that seems to arrest its movement. The singular moment is preserved anomalously by being endlessly repeated in the realm of art. The capacity of the reliquary to suspend time might be regarded as a definitive property of the work of art, making art into the exercise of a monstrous anomaly. With the reliquaries of the *mesurage* Orlan suspends the detritus of her performance in an aesthetic limbo, anaestheticising them from the effects of the temporal series.

Orlan returned to the relation of performance and reliquary in her series of operations from the 1990s. The latter effects an extraordinary neutralisation of time through the sophisticated combination of diverse series into an elaborate reliquary practice. The transition from serial combination to reliquary may be understood with the help of a unique reflection on art as a reliquary practice, Levinas's 1948 essay 'Reality and its Shadow'. In place of the Platonic assumption that art participates in varying degrees in the timeless idea, that art somehow transcends the temporal series, Levinas proposes that the work of art marks the monstrous suspension of time in a parenthesis which 'marks a hold over us'[7] characterised by 'the consciousness of the absence of the object'.[8] Although remaining at the limits of a language of representation, Levinas's decription of the work of art is essentially one of a reliquary without a relic:

> Spots of colour, chunks of marble and bronze. These elements do not serve as symbols, and in the absence of the object they do not force its presence, but by their presence insist on its absence. They occupy its place fully to mark its removal, as though the represented object died, were degraded, were disincarnated in its own reflection.[9]

The work of art interferes with the temporal series, effecting a 'stoppage of time, or rather its delay behind itself'[10] presenting 'an instant that endures without a future'.[11] Levinas gives the example of a statue that, while occupying our space, has

another time, one which has exhausted its futures: 'An eternally suspended future floats around the congealed position of a statue like a future forever to come'.[12] The work of art is given a reliquary function in providing a loop that suspends the progression of the temporal series.

The reliquary effects the same operation as Levinas's statue but in reverse, marking the eternal suspension of a past that will never pass away. Indeed, more than the statue, the reliquary exemplifies of neutralisation of time in art as something 'never finished, still enduring – something inhuman and monstrous'. Orlan's operation is between two positions – the perfect reliquary of a monumental past that will never pass and the monster of its passing.

Instead of an aesthetics based on the overcoming of the temporal series Levinas opens the way for an anaesthetics, an art that neutralises temporal experience. So too Orlan adopts the position of the statue/reliquary in suspended time by means of pharmacological anaesthetics that detaches her from her body but without loss of consciousness. The voice from the reliquary – Orlan's words during her operation in which she comments on her removal from the object – her body – comes from a strange site of temporal arrest. She recommends that in order to face her operation her viewers should anaesthetise themselves by other means: 'A few words more on these images that you will probably watch with discomfort. Sorry to have made you suffer, but know that I do not suffer – unlike you – when I watch these images'.[13] The anaesthetic recommended by Orlan is not pharmacological but cultural: 'When watching these images, I suggest you do what you do when you watch the news on television. It is a question of not letting yourself be affected by the images, and of continuing to reflect upon what is behind them'.[14]

The sight of Orlan reading aloud while the surgeon proceeds to open up her face in 'real time' realises Levinas's call at the end of the 1948 text for 'the immobile statue to be put in movement and made to speak'.[15] This monstrous issue of art is recognised by Orlan in her observation that 'the last operations gave the impression of an autopsied corpse that continued to speak, as if detached from its body'.[16] Here the work of art speaks from a point of suspension within and beyond the body. The place of speech is not the ideal realm of the Platonic ideas but a hollowed out face that continues to give voice even during the operation of time. The anti-platonic movment of the operation is also evident from the simulcral character of the paradigms guiding the operations. In *Images/New Images or the Reincarnation of Saint Orlan* the model for the surgical interventions was constructed 'by mixing, hybridising, with the help of a computer, representations of Goddesses from Greek mythology: chosen from Greek mythology: chosen not for the canons of beauty they are supposed to represent but for their histories'.[17] These images were further mixed with ideals of feminine beauty taken from the history of art, with the Mona Lisa serving as a 'beacon character' (she also played an important role in Levinas's text, as the model of artistic immorality).

Although Orlan describes the operation of these superimposed images in terms of symbolism (they 'are there deep beneath my work in a symbolic manner') it is

clear that they are much more than Platonic ideals of perfection. Indeed, one of the objectives of her work is to question the idealisation of feminine beauty perpetrated in the past by male artists. On the contrary, the morphed images are not ideal objects of mimesis but are more akin to the hybrid coats of the Harlequin mentioned in the passage from Michel Serres read out during an earlier operation and anticipated in Deleuze's description of nature as 'Harlequin's cloak made entirely of solid patches and empty spaces'.[18] The hybrid products of the intersection of diverse series themselves generate new generative series of images, in Orlan's words, themselves a succinct definition of the simulacrum, 'I make myself into a new image in order to produce new images'.

In 'Reality and its Shadow' Levinas does not yet have a name for art's neutralisation of the temporal series, but its operation has all the properties of what he will later call 'obliteration'. The term itself marks a complex intersection, referring at once to a typographical erasure, the validation of a railway ticket and a surgical operation involving the filling or closure of a cavity or duct. The art of obliteration does not conform to the logic of fabrication – working an ideal form into a material shape – but suggests a procedure akin to the surgical cut and graft (an example Deleuze also uses to describe the intersection of series): 'If there is obliteration – by opening or closure, it is the same thing, there is a wound. For its significance for us does not begin with the principle which it tears, but in the human where it is suffered or in the other where it provokes our responsibility'.[19] In the language of 'Reality and its Shadow' the event under obliteration 'has a hold on us'. The obliteration is 'an invitation to talk. You say: obliteration interrupts the silence of the image. Yes, there is an appeal, a word, to sociality, being for the other'.[20]

Orlan's dialogue with a global-art-world public in fourteen galleries around the world during her 1993 operation seems to exemplify the sociality opened by the work, but the communication takes place under the sign of the temporal series marked by the clocks marking world time in the operating theatre. The omnipresence appealed to in the title of the Orlan operation is not the pure presence of global communication but itself already the relic of suspended time. The operation takes place in a real time that is already marked as a multiple but parallel series, one that gives rise to a number of different, dispersed presents.

Orlan's serial operation is maintained by the forty-one diptychs of magenta metal rectangles (30 x 150 cm) that were prepared on the forty-one days after her operation 'Omnipresence' on 21 November 1993. Taken together as an installation, the diptychs present a dual, dated mirror series with the top series bearing the *image du jour*, or the state of Orlan's face set against a dark blue ground on that particular day after the operation – 'a face first of all bandaged, then multicoloured, moving from blue to yellow, passing through red and very swollen' and the lower series 'a photo of a computer screen showing a face made with the help of morphing software'[21] set against a light blue-grey ground. Although at first glance a repeated double series, the work is more the site for a complex intersection of the number of diverse series. The first to be met is the series of repeated

stele dyptichs that mark a repeated temporal succession, registering a view of time as abstract succession indifferent to human concerns and aspirations. The first of many conjoined series in this work is thus an abstract and remorseless iterative series that could as readily end at 2 as at infinity. Yet each of these stele is itself an iteration, the top and bottom mirroring each and separated by a tain (itself repeated serially) within which is placed an inscription.

Then, lest the intersection of the two series be read too quickly in platonic terms of the intersection of ideal (morph) and material (flesh), Orlan leaves a well-defined interval between the two halves of the diptych, in her words exposing 'the "space between", in other words, an image of the exact, unretouched space conceived as the intersection of my face and the portrait of my reference personages'.[22] This is not the space of the painless revelation or participation of the ideal in the real, but that opened by the obliterative intersection of computer morphing and the surgical scalpel. The space between each diptych in the series marks the time of convalescence dominated by medical ritual – forty days in the wilderness of constant medical surveillance – while that within the diptych marks the intersection of surgical and digital morphing. The series of diptychs thus obliterates the platonic distinction between the timelessness of beauty and the finitude of the flesh, showing it to be the issue of a particular electronic and medical technology.

Towards the end of the *Conference* on her work, Orlan refers to two further reliquary practices that together reveal an important contrast operating within her work. The first is the proposal that '"I have given my body to Art". After my death it will not therefore be given to science, but to a museum. It will be the centrepiece of a video installation'. Both serious and humorously provocative, the proposal would make Orlan's dead body the *centre* of a reliquary installation. Characteristically, Orlan's proposal occupies the intersection between the series of events that constitutes the religious reliquary, the secular scientific equivalent pioneered by Jeremy Bentham of giving the body to science and then having it preserved in a reliquary, and then the attempts by the art museum to appropriate video installation work.

The location of the reliquary in a centre after her death contrasts with the dispersed reliquary work that emerged from the sixth operation. This comprises the engraving of the words of Serres 'on bullet proof glass, 12 cm. thick, of 0.9 x 1m. dimensions. In the centre of each glass plate is a circular receptacle containing 20 grams of my flesh, preserved in a special liquid.' The plates are also 'encased in a welded metal frame, giving an impression of inviolability'.[23] This definitive reliquary, given the utmost protection from the passage of time, will form part of a series of 'as many reliquaries as possible' – repeating the text but each time in a different language 'until there is no more flesh to put in the centre of the reliquary'[24] The description of these exquisite, apparently invulnerable works is highly qualified – they will give an 'impression' of inviolability but no more; the series will be 'as long as possible' the length dictated by intersection of the series of existing languages and the limit of the possible iterative extractions of 20 grams of Orlan's

flesh. Here the reliquary practice is surrounded by intimations of finitude and the remorseless attrition of the temporal series.

There is a tension if not a contradiction between the two reliquary practices whose source lies in the limits of Orlan's body. If the project of reliquary dispersal is pursued to its limit, then there will be no body left to occupy the reliquary installation. But perhaps this disappearance is the true objective of reliquary art, which can only suspend the effect of the temporal series by deferring the moment of vanishing. Placed beside each other, the monadic singularity of the reliquary installation and the nomadic dispersal of the Serres series creates a new impossible object, one that is uncanny in so far as its terms – unity and dispersal – replicate those of platonism while producing yet another strange doubling that drains the original of its originality.

TIME, ART
AND THE VIEWER

Out of the blue

Parveen Adams

You recognise Catherine Yass's work instantly. 'Catherine's Blue' as David Ward says.[1] And out of the blue comes what I want to say about her pictures, about the blue, and about its relation to light. The interest of the blue stems in part from the way it is produced. For I think the technique stamps time into the picture. I want to suggest that the very times of the process of producing the photograph materialise an image which powerfully activates another kind of time – the time of psycho-analysis.

We all know that Freud said that the unconscious knows nothing of time. But the passage of time of the analysis, the timing of interpretation, the duration of working through, are all central psychoanalytic concepts. Lacan spoke of the opening and closing of the unconscious and he made time the medium of the analytic process. Time is necessary, '*il faut le temps*' for the subject to *come to be*. If in the beginning there is no being, where does it come from? Lacan's answer in *Radiophonie* is that it comes forth from a material which is itself full of gaps. Lacan says that the unconscious is articulated from that which of being comes to be said and he continues: 'That which from time makes a stuff of it (that is, makes a stuff of what is said) is not borrowed from the imaginary, but rather from a textile where the knots speak of nothing but the holes which are there.[2]' Such a stuff is the material from which the subject can *be*. But how does that being emerge from a textile which itself comes out of the unconscious text. This poses the problem of how we can think a passage between two heterogeneous registers, the signifier on the one hand and being on the other. The passing of chronological time does not allow us to think this out. Certainly time is necessary, but we must think of it differently – not as continuous duration but rather as the time of certain logical articulations. This logical time is the time in which to make oneself being. In this time, being may somehow emerge from the talking cure. For indeed something emerges from the analytic situation which is more than meaning.

How can the idea of logical time help us to understand this? Lacan distinguishes in the duration of the analysis between the moment of seeing, the time of understanding and the moment of concluding. Obviously the time of understanding is dependent upon the moment of seeing, but what is surprising is that the

time of understanding has a conclusion. The analyst starts off as the omniscient Other, the subject supposed to know, and the analysand places all his idealisation into the analyst's capacity to understand him, to supply meanings to words and symptoms. But the analysand is proved wrong in these hopes, and he finds that however much material he supplies there is always something missing. Gradually he indeed feels he is describing a circle that goes round a hole. In Lacan's words, the Other is incomplete.

This gap of course is the Lacanian object *a*, the leftover of *jouissance* after the entry into language. But clearly this object is not made of the same stuff as the signifier and now it starts to come apart from the signifier and is put into play, into the time of understanding. Indeed it is this object that is lacking in the Other. But what precisely is it that is lacking? Consistency. The object *a* is the consistency that the Other is lacking. The end period of analysis is marked by the inconsistency of the Other on the one hand and the consistency of the object *a* on the other. However, this does not come about by itself. The analyst plays his part here. Of course the object *a* is already there, but the analyst's task is to produce the object as logical consistency, as a product of the experience of analysis.

This master of interpretation must relinquish the role of the subject supposed to know and must instead act the part of the object. One task of the analyst is to interpret but another is to be silent. Michel Silvestre has described this silence:

> Certainly not conventional silence, for it is indeed necessary to be silent in order to hear the other who speaks, but the refusal to respond there where the analyst would have something to say, but the leaden silence which comes to redouble that of the analysand, but again the mute question, anguished echo of the limit of the Other's knowledge. The being of the analyst is silent, through which he makes himself presence, massive and enigmatic.[3]

The analyst puts himself in the place of the object; he makes himself the stuff through which his very being is involved in the production of the object; in this way the analyst makes himself semblant of that which is not yet of the order of the signifier.

In what really is a matter of logical articulation, the analysand must deduce the consistency of the *a* from this performance. The object *a* that is missing from the Other is shown to be consistent. Therefore it must be the Other that is inconsistent. This has the effect of intensifying the subject's division. Something is missing on the side of the signifier, which separates it all the more clearly from the side of the object in all its consistency.

The analyst can take the analysand no further, though there is one step yet to the destitution of the subject, the moment when the subject is reduced to its being without the Other. The moment when I am not for anyone. '*Je ne suis pour personne*'. Such a moment is on the very margins of logical time, perhaps a moment beyond logical articulation. The analyst has led the analysand to the brink of what Colette Soler speaks of as an 'unthinkable decision'.[4] The analyst

has made possible the production of a certain *jouissance*, but the decision itself must be solitary.

I have tried to sketch something of Lacan's moments of logical time as they function in the course of an analysis. I now want to suggest that these moments can function in the course of looking at a picture, in particular in Catherine's photographs. But what would it mean to speak of the time of understanding that comes up against the gap in understanding when we are looking at pictures? (Plate 3) Or what would it mean to speak of the concluding moment of analysis when we are looking at pictures? We will have to find an analogue of the logical consistency that the analyst's acting produces.

I repeat what Lacan says: 'That which from time makes a stuff of it (makes a stuff of what is said) is not borrowed from the imaginary, but rather from a textile where the knots speak of nothing but the holes that are there'.

The 'textile' here is a certain moment that has been generated from the order of signifiers/text in the time of analysis. So 'textile' looks back one way to the text of the patient, whose initial hope had been to find the meaning of this text but who has now to come to understand that the text is a textile, has come to understand it as stuff rather than a string of meanings, a textile, a stuff that is woven, and that is therefore as much made up of the holes as it is by the knots. But 'textile' also looks forward to the end phase of analysis, to the replacement of text and the order of signification with a texture that is the semblant of being.

Portrait: Chairpersons of the Council of the City of Salford (1994) (Figure 1). A number of persons, a woman and several men in dignified Chambers. They form a striking group posed in the space of civic pride. Yet something strange is in the air. These persons pervade the image in a most perturbing manner. They are photographed more than once, in different places at different times and, more intriguingly, in the same place at different times. They appear and reappear. Here is the woman, and just here is an ill-fitting shadow of herself, and again, there she is in another part of the room and not quite the same as before. In the midst of these multiplications and divisions the figures remain frozen – no breath animates them. Yet time animates the picture. Picture and persons are worlds apart.

A group portrait like any other? Look again. Each figure stands quite separate from the rest in this group. It seems that there are fewer real life councillors than there are portraits. Not only is the woman represented twice, in two different places, in what at first seems to be a simple picture taken at the same moment of time in a room, but notice that she is wearing a different blouse each time. Several of the men are also multiplied in this way, with changes in tie or shirt, made at some time or other. And suddenly the seats do not make sense spatially. Yet all the time the gaunt old man, taut as a wire, his jacket collar now too large and standing well back from his shrunken frame, continues to face us.

Of course, there was already a disturbance in the picture, visible at first sight – the patches and slashes of vivid blue that lie within the window panes at the rear and along the sill of the near benches and which outline like a halo or alight like

carnivorous insects on the figures in the picture. At first it looks as though this is somehow a decorative contrast, a foil, or a random illumination of the space. Of course it functions as Catherine's signature. But that is not all there is to it.

I want to argue that the way in which this blue enters the picture sets up a radical interrogation of the relation between light, time and the object. For the moment let us note that an interval of time is what the picture is. The gap between the picture and its non-representational blue is occasioned by the fact that the picture is an overlay of two different times; one picture is made from two photographs.

The blue is often found at the boundaries of figures. But why have some of the chairpersons been assigned halos where others have lost the top layer of skull? It turns out that they themselves are responsible for such differentiation. The interval of time that is *in* the picture gets there because there are really two photographic images before us, two images of the same objects, but not identical images, filmed once and then again on reversed film. These are later combined. Now the

1 Catherine Yass, *Portrait: Chairpersons of the Council of the City of Salford*, 1994, four photographic transparancies, light boxes, 105 x 138 x 10 cm

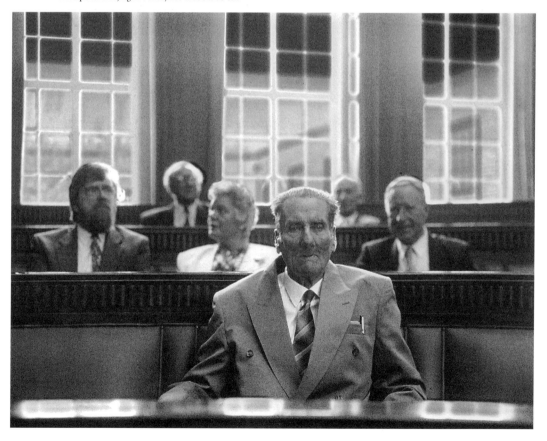

reversed film turns major sources of light into Catherine blue, while at the same time cutting out all other primary colours. One might say that the blue of the film erases the registration of objects. Indeed it is cannabilistic and eats into objects in a surprising way even in the process of combining the two pictures. The pictures are not identical, not only because of this reverse proceedure involved in their making but also because the figures *move*. And some move more than others. Already the picture has a reduced depth of field, many figures are out of focus and blurred. But blur is simpler than blue blur. What does the technique do to our perception of these figures?

I have already suggested an answer – that the photograph repeats the moment of logical time spelt out by Lacan. If that means that the technique puts us in the time of understanding, how does this come about? How much does the technique contribute to it? In particular, the repetition of the figures? For the image is constructed from a repetition of images just as the patient repeats images that circle around the object that is put into play.

Repetition in the Chairpersons' picture coincides with the way in which the image is cut. The chairpersons are cut in several ways, but most important is the role of blue in this. The blue cuts into light all over the surface of the light box – that is, at each point we experience the effect of that gap in time which produced those two images which are then recombined for the light box. Catherine transforms duration into simultaneity for the image, but this does not deprive the photograph from having its own time. We might think of the blue as a kind of photographic negative of time.

Is there an analogy between that which happens here and in analysis? The chairpersons are caught in a repetition that completes and doubles their picture. We who watch, slowly shift from the first impression of the image – insofar as it appears to be an ordinary group portrait, subjected to a transference of blue. We now recognise the difference between the picture and its haunting other, and can now recognise other local dislocations. This is the analogue of the time for understanding, where we loop around the central gap, the time that Catherine put *in* the picture. The spectator is able to identify the repetitions in the picture as a work of working through.

Gradually this leads to another time, a reverse time that sets the object in play. We are no longer in the atemporal space that the picture offers us at first – frozen figures and the menace of colour which threatens them – dead figures in the landscape that devoured them. All that gives way to a movement in which the spectator traces and retraces a loop around the central gap of the picture – the gap in time between the image and its reverse. This gap is the analogue of the object *a*; the spectator accomplishes the experience of a temporality governed by the object *a*.

I have tried to show how the gap in time in Catherine's pictures might mirror the effects that take place in the time of psychoanalysis. There are two pictures in one, but it is as impossible to disengage them from one another as it is to superimpose them one on another. The one is not the complementary of the other; nor is it part

of a jigsaw or a mirror image. We can only speak of one haunting the other. This is clearest in the picture we have been discussing and I spoke of it earlier in terms of persons and picture being worlds apart.

I now want to speak of Catherine's pictures in terms of *Trompe-l'œil*. Because, paradoxical as it may seem, it is in this way that I can establish the fact that the picture produces the experience of the object *a* in its logical consistency. For it is this that establishes the end phase in analysis. Now Lacan talks about the *Trompe-l'œil* of painting, not as a specialised genre but as the general function of painting. Normally we regard a *Trompe-l'œil* as the deceit of the eye, as for example when the objects of a painting substitute themselves as objects of our perception. We walk towards an interior wall of a Renaissance palace and see four windows all showing a segment of the same landscape. But when we get closer we see that only three of the windows are real, the fourth window and its landscape is painted. Parrhasios triumphed over Zeuxis because while the latter's painting of grapes persuaded the birds to come down and peck, Parrhasios' painting of a veil over a painting tricked Zeuxis himself, who demanded that the veil be lifted. Parrhasios' painting would normally be classed as *Trompe-l'œil* but Lacan extends this as the condition of pictures as such. They are something other than they pretend to be. In Lacan's terms the picture 'is the appearance that says it is that which gives the appearance'[5] (Plate 4). At first we may be taken in, but as we recognise the trickery, it is *then* that the force of the *Trompe-l'œil* is registered, in the experience of the emptiness of the image.

Catherine's pictures also raise the question of the *Trompe-l'œil* and I think they do so in respect of the light-boxes within which her pictures are presented. David Ward has made two important points about *Grave: Robertus Blair* (1997) – firstly that the pictures can look very thin in places, and secondly how dramatic the differential absorption of the light by different colours is. At one end of the scale the density of the blue absorbs all light that meets it. Surely the two points are connected; slivers of light get through, while whole areas of light are eaten up by the blue. It is as if the image has a great deal of difficulty 'coming through', as if it were fragile. This of course relates to the general condition of representation, of *Trompe-l'œil* in Lacan's terms – the reality of the image is intensified by those elements that seem to obscure it. We seek to rescue the phantom and only then behold the emptiness of the image.

This explanation of a picture, of the logic of *Trompe-l'œil* inherent in any representation, of the way in which the imperfect iteration of the picture preserves its status of a picture of something, is as it were, an exploration of the picture at the level of representation, of the signifier. We have been discussing the picture in terms of the relation to its referents, to the objects it represents. In such an exploration we find ourselves in a relation of profound inconsistency, or at least unable to state the real relation between the image and what it signifies. In this we replicate that time of analysis where, however much meaning is produced, *the* meaning repeatedly eludes the analysand, until rightly despairing of finding it, the patient,

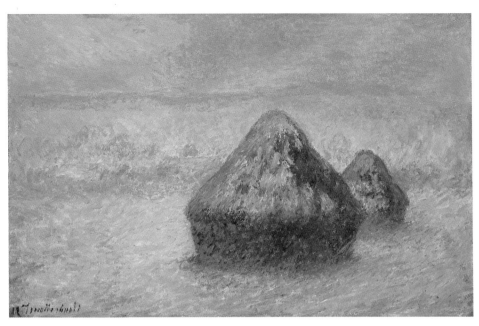

1 Claude Monet, *Stacks of Wheat (Sunset, Snow Effect)*, 1890–91, oil on canvas, 65.3 x 100.4 cm

2 Claude Monet, *Grainstack (Sunset)*, 1891, oil on canvas, 73.3 x 92.6 cm

3 Catherine Yass,
*Portrait: Chairpersons
of the Council of the
City of Salford*, 1994,
four photographic
transparencies,
light boxes,
105 x 138 x 10 cm

4 Catherine Yass,
Grave: Robertus Blair,
1994, photographic
transparency,
light box, from
the series *Graves*,
89 x 72.5 x 12.5 cm

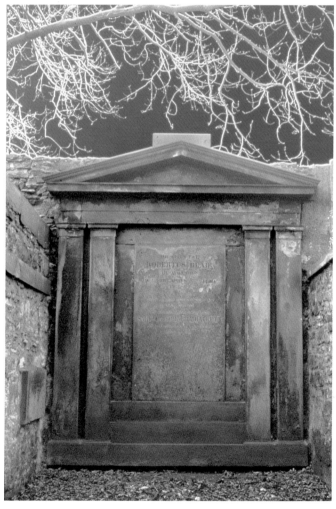

5 Catherine Yass, *Stall: 70*,
1994, photographic
transparency, light box,
from the series *Stall*,
89 x 72.5 x 12.5 cm

6 Eva Hesse,
Expanded Expansion, 1969,
fibreglass and rubberised
cheesecloth, three pole unit
310 x 152.4 cm. The
Solomon R. Guggenheim
Museum, New York, Gift
Family of Eva Hesse, 1975

7 Rachel Whiteread, *Untitled (One Hundred Spaces)*, 1995, resin, 100 units. Size according to installation. Installation view, Carnegie Museum of Art, Pittsburg

8 Rachael Whiteread *Untitled (Twenty-Five Spaces)*, 1995, resin, 25 units, Queensland Art Gallery, Australia

aided by the analyst begins to apprehend the object *a* not as gap, but as consistency. The analysand is no longer concerned with the regime of signifiers but with the reference to the order of being which is signalled by the transition from textile to texture. At this level the question of *Trompe-l'œil* appears in a different way. You are aware now from the beginning that the appearance is a trick of some hand. In Seminar XI Lacan writes of the second moment of *Trompe-l'œil*: 'For it appears at that moment as something other than it seemed, or rather it now seems to be that something else'[6] (Plate 5). This marks the two times of the *Trompe-l'œil* – the first at the level of signification registers the gap; the second tries to understand the materiality of the object, the 'something else', the texture of representation. Substance and appearance are no longer opposed to each other anymore than the knots and gaps of the textile are. At this stage the inconsistency of the referent, of signification is replaced by the consistency of this substance/appearance object we are calling texture.

I will try to indicate what I mean by the *texture* of the picture and I will use two pictures to show you this. First, one of Catherine's Smithfield Market pictures, *Stall: 70* (1996). At the bottom of the picture is a floor strewn with shavings, forming a remarkably shallow space. At the top of the picture is a clear space of rafters with two long receding strip lights, now blue and six long hooks hang down from this space. The middle two-thirds of the picture is taken up with what must be the side-wall of the stall. It looks both transparent and opaque, it changes colour continuously and without any reason; its roughnesses are infiltrated by a colour that has nothing to do with itself. It is impossible to determine whether the expanding blue stain, diminishing in intensity is in front of, behind, or in the same plane as the wall.

It is better described in terms of its texture that is made out of colour. There is nothing homogeneous about this texture. It is as though it was woven, not only of materials of different thicknesses and shades, but out of incompatible materials like glass or pure blue light. It looks like a relief map in places; in others, it is transparent. The wall is perforated by light. Catherine has acted on the stuff of the wall, cutting it in different places with different effects. The most immediate of these is our dislocation in space. The sequence of looking at this picture uses the same system of times of analysis as did the picture of the chairpersons. At first glance we see a somewhat unfamiliar wall; and then we rehearse the possible distances of the wall, only to find that there *is* no single distance, that there is no outside and inside. The wall is not an object that can be spoken of. The object *a* is, of course, in play in our discovery of the impossibility of the wall. The work of viewing the wall includes the baffling variation in the densities of light. It is this that finally destroys the singleness of the wall and its distance. But what has been lost as wall returns as texture.

The second picture I want to talk about in which texture is foremost is *Mirror* (1997). This was recently shown at Richard Salmon's London gallery and I remember my surprise at the dark, chocolatey tones tinged with orange in this

smaller than usual picture. There was a mirror and an edge of window with something of the familiar blue. This time the blue had not eaten the objects; nor was it modified into bluey greens where the highlights of a roughened surface had registered. This time you really could *not* work out what had happened to the surface of the bottom half of the picture. The effect of the blue negative this time was a change in the texture of objects. The time of understanding quickly gave way to the stuff of what is said. There is this cloth, this texture of the picture transformed from the reality of wood. It is almost alive, this texture. Catherine's texture has taken over from Catherine's blue. If I then make the unthinkable decision, I am where I haven't been before – in the texture of *jouissance* where I am not for anyone. *Je ne suis pour personne*.

Some translucent substance,
or the trouble with time

Briony Fer

In the work of Eva Hesse, there is, characteristically, a repetitive movement set against a moment of seizure or arrest when the viewer is, as it were, caught or trapped by the object, caught in one's tracks by it. Even an object that is hardly there at all may still be insistent in its effects. For example, in *Untitled ('Ice Piece')* (Figure 2), made in 1969, a thread petrified in fibreglass falls from ceiling to floor in an awkward spiral. The way it lies stiffly on the floor would seem almost ungainly, but the slight angles where the sections join mark points on a circuit. These points correspond to a spectator's circuit of inspection of an object, even though it is hardly there *as* an object. The points punctuate the eye's movement around and around, a movement that is at once repetitive and persistent. Like the spiral, it just goes on.

It is these effects of duration, of time going on, and arrest, of time being suddenly cut, which concern me as different kinds of time which co-exist in the encounter with the object and which exert uneven pressures upon it. My point is not to propose an aesthetic model in which the one yields to the other, where a moment of seizure or rapture overcomes and makes good the 'drag' of ordinary time. Rather, I would like to try to describe a model which takes account of these fluctuations of pressure and of the psychic disturbances of what André Breton called 'slits in time';[1] to suggest the to and fro of time just going on and time draining out. Eva Hesse had titled an earlier series of works *Metronomic Irregularity* – the very title of which bears witness to the idea of the rhythm of a metronome, but with irregular beats and irregular gaps between the beats. In *Metronomic Irregularity II* (Figure 3), the three panels hung on the wall are regular, but they go awry in the random configuration of the lines of wire and their shadowy traces. My question is this: what would it be to take account of the time of the art object, as Eva Hesse would seem to be suggesting we should? And, if there are different kinds of duration, different temporalities, which operate in the artwork, and if they work against the grain of one another, then where is the spectator or subject situated in such a field of temporal interference?

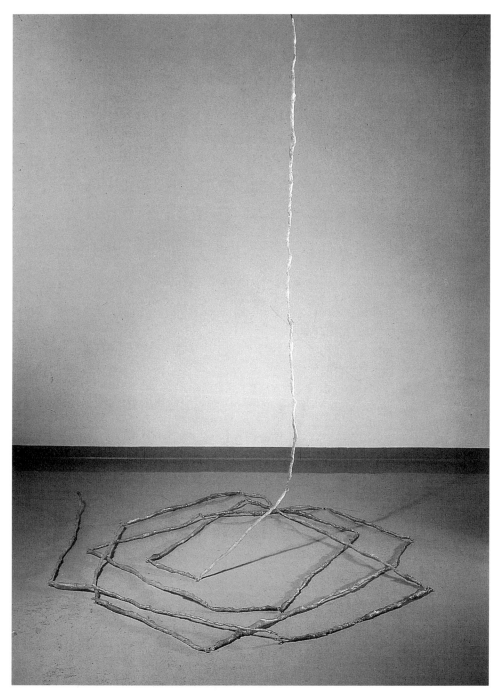

2 Eva Hesse, *Untitled* ('*Ice-Piece*'), 1969, fibreglass and polyester resin over cloth-covered wire, 20 units, total length 18.9 m, irregular width ca. 2.5 cm

3 Eva Hesse, *Metronomic Irregularity II*, 1966, painted wood and cotton wire, 1.22 cm x 6.1 m overall

Duration

'Duration', meaning experienced time, was a central term in the critical language of the 1960s. Duration could be definite or indefinite, longer or shorter; as opposed to the immediacy of the actual present, duration had a past as well as a present and maybe even a future. If, as Robert Morris claimed 'The object is but one of the terms of the newer esthetic'[2] then it followed that the viewer's experience of the art work in a particular situation existed in time. From a phenomenological point of view, time might be compressed to an instant, but cannot be transcended. Morris had made a series of drawings in 1962 where he measured how long it took to cover a sheet with fairly random marks, timing each page according to how many minutes it took, *marking* time and punctuating intervals in a way reminiscent of Duchamp's *Three Standard Stoppages*. On the other hand, there were other ways of leaving things to chance by letting time lapse: for example, when Hans Haake allowed condensation to accumulate on the walls of a perspex box. The repetition of modular elements suggested an infinite duration. The use of repetitive sequences served to scramble sequential time by denying a logical order or a sense of why one thing should follow another, or indeed why or whether an action would terminate, an event stop, by seeing how many times something could be repeated to the point of exhaustion. George Kubler's cult book published in 1962 called *The Shape of Time* offered a wide-angled lens on the morphological patterns and series revealed in all man-made things and their many durations.[3]

When Michael Fried famously drew attention to the problem of duration in his essay criticising Minimal art called 'Art and Objecthood' of 1967, he certainly did not invent it but he did turn it to his own advantage and inflect it in striking ways. And what he most obviously did was to reduce the many durations that had been Kubler's and other's concern to a singular and monolithic sense of duration, so as to give greater emphasis to his own opposition between duration and that moment of 'presentness' that was the defining moment of aesthetic experience. This binary

opposition has tended to stick even when commentators have taken issue with
Fried's critical purpose. My point is that by the time of Fried's intervention, the
critical field was already steeped in the idea of duration, and indeed the possibility
of many durations, both definite and indefinite. Time ends up being a point of ten-
sion and anxiety within Fried's essay because central to the Minimal art he sought
to attack was its 'presentment of endless, or indefinite, duration'.[4] For example, the
kind of repetition found in the work of Donald Judd is experienced as part of a par-
ticular situation and was an experience which persists in time; moreover, Minimal
artists treated 'time itself as though it were some sort of literalist object'.[5] In a foot-
note, Fried likened their concerns to those of the Surrealists. Damning by associa-
tion, what he saw in both were not formal similarities, of course, but rather a certain
kind of temporality manifested 'as expectation, dread, anxiety, presentiment,
memory, nostalgia, stasis'.[6] This was the trouble with time: presentiment not pre-
sentness, anxiety not grace. For Fried's notion of 'presentness' was a moment of
aesthetic recognition or what he called 'conviction', not a literal instant so much as
a sense of what it would be like if literal or mere time were momentarily suspended.
The strange and unwelcome cord the literal time of Minimalism struck for Fried
was the void where conviction should have been, symptomatic of what had hap-
pened to the Minimal object to break the logic of the modernist imagination. What
may have been meant as a damning comparison to Tanguy, de Chirico, Dali,
Magritte and so on, a comparison implicitly driven by standards of aesthetic judge-
ment (Surrealism was bad art) none the less prompts us to think about the temporal
structure of the unconscious that has been occluded within modernism. The com-
parison may seen unlikely, but the way Fried cranks up the problem of what he calls
theatre is itself driven by the very modes of operation he seeks to question. As
Robert Smithson said, endlessness represents for Fried the 'terrors of infinity':
'What Michael Fried attacks is what he is. He is a naturalist who attacks natural
time'.[7]

 At stake here is not so much the way we understand the temporal order of our
world through cognition, but rather, the points when that symbolic understanding
gets skewed or made strange. In 1934, André Breton had seen in the accidental con-
figuration of a crystal the spontaneous action of the mineral deposit – a crystal
'convulsed' through natural movement from the rock in which it was embedded.
For Breton, a crystal in convulsion suggested an extreme compression of time,
where a moment of crystallisation was detached from the long, slow process of its
formation in actuality – a moment not so much arrested in as created by the photo-
graph. This was what Breton called 'convulsive beauty' and was not to be found in
movement but precisely in the 'exact expiration'of movement.[8] This is the going
away, the passing of movement, a kind of spectral moment that is already a haunting
of the actual moment. The word 'convulsive' does not describe some property of a
thing, but rather the unsettling or even buckling of the spectacle it produces.
Another image of convulsive beauty was a photograph of a dancer, a blurred, con-
torted figure in eclipse. Fast, slow; animate, inanimate; moment, duration – such

oppositions collapse in the face of the frozen action of the photograph as the looping skirts and endless circling of the dancer of a tarantella become an indistinct phantom. The word 'convulsive' also reminds us of the originary place the hysteric occupied in the Surrealist aesthetic, where her convulsions represented a poetic rather than pathological phenomenon. The hysteric has always been trouble; that was, after all, why her 'private theatre'[9] had appealed to the Surrealists in the first place and I shall return to her later. But it is also the eerie residue of her convulsive gestures – mere bodily affect – that haunts time present with the insistent and trau-matic resonances of time past.

Dust to dust

The world of crystalline structures and petrified movement may seem hard to rec-oncile with the industrial surfaces and shapes of Minimal art, but not for Robert Smithson who, rather like Judd, always favored the dead-pan critical tone of a geology text-book. Smithson began his essay 'The Crystal Land' of 1966 by recording how the first time he had seen Judd's pink plexiglass box it had suggested a giant crystal from another planet.[10] It is as if the alien, archaic, inanimate proper-ties of a crystal acted as a spectre to experience and its conscious durations, indelibly casting it in the direction of death. When Smithson quoted Eliot: 'Show me a handful of dust and I will show you fear', it was perhaps to provide him with a way of talking about death indirectly, because to talk of death more directly would be a fatal blow to the desired effects of sheer inertia and endlessness. The kind of infinity that was interesting, after all, did not have a capital 'I' and was not Sublime but made one lose one's bearings by the sheer persistence of repetition.

This is the kind of time that goes on, and on, which cannot be salvaged or redeemed; dissect it at any point, and there will only be the empty time of the pause. George Kubler, certainly very influentially for Smithson, had described 'actuality' as the point 'when the lighthouse is dark between flashes: it is the instant between the ticks of the watch: it is the void interval slipping forever through time … (the) pause when nothing is happening'.[11] For Smithson, it was Ad Reinhardt who had most vividly demonstrated Kubler's void between events, but the void also provided him with a context for, amongst others, the 'mummified' and 'dessicated' aspects of Hesse's work; of Hesse's *Laokoon*, he wrote, 'coils go on and on; some are cracked open, only to reveal an empty center'.[12] Whilst the classical sculpture her title invoked had been celebrated for capturing the climactic moment in the narra-tive, in Hesse's work, 'Nothing is incarnated into nothing.'[13] Smithson is a brilliant commentator and what he draws attention to here is the crux of my concern, which is how material presence, that palpable sense of what Hesse's work was made of, can combine so disconcertingly with the sense of a void. Fried's opposition between presentness and duration was quite inadequate to this problem as well as unsympa-thetic to the work. Instead, we need to retrieve the complexity of the temporal field in order to consider the various ways in which too much or too little duration could

be put in play by artists such as Hesse – precisely *because* of the disturbances created within the field of vision.

As the title suggested, the Whitney show 'Anti-Illusion; Materials/Procedures' brought together artists interested in material processes: apart from Hesse, there were, among others, Robert Morris, Bruce Nauman, Keith Sonnier and Richard Serra.[14] Rafael Ferrer used real ice in his work, which melted. The work was characterised by the often unstable materials that the artists used which could be contrasted to the hard surfaces like aluminium or plexiglass used by the Minimalists, though in retrospect this sense of a sharp opposition hardly does justice to the strange effects of the latter, the kinds of effects Smithson, for example, had noticed in Judd. Robert Morris described the tendency to use 'stuff, substances in many states – from chunks, to particles, to slime, to whatever …',[15] materials which drew attention to impermanent, transitional states. This could be traced back to Pollock, as almost anything could, by thinking about the fluidity of Pollock's drips fixed in the moment of drying, leaving the scabs and puddles of paint as evidence of that process. The emphasis was on matter and its palpable effects and random rather than regular arrangements; materials scattered across a floor in a way that refused to redeem 'stuff' and transform it into a vehicle of expressive value, but rather left as a merely material residue.

Eva Hesse made *Untitled ('Ice-Piece')* in 1969 especially for this exhibition. The thread is translucent and made up of shorter sections looped together to make in total a sixty-two foot length which appeared not to have an end. It seems inappropriate to call it a sculpture because it is so nearly nothing and as a consequence must insinuate itself quite slowly. Yet, though made of so little, there is still a palpable sense of the crust of fibreglass which wraps the wire. Fibreglass is a resin which comes in liquid form and which has hardened on the cloth-covered wire, reminding one of words like 'mummifying' or 'petrifying' which Smithson had used about Hesse's earlier work. There is a sense of imminent dread of forgotten states, an uncanny stillness or an unforeseen anticipation of deathly stasis. And although fibreglass is in fact one of the most permanent materials, it discolours over time and the play of light on its surface subjects it to random and fleeting effects.

The work Hesse associated most closely with *Untitled ('Ice-Piece')* was *Expanded Expansion* (Plate 6), which she also exhibited at the Whitney show. Sections of rubberised cheesecloth hung loosely between ten foot high poles made in reinforced fibreglass which leant fairly casually against the wall. Hesse had painted latex layer by layer on to the cloth, fully aware of how impermanent and unstable latex was as a material. According to her collaborator, Doug Johns, Hesse liked it because it was 'a moment in time, not meant to last'.[16] The pinker tone and brittleness of the second panel is due to the fact that it was stored with this section at the top and open to the air, and so has deteriorated.[17] This kind of change may seem to work against the idea of repetition in the regular verticals of the poles; but there is another kind of repetition in play here, the deathly repetition of the phrase

'ashes to ashes, dust to dust' which returns matter to its primordial state. The chance or arbitrary effect, the deterioration of the substance itself, are all part of an expanded sense of the time of repetition.

Expanded Expansion could shrink or expand depending on the space where it was placed. It may look nothing like *Untitled ('Ice-Piece')* but for Hesse both were 'endless'.[18] If the floor space were larger one could occupy more of the floor; if the ceiling were higher, the other could continue further up. If one has a looming presence and the other hardly registers as a presence, both seem as though they could extend to infinity. This endlessness is not only spatial but temporal; seemingly, both could go on *ad infinitum*. This kind of duration that is infinite does not simply reflect but puts pressure on the phenomenal time of the encounter, the time it takes to walk along or around to view the work. It may be the very pressure of its deathly inertia that makes us turn our backs and leave the room. But there is also another kind of pressure the work exerts, another kind of incompleteness, which concerns that moment of arrest or seizure with which I started. What would it be to think of that moment of being in thrall to the object not as a moment of resolution or fullness, but as an interval or gap or missing beat: that point where the long and the short of duration collapse into one another? This is an interval that may be revelatory in its way, not of presentness, but of another temporal structure, that of the unconscious – as if a small piece of time were trapped in a cavity within a field of agitation.

Syncope

If endlessness persists, it may also falter and lose track. One way of thinking about the losing track of time or a temporal disturbance triggered by the artwork is to return to the hysteric, not, I stress, in order to portray the artist as a hysteric, but in order to suggest that the interval or gap is also a psychic disturbance; an interval that might at once appear to be empty but at the same time to contain an excess, something that is enervating not in spite of but because of the void it encapsulates. I have already discussed the trouble with indefinite duration: that it has no end. I now want to pursue further the irregularity of a disturbed duration that is arguably even more troubling, when time buckles under in the time of hysteria. Being caught or arrested by an object, in this context, is not so much reparative as disconcerting, reminiscent of Breton's 'slits in time'. Catherine Clément, in her book *Syncope*, notes that syncopie is a musical rhythm, but the syncope is also a faint or swoon or black out. '*Tomber en syncope*' means to faint; it is a temporary absence; it is the irregularity of the heartbeat, a cerebral eclipse. It is like death in many ways but a temporary death. As in music, it signals a rhythm but only to describe a delay. For Clément 'imagining the short circuit is working at the limit'.[19] It is where something gets lost, but it is also for, Clément, a gain (and from my point of view the artwork is the gain). We might think about the artwork in terms of the syncope as that kind of temporal eclipse or the missing beat of Hesse's 'metronomic irregularity'.

As Clément points out, 'psychoanalysis arose out of the spectacle of the hysterical syncope'.[20] We might think here most vividly of Anna 'O', Breuer's patient, who suffered from 'losing time'. According to Breuer, Anna O 'would complain of having "lost" some time and would remark upon the gap in her train of conscious thoughts'.[21] She 'lost' time through absences just as she later lost her command of grammar and syntax. Freud saw Dostoyevsky's epilepsy, that 'uncanny disease', as a severe form of hysteria, with unprovoked convulsive attacks or brief absences. He describes how Dostoyevsky's early attacks 'had the significance of death', a feeling 'as though he were going to die on the spot'.[22] The syncope, its repetitions, delays, deferrals, are the troubling effects of time. This is the very antithesis of Fried's moment of grace, where it is as if there were no duration, and where that 'as if' holds the expressive metaphoricity of the artwork in place, as if a single instant 'would be long enough to see everything'.[23] In Clément's notion of the syncope, on the other hand, it is the subject who is eclipsed.

Clément describes an accordeon or Mallarme's fan as syncopal objects.[24] The fascination these objects exert is in the very act of disappearing and reappearing that they enact. Now you see it now you don't. Sections are revealed as they expand and cut out as they contract. Like Hesse's *Expanded Expansion*, they put in play a temporal register, with the possibility and anticipation of its extension or its shrinking, of folding out or in. The artwork is a site, then, of both literal and imaginary temporal dislocations. It is the very lack of an inside and an outside that enables these fluctuations to occur. Hesse liked the absurdity of exaggerating or shrinking a thing by making it larger or smaller. In the repetition of the sections of *Expanded Expansion* she uses a structure that could go on indefinitely, like *Untitled ('Ice-Piece')*, just as it could as easily collapse. It also follows that the points of elision when time 'cuts out' do not come singly, but also repeat in flickering, irregular movements.

An artist whose work vividly demonstrates the syncope now is Rachel Whiteread. It is as if the time of repetition can only ever register in relation to its lapses or moments of eclipse. It is no coincidence, from this point of view, that Whiteread prefers her work to have the flexibility to expand or contract depending on the circumstances, as Hesse had. Her work *Untitled (One Hundred Spaces)* (Plate 7) is intended to be variable in scale. The grid may be magnified to fit a large space or shrunk to fit a smaller one. The 'hundred spaces' of the title are blocks of cast resin, cast from the undersides of chairs and some small tables. The flashback to Nauman's *Cast of a Space under my Chair* looks to that moment in the 1960s when sculpture was at its most elastic; so too does the arrangement of units on a regular grid. The point is that such gestures are ubiquitous, as if the past were always embedded in the work, the always already habits of modern sculpture, the always already repetition of the avant-garde. Rendered habitual in this way, the grid is not just the articulation of a prevailing symbolic register, but also its undoing. Repetition, watchword of the avant-garde, is a complex operation, quite unlike a succession of stages placed in a logical progression. If we imagine it as a sort of screen, then it is many-layered and perforated.

I like to think of *Untitled (Twenty Five Spaces)* (Plate 8) as Whiteread's 'ice-piece', not just because the clear pale blue resin (which has been injected with dye) suggests so many frozen cubes of ice, but because of the same possibilities of expansion and reduction as Hesse's fibreglass encrusted thread. Translucency is a midway point between seeing clearly and not seeing clearly. Light coming through an object called translucent actually has the effect of stopping you seeing through it properly (it is unlike a transparent window in this respect). Robert Morris wrote about translucent materials as maintaining an inner core that can be seen through but which is also closed off.[25] Chunks of space are reserved or blocked off from the field of vision at the same time as they allow the light through. For Morris, this marked an opening of the object to its surroundings, but what he also pointed to is the way in which such translucent substances can function almost as scotomised sections, detached or cut from the visual field. Blindspots or scotoma where dizzy spells were accompanied by a dimness of sight were characteristics of hysterical vision originally described by Charcot. Then it was Anna O, the hysteric, who encapsulated most vividly the double distractions of 'losing time' – a detachment from the continuity of time – and scotomised vision. Parts of her visual field were cut out and erased; people around her seemed like wax-works, detached from her; it was as if, she said, they had no connection to her.[26] Lurching in and out of the field of vision as she does is also marked by a very precarious hold on the temporal order of experience. This suggests the kind of vertiginous viewing that Smithson also noted in Hesse.[27] Or rather, there is a falling through of the present, of actuality, as if the trouble with time were that it is full of holes.

In *Untitled (One Hundred Spaces)*, different colour blocks are placed at the nodal points of an imaginary grid. Caught by the light, the resin of some looks orange shot with pink or blue-green, others have the irridescent bloom of milky white, like a bloom on a fruit. The blocks of resin can be seen through, yet they also block off the light, as much as let it through. All glossy surface reflecting light, yet at the same time they emanate light from within. The translucent blocks may follow an imaginary grid but then they play havoc with it. What is arrested there is not just the liquidity or a bubble of air suspended and trapped in the resin, but the subject or spectator caught in a dazzling panoply of colour that plays havoc with vision. The effects have an almost hallucinatory vividness.

I have deliberately placed this discussion in close proximity to the discourse of hysteria at the origins of psychoanalysis, not in order to re-establish the hysteric's time, but to ask how the time of the hysteric puts in question the time of the image, to trouble it and make it – like the hysteric herself of course – troublesome. What might reveal itself as a result is that small piece of ourselves that is left over, reveals itself, that is, in the little bits and pieces of time that get lost. The task of the symbolic is to hold in place the screen of the image, and as such it is always in danger of 'losing' time. The sense of losing time, of the temporary death or syncope, is intimately caught up in the bits of time that are detachable, the bits of time that are in effect cut off from the continuum. Perhaps the moment of arrest of the object is not

so much the moment when we have the object in our grasp, but rather when it seems that we are caught by the object, when the syncope lodges in the subject.

Whiteread has spoken of her work as a space 'frozen' in the mould.[28] There is a freezing of the moment that is reminiscent of a shutter closing. This is the temporary death, the moment of detachment of the subject, the flickering in and out of the picture. The *Hundred Spaces* are both thing and cavity; there is little evidence now of the imprint of the underside of a chair, or the textures we might associate with other work by Whiteread. There is only glistening surface and light emanating object – the kind of light that persists after the event – that gets left behind the eyes, flickering on the back of the eyelid. Commentators have drawn attention to the idea of the death mask in relation to Whiteread's work, but in this work this seems much less the point. For in the intersection between the hallucinatory quality of translucent colour and the hysterical absence or eclipse, a convulsion in the field of vision has occurred. The moment of arrest opens onto a different temporal structure: it is the hole in duration, the momentary flicker or eclipse, the moment which is, however temporarily, detached … and which is already gone.

Sticky images: the foreshortening of time in an art of duration

Mieke Bal

[E]very image of the past that is not recognised by the present as one of its own concerns threatens to disappear irretrievably.
Walter Benjamin ('Theses on the Philosophy of History', thesis V)

The aim of the historian ... is to portray the manifold shapes of time.
George Kubler (*The Shape of Time*, p. 12)

Although there were no nudes, Caravaggio's paintings exuded a sensuality that physically aroused him. Strange, he thought, because most of the themes were religious. What was it about that artist that was so profoundly affecting?
Margaret Truman (*Murder at the National Gallery*, p. 94)

Introduction

Time is the stuff of history. In a historical perspective, art is examined through the perspective of change over time. This change is analysed in terms of periods, movements, styles, tendencies and influences. All these concepts pre-suppose two notions: that time is a continuum that can be divided, and that art is bound to the social-cultural environment within which it comes into existence. If applied with due caution and qualification, both of these assumptions have enough plausibility to lend themselves for use in standard accounts of the history of art.

There is, however, also an altogether different relation between art and time: that which concerns time *in* the image. This relation is likewise grounded in two assumptions. The first concerns representation. In spite of claims to the contrary, in spite, even, of a culture where the media dominate and words and images can no longer be separated, the double binary opposition between space and time and between image and language continues to persist in thinking about visual images. Images unfold in space, texts in time. This assumption has prevailed for centuries, and no critique of it will eradicate it, even though it is quite obviously false.[1] It is

based on the idea that a text needs time in order to be read; but so does an image. It also pre-supposes that an image takes space; but so, too, does a text. Text is measured by the standard of its processing, image by its ontological mode of existence. This confusion continues to exist today.

The second assumption is an ontological one. It stipulates that images *are* in time, that they are still objects which, if well preserved, can last without changing. Although it is obvious that images can *evoke* or *represent* time – the past, the future, or two or more moments simultaneously – it is more difficult to see how they can *be in* time without simultaneously unfolding that being in time as film and literature do: in a sequential development, a time axis whose continuity moves forward. The temporal realism that sticks to those media is just as tenacious as the confusion outlined above, even if different rhythms can bring temporal variation into play, as in fact they routinely do in those media.

This paper is about art that actively opposes such assumptions that strike the image dumb and fix it in stillness. The art I would like to talk about makes time its business and its medium yet is not deployed in the allegedly temporal media. It works with time on a level that simultaneously acknowledges and challenges the fixity of the visual image: the level of process in real time. I am less interested in arguing that this art represents narrative even without resorting to traditional methods of visual narration such as condensation, sequentiality, anachronism and metaphor. Rather, I would like to explore several ways that time can inhabit the still image not by encapsulating it but by using it as a medium to reach out into the social world. In other words, rather than looking at the image as a still 'thing' that has a social life – one of the most important programmes of art history and anthropology – I would like to see it as a social agent in itself.[2]

But, writing with a sharpened awareness of time, I will avoid the Scylla of pretending that the temporality of these works is a novelty of our time – a 'parontho-centric' view – as well as the Charybdis of universalising it.[3] Nor do I want to fall back into a formalist bracketing of historical context. To avoid the first dilemma, I would like to analyse the way images do their time-work by confronting their work with that of Caravaggio, the painter who allegedly 'destroyed painting' by disrupting narrative; narrative, the art of time. This paradoxical move makes sense because, as is well known (and this is the view I take as the starting point of my book on the subject), Caravaggio's work effectively refrains from telling stories the way classical Renaissance art did.[4] Nor is his work descriptive in the sense that Svetlana Alpers articulated description as the alternative to narration.[5] Its narrative dimension derives instead from its appeal to an interaction with the viewer; to its own processing in time rather than to representing time in a represented *fabula*.[6]

This processing is evoked, represented and simultaneously 'enforced' in what I would like to call 'sticky images': images that hold the viewer, enforcing an experience of temporal variation. They enforce a slowing down as well as an intensification of the experience of time. I will analyse a few cases of such sticky images that

have come from different socio-historical backgrounds, use different media and offer different visual 'thoughts'.[7]

Fortunately, I am able to avoid a formalistic isolation of the image; the way these images 'recycle' Caravaggio's sense-based alternative to narrative already precludes this possibility. Moreover, rather than appealing to the logic of synecdoche that underlies contextualism, I will consider the way the images *respond to* and eventually *intervene in* the thought that culturally surrounds them. I will argue that this art deploys a vision of temporality that is a polemical counterpoint to 'modern time' as envisioned by Walter Benjamin in his over-cited article 'The Work of Art in the Age of Mechanical Reproduction' from 1936. Whereas the speed and overload of visual stimulation is generally criticised by cultural analysts, this modernist view is nostalgic in its paranoia about time.

Taking your time

In an age of electronic media, virtual reality and visual overload, New York-based artist David Reed, simply and obsessively, paints. To date, his œuvre consists of hundreds of paintings, all colourful depictions of curls and folds. He is known as an abstract painter. His painting *# 261* from 1987–88 (Plate 9), which is quite typical of his work, is just one example that demonstrates why critics would want to call his work abstract, and also, why that label is misplaced. The painting is not abstract; it is actually full of figures. Its mode of painting is utterly illusionistic. And whereas there is no 'window on the world', the figures are three-dimensional.[8]

Instead of producing the illusion of depth by means of linear perspective, the curls and waves push forward and upwards: forward, in the bottom row; upwards in the middle section, towards the left. The disks on the upper right stand obliquely to the picture plane, and the section next to the disks, where the dark green is illuminated from behind by yellow – countering the other movements – yields to blue, with white light shining through, pushes downwards. In the upper left section – a red ground with grey figures – one tends to see brush strokes, which undercut the illusionism. But no, even these have volume, shadow, and, in the bottom left of that small section, the stroke, all by itself, moves upwards.

On the first and broadest level – that of historical time – this painting intervenes in the past. It is not simply a 'baroque' painting, with its curls and waves. It changes what we thought we knew that past to be. The incongruity of this image, the impossibility of seeing it coherently, turns it into a kind of postmodern collage. And the way it enables me to see mutually incompatible perspectives as well as illusion and its artificial construction simultaneously (*pace* Richard Wollheim) made me see aspects of Caravaggio's work in a new light.[9]

The spatial confinement that pushes the baroque painter's figures forward into the viewer's space – dirty feet and bottom first – as in *The Crucifixion of Saint Peter* – becomes highlighted in the satin ribbons that overcrowd Reed's space. The waves of the red garment of the Kansas City *Saint John the Baptist*, as a visual footnote to

the texture of the skin of the nude youth whose body, like his eyes, is out of reach, come to stipulate the limits of the viewer's freedom in the face of the tactile quality of Reed's thick ribbons that are foregrounded and 'protected' by the sharp disks. The tricks the light plays – perhaps the most common cliché about Caravaggio – merge surface into depth and depth into surface, as in *The Calling of Saint Matthew*, where the calves of the boy seen from behind are cut vertically by as sharp a line as the ones between Reed's disks and on the border of his satin waves. This cannot be dismissed as simple 'influence', for Caravaggio's project did not involve the agency of shape, volume and light that Reed retrospectively seems to attribute to Caravaggio's paintings. Reed seriously *transforms* Caravaggio. Across four centuries and an ocean, these artists are talking with one another. Over the gap of historical time, coevalness is established.[10]

But the most important aspect of the temporality embedded in this coevalness is the time it takes to see this painting. Although its surface as a whole attracts the viewer, its many levels of figuration cannot all be seen at once. The *coup d'oeil* that allegedly allows one to see an image in an instant, as opposed to a text that must be read over time, here only allows the viewer to see the painting as object, an object appealing enough to make the viewer want to see more, in the same way as a good dust jacket would attract a reader to open that spatial object and begin reading it, unfolding it in time. By disturbing the quick glance, this painting, in all its visual splendour, *acts* like a text.

Part of the slowed-down temporality is due to the sheer format of the painting. It is simply too wide to be taken in at a single glance. Like a film, it scrolls by; like a film, it takes time. In a sense, even more time than a film would. The lack of a 'third-person' narrative makes it difficult to decide where to start 'reading' – at the left or the right, in the upper half or the lower – so you do both. The sharp divisions of the painting's surfaces – the disks, the brush strokes, the ribbons going upwards or downwards – the chosen starting point decides the effect of what follows. Consider what the disks look like if you start at the right-hand corner, then try again from the red rectangle at the upper left. In the former trajectory, darkness pulls the eye towards the light that dominates the disk about two thirds down. In the latter, the differences in colour, surface, shape and size of the sections dominate the effect, as does the different degree of regularity. After the oversized blue curls, which set the pace for a gradual aggrandisement, the regularity of the disks' size and shape is restful. Meanwhile, the thin relief of the upper left section, the brush stroke with shadows whose edges have been cropped in such a way that one easily wanders off the edge of the painting, solicit a longing for the soft-cushion comfort of the ribbons that probe the depth that the initial section teasingly suggested but failed to offer. From the right, one is led outside the image; from the left, one is led into it, enticed to want to lie down in it. Colour and light both divide and bind these surfaces so that one doesn't have an easy time making sense of what the eye encounters.

Not third-person narrative, then, where the time of the fabula can be measured regardless of how much time one spends making that reconstruction.[11] Nor

first-person narrative, for the painter does not refer to himself, his act of painting, or his hand; this is not an abstract-expressionist painting at all. The image's temporality is *erotic*; it is based on the nervous and unequal rhythm of courtship. The glance surveys, then takes off, is pulled back again; a more time-consuming interaction begins to take place. There is a teasing quality to the image's play with illusionistic painting – the refusal of a smooth formal coherence yet the cushioning softness that is not at all cancelled out by the hard edges. To see this image for what it is – not a blurred impression of colours in an abstract surface but a divided collage of various surfaces and various spatialities, a shifting sense of depth and a variety of tactile textures – one must fall for its pull, take the time for it.

If there is narrative here, it can only be described as *second-person* narrative.[12] What the fabula is cannot be determined as clearly, say, as in Michel Butor's famous second-person novel *La modification* (1957). Perhaps the idea of narrative alters with this uncertainty. But one can circumscribe it as erotic, perhaps also as theatrical, to the extent that the different levels of thickness and relief become a multilayered stage set. It is only with the collaboration of the viewer that the fabula can come about. But the 'text', the painting, tyrannically commands that collaboration. One can perform one's role as an actor performs it on stage, knowing full well that one will go home after shedding it; or one can believe in it, be absorbed by its appeal, taken in by the mode of painting that Caravaggio first exploited to undermine the idea of representation and reference.

Caravaggio was the first to make utter illusionism into a statement on the body. Two of his works, *The Crucifixion of Saint Peter* and *The Conversion of Saint Paul*, both from 1601–2 and both large canvases (230 x 175 cm) painted to be companion pieces in the Cerasi Chapel of the Church of Santa Maria del Popolo in Rome where they are still found today, give a sense of what this entails (Figures 4 and 5). And, of what it does *not* entail: no narrative in the third person, no referential illusion that the temporality of the image is safely ensconced within the historical past of the dramatic events.[13]

In order to see the paintings fully, one needs to stand between them, something the casual visitor, time-pressed by the hundred-lire piece inserted into the automatic lighting machine, is not allowed to do. As far as temporality is concerned, this pressure ironically makes up for the limited access, for on this utterly mundane level one is made acutely aware of bodily frustration and the effect of duration. Like Reed's # *261*, these two paintings are totally illusionistic in their texture yet totally artificial in their figurativity. This disjunction between illusion and realism sharpens the qualification of illusionism as a tool to attract the embodied look that the figuration further elaborates. Both scenes are utterly theatrical, with Peter lifting his head and shoulder to look away in boredom at having to pose in an uncomfortable position for too long, and Paul displaying his muscles, tense from holding up his arms for the length of time it takes to paint him so painstakingly.

The tension between illusionistic painting and artificial, anti-narrative figuration has been brought to awareness most effectively not by art-historical

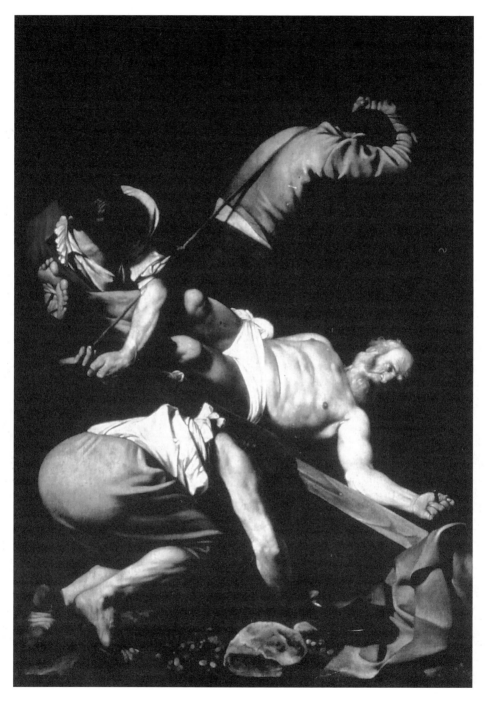

4 Michelangelo Merisi da Caravaggio, *The Crucifixion of Saint Peter*, 1601–2, oil on canvas, 230 x 175 cm, Santa Maria del Popolo, Rome

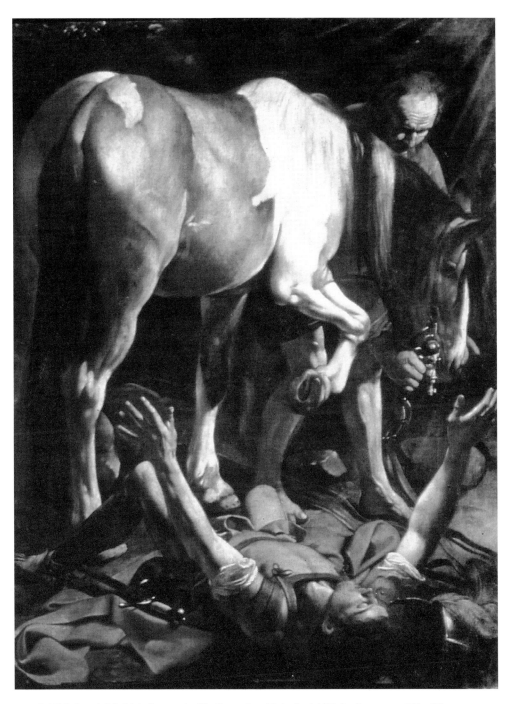

5 Michelangelo Merisi da Caravaggio, *The Conversion of Saint Paul*, 1601–2, oil on canvas, 230 x 175 cm,
Santa Maria del Popolo, Rome

commentary but by Derek Jarman's film *Caravaggio*. The transformation of the acting friends and assistants, who set up the *tableaux vivants* for Michele as he paints, into the actual paintings that result, is a precious tool for art history classes, for driving home a sense of the performativity that mediates between illusion and theatricality.

Peter's fingernails are dirty but his hand does not bleed, is not pierced by the nail; and, in case you are mistaken, the arbitrary spatial direction of the nail, doubly oblique – bent away from the wood and towards the picture plane – drives home the point that it does not connect to the wood to which it is supposed to fix the hand. Instead, the posing man is holding it but, due to the duration of the session, forgot to keep it straight. This is a real man, not a legendary saint or a historically remote narrative figure. It is a man who does odd jobs, who, just one or two years ago, saw a turn-of-the-century celebration, and who is now posing for Michele. Illusionism serves not realism, but its opposite.

The Crucifixion of Saint Peter manifests this activism against narrative third-person distanciation and the temporal closure it entails most famously in the figure of the man who is holding the shovel, helping the other actors for whom lifting the cross with a live man on it is not the easiest way to spend the afternoon. This helper has the dirty feet of a street worker, the rough, reddish elbow of a manual labourer, and an incredibly live, fleshy pair of buttocks that press through his pants so as to make you look twice both at them and at the shapely, manly shoulder. This man's body is totally real, and its back is turned obliquely towards the viewer, seducing you to come in, or, at least, to stay captivated. You keep throwing in hundred-lire pieces. Looking, even at religious imagery, clearly, is not disembodied flight into piety but an act mediated through the body.

Reed has a different point to make, a different Caravaggio to show us, than Jarman. He takes Jarman's point for granted, then builds on it.[14] The volume of real flesh returns in the real, tactile matter of his *# 261*. The theatricality of the scene is alluded to in this work's layered waves and curls, which leave only setting and figures but no human characters on it. But the connection established between real flesh and bodily attraction through the figure on the left in *The Crucifixion of Saint Peter* is the foundation for Reed's painting of unequal, variable duration. Where the rhythm of Jarman's transformations of live scene into *tableau vivant* into painting is constant, punctuating the narrative-theatrical segments of the film, Reed emphasises the live rhythm of the embodied look, which is attracted and repelled, invited in and rejected, then stops at the sight of the dirty soles of feet, the fingernails, the irritated facial expression, or the fleshy, tactile buttocks.

Once the viewer is caught by the painting's way-in, the painting at the right-hand side of the chapel continues the spatial captivation in a time-consuming process. It also seems to comment on a feature of the *Crucifixion*: the fact that this painting resists eye contact.[15] The figures hauling up St Peter's cross are too busy to look at us; the helper who most directly pulls us in does so by turning his buttocks to us; and Peter, whose face is more or less directed towards the viewer, only seems

to face us because he is looking away from the others, clearly aggravated, as if thinking, or saying, to the audience in a theatrical aside: what's all the fuss about?

The Conversion of Saint Paul clearly demonstrates that Caravaggio knew what he was doing with his famous confined spatiality. This painting is an extreme case of the claustrophobic representation of space. Yet, the centre of the picture is a deep black hole. As one critic phrased it: 'the clarity has a bare-bones drive; the man's stretched arms and the corresponding horse's legs set up the centre of the drama as a deep hole.'[16] The low point-of-view makes you almost afraid of the horse's bulk and of its menacing lifted hoof. And, whereas the figures in the *Crucifixion* look in different directions, here they are blind.

This is most emphatic, of course, in Paul himself, whose shell-covered eyes – cleverly taken up by Jarman, who covers the eyes with coins – are close to us, symmetrical to the man's buttocks in the other picture. But the clearest structural device used to bind the two pictures together, from left to right, despite the chronological oddity – the *Paul* represents the beginning, the *Peter* the end of apostleship – is light. In the *Peter* the light comes from somewhere at the left, in front of the picture plane. Once you are attracted, you follow it to step inside. In the *Paul* the light comes from somewhere to the right, behind the picture plane, leaving the back of Paul's head in the dark, emphasising the skin of his chest and the inside of his arms as well as the large flank of the horse and the balding forehead of the old man who is holding the horse and also afflicted by blindness.

Paul is lying with his legs spread open, his arms and hands stretched out to receive whatever it is the light brings. Grace, revelation, the third-person story would say; and, thanks to the predominance of iconography, the painter could make sure that this third-person story passed muster.[17] But this second-person story invited ordinary people with live bodies into the scene, just as the helper in the *Peter* did, with his buttocks. The space has grown more confined, the body more passive, receptive. Taken together, the erotic quality becomes poignantly concrete, so much so that the blindness comes to signify the substitution of touch for sight, a radicalisation of the thought of visual tactility.

Reed adopts this thought, but he radically changes it. For no body can be seen in his painting. Yet, the utter physicality, the sense-based involvement of the body, is just as keen. The body, in his work, is made drastically present, but not as an actor on stage. The body that cannot escape, does not wish to escape, the *touch* of this painting, is that of the viewer. It makes the erotic quality equally intense but infinitely malleable. The viewer becomes the sole actor, and the painting the sole seducer, a 'trisexual' figure whose primary characteristic is to be universally available, for whom it may concern.[18]

What temporality is at stake here? As a result of the visual erotics, the mobilised body, conjured into participation *qua* body, is the same body whose eyes are doing the looking. Hence, in contrast to the disembodied gaze that we have learned to cast on images, the gaze that is a-temporal and does not even know that it has a body let alone a body involved in looking, the mode of looking which is not only a desirable one for

this painting but also the only possible one, the only one that leads to *seeing*, is a participatory look, one beyond that of 'participatory observation' based on coevalness, the long-standing ideal of anthropology. This intellectual posture, this embodied look, is not only epistemologically indispensable, as was participatory observation for modernist, self-conscious anthropological knowledge; it is ontological. Taking into account the deceptiveness and other drawbacks of this epistemological mode, the notion of *performance* seems more appropriate for characterising it.

Performance, in anthropology, is the construction of knowledge about a culture *with* the people and through collective research and discovery, as Fabian argued in a study which, loyal to its thesis, is an account of just such an endeavour.[19] Performance is an act; it is doing. Most often the word is used to indicate ontological dynamism. In theatre, performance is when the play becomes a play; without performance, it remains a text. In reception-oriented theories of reading, the same notion of performance is used to define a specific ontological status of textuality. Without reading, the book remains a dead object, existing only as a thing in space.[20] Text and image are rigorously in the same ontological domain here for neither one exists as 'pure'.

But the notion of performance was most prominently articulated in the analytical philosophy of language, in which John Austin broke with the referential theory of meaning in his famous and aptly-titled book *How to Do Things With Words*.[21] To be sure, this thesis has had predecessors, followers, contestants and amenders, thus in itself embodying the cross-historical process I argued for in the Reed-Caravaggio connection.[22] But in all of these endeavours except Fabian's, little attention has been paid to the temporality of performance. Not only is a performance something Austin aptly compares to fire, something which hovers between thing and event, but the ontological indeterminacy which results also necessarily *takes time*. The performative work, then, is ontologically anchored in time, even if the 'thing' that constitutes its dead letter exists in space.

Reed, radicalising Caravaggio's play on play-acting, takes the represented body out of the performance, so that all the illusionism he musters can never distract the performer away into the illusion of third-person narrative, 'out there', into a different space *and* time. And because of it, we can see in a way we could not before Reed's work came along, that Caravaggio's foregrounding of theatricality was an indispensable tool for effectively 'destroying [third-person] painting', so that the second person, unable to fall for the illusion yet equally unable to resist it, has but one possibility: to take up the role and perform, in all of the many senses – epistemological and ontological, erotic, theatrical and narrative – that this richly overdetermined term has now acquired.[23]

An art of duration

There are other artists whose work in one way or another produces a bodily sense of duration, a variable rhythm that enforces temporal awareness, a sense of duration

which in turn is deployed in a variety of ways and to a variety of effects. To demonstrate this variety, to make a case for a category of 'sticky images' that coheres only on the basis of stickiness, I will briefly discuss works by two artists. Made in different media, the only thing these works have in common aside from their work on time is the colour red.

Norwegian artist Jeannette Christensen often uses Jell-O to make sculptures.[24] Sometimes she simply fills frames with Jell-O to produce monochromes that shine brightly at first, then dry up, leaving unpredictable marks. In her *Ostentatio* installation, in which she juxtaposed Jell-O-filled frames with laser copies of old masterpieces, the gelatine's ephemeral and transient quality, its painterly aspect and materiality, its luminosity, evokes Vermeer's fragile lighting, Rembrandt's golden displacements and Caravaggio's chiaroscuro harshness that so effectively underscores subtleties. The thickness of the works that exist as substance responds to the thinness and superficiality of the bold and disrespectful laser copies of unique masterpieces – blown up, blown to pieces.

Subject to change in time, Christensen's Jell-O works inscribe time and thus inscribe the installations themselves in time, as an intervention in the present, in a culture whose lengthy past makes the present appear hasty and time-ridden – an illusion, due to the temporal foreshortening that informs the critique of time in modernity. More radically, Christensen also makes gigantic sculptures entirely of Jell-O, which are installed for several weeks and then disappear, cleared away by the cleaning crew. They confront the viewer with the materiality of duration. And, since the artist cannot master what happens to the thick Jell-O volumes, she voluntarily relinquishes her power over her work and yields to time.

Her 1993 sculpture *Horizontal Vertical* consisted of two gigantic ladders of red Jell-O laid out on a base of marble chips, representing a whole and made from a substance we know only as a quick dessert – quick to make, quick to eat – a substance we eat and forget (Plates 10 and 11). This massive construct lay on chips – bits, small pieces – of the very material that stands for eternal art, for classical sculpture and for such universal beauties as the Venus of Milo and Greek male bodies. Monumental works, chipped into pieces, here, literally overruled by monumental pieces of gelatine. Yet, the classical monuments remained as the base, the background on which a contemporary sculpture of transience lay.

The reference to classical sculpture is obvious. The sharply cut pieces of marble literally *supported* the gelatine and could not be detached from it. The life of Jell-O is short, that of marble long – as the historian of the *Annales* school would contrast *la court durée* with *la longue durée*, the one changing fast, the other slowly – so that the notion of linear time becomes muddled. Christensen's work makes this opposition more complex. For the bright white chips remained what they were, and, being cut loose from the canonical sculptures whose skin has become smooth even where limbs have been severed by the work of time, they even looked brand-new. The red Jell-O, in contrast, quickly began to work, dripping amongst the marble chips and staining them, rotting in some places, drying in others. The beauty of the

bright red shapes slowly deteriorated and the smell of the gelatine intensified – from sweet to sickening to musty.

Smell, here, is the equivalent of the tactile quality of Reed's surfaces. The viewer is not so much pulled in as pursued by a work that aggresses the body. Looking, again, cannot be disembodied, and every moment shared with the sculpture is temporally intensified. The contrast between the two temporalities – of the marble and the Jell-O – is paired with a constant awareness that time, here, is at work, producing smell, rot, mould, patches. You want to return a week later, to see if the liquified gelatine has stained the floor under the marble or attacked the chips' pristine whiteness or if the form of the ladder has dissolved. Paradoxically, in this sculpture it was the short-lived material that slowed down the viewing, turning a quick glance into a bodily performance. This is the work's answer to a Benjaminian discomfort with the pace of modernity.

Christensen, too, responds to Caravaggio in a variety of ways involving that baroque painter's creative use of light and his literalisation of the body. In one work, she juxtaposed a laser copy of a detail of *The Incredulity of Thomas*, from the Gemäldegalerie collection in Berlin – the open wound with Thomas's finger in it at the centre – with a frame filled with red Jell-O that has dried up to leave marks resembling aggrandised blood cells. The iconographic allusion to disease and death, and specifically, to the AIDS crisis, is obvious. This allusion was also present in *Horizontal Vertical*, but less directly as theme and representation. Here, the decay that took place gradually made this a *moving* sculpture in the double sense. The blood-red colour and the sweet, then sickly-sweet, smell that recalls the smell of blood converged to make the white pieces of marble glow like an excess of white blood cells that absorbs the red or the other way around, an absorption that destroys the body. Abjection characterised the temporality of this work, the diversity of its rhythms. This temporality of abjection recalled the necessity of conceiving of time as experiential, not simply as the biological time that dominates our thinking with false ideas of development and false illusions of a predictable life span. This was the work's response to the social environment of the present, in which its making is embedded.

Experiential and diffuse time, first foreshortened and then sped up, as the very sick know better than anyone, is thus the embodiment of an engagement with the social present. It is also a critical response to the persistent Enlightenment conception of time as development, based on a specific popular conception of biology. George Kubler, one of the few art historians to write about time, already resisted the biological analogy, but, if the recurrence of terms like 'development' and 'maturity' in the discourse on art is any indication, his warning was not heeded. Kubler wrote:

> For the shapes of time, we need a criterion that is not a mere transfer by analogy from biological science. Biological time consists of uninterrupted durations of statistically predictable length: each organism exists from birth to death upon an 'expected' life-span.

> ... but in biology the intervals of time between events are disregarded, while in historical time the web of happening that laces throughout the intervals between existences attracts our interest.[25]

The dripping gelatine that stained the marble chips is a powerful three-dimensional image of this web.

Another red work that slows down the viewer – another sticky image – and in which development is ironically evoked is one by New York-based painter Ken Aptekar. Like Reed and Christensen, Aptekar engages time in his work on several levels. He, too, engages past art, but in a way that seems diametrically opposed to that of these two artists. Whereas they allude to Old Masters in works that pass for 'abstract', Aptekar copies them as literally as possible.[26] In his series *Talking to Pictures* (1997), the relation to the artistic past is mediated through another layer of present/past dialogue. In this series, he selected a number of works from the collection of the Corcoran Gallery of Art in Washington, DC. Having talked with target groups – visitors, students, museum guards and curators – about these paintings, he then scanned reproductions of them on a computer and manipulated them slightly, either by cutting out fragments or reversing them, or by cropping them or changing their size or colour. These computer mock-ups formed the basis of his copying performance. The paintings were always single or multiple squares, either 24 x 24 inches or 30 x 30 inches, and they were never framed. The source painting's frame, however, was often painted into the copy, but transformed. The new paintings 'talked to' the Old Masters, but this time both the museum as institution and today's audience were participating in the conversation, the discussion, the debate.

The second relation to time comes from another feature of Aptekar's work. He writes short texts. He then sandblasts these onto glass plates and bolts these plates onto the painting. The effect of the texts is primarily temporal, even before it becomes an intervention against modernist visual purity. For their presence makes viewing self-conscious and slow. The viewer is hampered in the act of viewing. The texts tug at you and you want to know what they say, are irritated by this aggrandised imposition of captions. But the reading is slowed down as well, for behind the glass is the picture you want to see and that keeps distracting you.

The example shown here, *Dad is showing me how to develop* (Plate 12), is based on *Before the Storm*, a small and little-known Dutch seascape by Willem van de Velde the Younger (1623–1707) from 1700 (Plate 13). Aptekar has copied this small, modest painting in reverse, blown it up, and then turned the grisaille seascape into a red monochrome. The two temporal interventions are 'sticky' to the extent that neither is simple. The historical dialogue is muddled both by the choice of a little-known and unspectacular painting from an in-between period, and by the mediation of the museum. The mutual stickiness of the text-image is aggravated by an irreverent mix of discourses, since the text is a snippet of autobiographical writing, personal in tone and totally unrelated to the official discourse of Dutch seascapes and American museums. Except, of course, for the allusion to 'development'.

In the text, whose first line is also the title of the work, developing photographs is a typically modern activity, and in the context of painting, a direct allusion to Benjamin's paper on the loss of aura. But the very first line, the shortest sentence of this short text, is very sticky indeed. 'Dad' is the synecdoche of children's discourse, placing the story in an autobiographical past. The tense, however, is the present. Dad is doing what museums do: showing. And 'how to develop', when framed in the discourse of a child growing up, is replete with *double entendres*. Is the boy to develop into manhood by learning to develop pictures? The small figure in distress in the boat suggests as much.

Thus, the first line already points us back to the image. The boy, with his back bent towards us, alone in the dangerous dark sea (room), trying to manage a ship (picture) that is too big for him on a sea that is too vast and too wild, figures the 'other' meaning of the simple sentence. The boy/man on the ship, big enough to be out there on his own, is wearing shorts as a token of his youth. But, as we look at this boy, projected as the man he is to develop into, at the painted figure with the sticky text we cannot shed, the railing behind the figure inevitably also starts to look just as double-edged, evoking the edge of a film roll and thus pointing back to the story of the lesson in development. Dad's 'showing' comes with 'explaining', just as museums communicate between art and audience using explanatory labels.[27]

The lesson is about enlarging. This makes all kinds of sense, since the boy will himself be enlarged as he develops into a man, and this painting has enlarged the Dutch painting. The text says as much: 'It's all up to me how big to make my pictures.' But the harmony between the text and the image – between the father and the son – is too fragile to last. The first part of the lesson is disobeyed: '... so the picture won't come out backwards' is a lesson in obedience to realism that is not heeded. At this point, already stuck in a continuous game between text and image, you realise that this is precisely what the painter has done to the historical predecessor (and to his Dad): he has reversed the seascape/photograph.

Combined with the faithful, detailed performance of copying, which is also a homage to and performance of slow time, this intervention in the form of reversal is also a creative appropriation of the past that changes the source painting into a non-linear, non-developmental work that is present in the present only. And, since Aptekar's story frames the interaction in terms of development, the way the present interacts with the artistic past is also at stake. The freedom granted – 'how big to make my pictures' – is used to appropriate the freedom denied – 'so that the picture won't come out backwards'. The artist, who used to be this little boy, is now, thanks to 'Dad' and his lesson, able to understand the meaning of opposing the rules and regulations of the institutions that have 'development' as their goal: museums, art schools, families. You can oppose the rules but it helps to know them first.

But what does the seascape have to do with this? Not necessarily a whole lot. The almost arbitrary choice of the source painting is in itself an intervention against the canonisation of 'masterpieces' at the expense of other works. Many of

the paintings selected from the Corcoran collection, if they had not disappeared altogether, had to be dusted off after years of storage.[28] Seascape is a minor genre in a major period; which art student does not learn about the Dutch 'Golden Age'? The lone ship in a storm is also an expression of the romantic image of the artist as genius, alone in a hostile, unresponsive world. Dressing his sailor in shorts and pulling him back into the darkroom is a humorous way of undermining the prestige of that image. 'I'm often alone in the dark while I'm developing' says the last sentence, which appears to be a caption for the image in the centre of the picture: the boy, alone on the dark sea, abandoning his framed development, holding hands with Dad, surrounded by bright splashing seawater that now frames him so differently. But, alone as we all are in the dark adventure of life, 'hero' and 'genius' are not the words that ring true here.

There is another element in seascapes that connects the various strands of intervening in linear time. Seascapes are strongly narrative; they tell about danger and imminent disaster. But they do so in a peculiarly un-linear manner. In this sense, this modest genre is eminently suited to help re-focus our conception of visual narrative, and Aptekar's commitment to combining textual stories with images is a particularly suitable place for helping us to think about what that re-focusing might produce. Aside from the tiny figure of the boy/man against the railing/film roll, the painting is dominated by cloudy skies, raging waves and a bright, two-part sail. Both the sail as the figure and the waves as ground are anti-narrative. They each have a referent, but, recast in an unreal red, they cannot so easily be reduced to their referential meaning. Although much larger, Aptekar's painting subtly makes the sail and waves less figurative, or at least, less easily reduced to a banal, realistic, window-on-the-world reading of the painting. Making a pun on red and on the past tense of the verb 'to read', Aptekar transforms the narrative of the storm into a discussion of the complex and contradictory fibres of 'development'. Now red, the painting must be read.[29]

The performance asked of the viewer/reader is not only time-consuming, slowed-down by the work's commitment to promote caring, loving and reciprocal *attention*, promoted by the various elements that slow it down – from glaring glass to the enticing text, from the verbal, visual and verbal/visual puns to the ambiguities of tense and tone. It is also temporally intense at the same time as being anti-linear. To be sure, there is a story; anti-linear does not preclude narrative. But the narrative 'line' is not sequential, as in third-person narrative. Instead it is based on the long duration of an unending back-and-forth between viewer and work, solicited, if not enforced, by the interaction between text and image, and then further expanded in many ways, a few of which I have touched on. The thematic of 'development' is crucial to an engagement with time. Here, this is an engagement with an interaction – with the past, with art, with institutions and family – that knows of development but does not take it for granted in all its forms. Thus, this work gives shape, in yet another way, to second-person narrative as an art of duration.

Foreshortening time

Attention, then, is the offshoot of the foreshortening of time in duration art. It is the performance that makes this art socially interactive and potentially politically effective while also offering the play, the unexpectedness, the multi-sensuous provocation of desire and dread that defines art perhaps better than 'beauty'. While infusing their images with a sometimes pleasurable sense of temporality which polemically engages in a debate with the negative view inherited from the theorists of modernity, the artists I have discussed so far also address the tragic aspect of time. For their work also responds to the foreshortening of temporal experience in the face of danger, disease and imminent death.

For these two reasons, the account of the relationship between time and image must be emphatically distinguished from the formalist analysis included in one of very few early attempts to grasp the temporality of visual objects, George Kubler's 1962 essay *The Shape of Time*. In this essay Kubler presents his approach as an analysis of the 'morphological problems of duration in series and sequence' (Kubler 1962: viii), as an attempt to describe how 'they [desirable things] fill time with shapes of a limited variety' (1). In spite of its promising title and its insistent return to the theme of duration, Kubler's essay is more focused on sequential order than on duration proper. The difficulty of defining and analysing duration of which Kubler repeatedly speaks, keeps displacing his attention from the shape *of* time to shape *in* time. This shift results from the comparativeness of the approach, even more than from its other obvious limitation, its formalism, which paradoxically prevents the author from taking art itself seriously as a form of thought *on* duration.[30]

A contemporary artist who does manage to shape time is Colombian Doris Salcedo. She makes the visualisation of duration the crucial weapon in her art, which wages war against violence and for its obliteration.[31] Her sculptures militate against forgetting by making used furniture the site of the presence of the dead. Like the other artists I have discussed, Salcedo attempts to break the wall between private and public by bringing the disappeared victims of violence into the public domain from which their murderous deaths had torn them away.[32] Spatially, she does this by using old kitchen furniture as the ground for her sculptures. Temporally, she gives them, in ways I will try to indicate below, a duration, specifically, a *lasting actuality*. Actuality is the most intense moment of presentness which, by definition, passes unnoticed. In Kubler's poetical account:

> Actuality is when the lighthouse is dark between flashes: it is the instant between the ticks of the watch: it is a void interval slipping forever through time: the rupture between past and future: the gap at the poles of the revolving magnetic field, infinitesimally small but ultimately real. It is the interchronic pause when nothing is happening. It is the void between events.[33]

Salcedo fights the anonymity of actuality. She fills its void, stretching its space to *make time* for remembrance of the dead who died in the past but are violently dead

in actuality. Beyond the everyday bombardments of fleeting images, art seems a suitable place for us to stop and invest these deaths with cultural duration.

This is no mean task. Recent re-memorialisations of the holocaust have made it increasingly clear that art cannot in any simple way represent horror and violence. Representing the holocaust in art leads to charges of 'having made "beauty" out of horror' and 'fiction' out of a reality whose realness it is so utterly important to maintain; and also, given the experiential intensity of horror, of representing the unrepresentable. Yet, important as these cautionary discussions are, it is equally important that the holocaust, for these very same reasons, not be allowed to disappear from the cultural scene.[34]

Moralising prescriptions of what art can or cannot focus on are out of place – or should I say, out of time – in an era as riddled with violence as ours. Activist art made and exhibited over the past two decades has made that clear enough. Salcedo's art, although not as 'loud' as most activist art, cannot exist within the confines set by this prescriptive view, which is in fact grounded in a resilient formalism.[35] For, without the outside world and its politics of violence, there is, in her sculptures – which are both big and discrete, ordinary and stunningly powerful – simply *nothing to see*. No image, no beauty, no forms.

If television news, newspaper headlines and journalistic photographs are to be the casual purveyors of the horrors that take place, then the Benjaminian anxiety about the amnesiac effect of visual speed is entirely justified. Geoffrey Hartman, for example, makes a convincing case for the importance of distinguishing collective memory, which is bound up with community as Halbwach discussed it, from public memory, which is dominated by the media that all but destroys the former.[36] While I find Hartman's view of the media too massively negative, it is important to acknowledge the *loss* of memories that this kind of public memory erases.

I wish to contend that the reason Hartman alleges for this loss is in danger of repeating the same erasure, whereas erasure is precisely what he rightly wishes to counter. He speaks of 'the loss or subsumption of the past in the present, a present with very little presence beyond the spotlight moment of its occurrence' (106). As a generalisation about the media in relation to memory, Hartman's view seems excessively condemnatory and essentialising, precluding differentiation in the immensely rich domain of the media; but as a counterweight to an idealised, collective, communal memory, it makes a good point. As a caution against an erasure of the past, however, it becomes counter-effective, particularly when what the author calls the 'subsumption of the past in the present' is equated with loss. The previous discussion has demonstrated a contrary deployment not of the subsumption but of the wilful, dialogic, critical and respectful adoption of the past within the present, so as to hold the present accountable for what happens to both it and the past.

But Hartman's discussion also points to another basis for a distinction, namely mood, which I would like to take up and bring to bear on Salcedo's work. Hartman's avowedly moralistic view of cultural – collective as well as public – memory usefully integrates the affective aspect with the political, an integration of

crucial importance, which focuses on how cultural memory involves activity. Salcedo's art, while sharing the interactive production of duration, adds to the effects of the previously discussed works a strong sense of mood – in this case, a tragic and rebellious one, tender, even, at times, humorous, but one that always fights melancholic paralysis.

Exposing pieces of used furniture in an art gallery compels the viewer to think about time. For it positions the pieces in the past in which they were used, ensconced in the private sphere, unspectacular. What do we viewers do with these pieces? The sheer fact that they are now in a museum indicates that the private realm of the home has somehow been violated. This violation of the home is represented in Salcedo's early work. According to Charles Merewether, some of her early pieces *look like* wounded surfaces: 'Chairs are covered by a fine skin of lace as if seared into the wood, bones are embedded into the side of a cabinet, a spoon forced between the seams of wood of a kitchen bureau' (20–1). Thus, these early sculptures represent the violation of the private lives of the victims of violence, by displaying the violence itself on the objects that were taken out of their lives, just as they themselves were dragged out of their homes to be slaughtered. The furniture is stubbornly banal but at the same time slightly anthropomorphised to enact the violence that depleted its territory, the home. It is as if the small things that evoke woundedness have taken up *mimicri*, to adopt to the environment of the outside world in order to be less noticeable.[37]

In contrast to the early works, though, the pieces in Salcedo's *Unland* exhibition (New Muscum of Contemporary Art, New York, 1998) are committed to a fundamentally different mode of representation, one that understands, proposes, then rejects, and offers alternatives to, the predicament of the art/horror connection that so worries contemporary thought. Looking at her earlier work in the light of this later work, we can see that there the violence was in a sense represented by repeating it. The relation between victim and violence was established on the basis of indexical signification – through the deployment of furniture and kitchen utensils as extensions of the victims, evoking them through these synecdoches of their lives – but the violence itself was perpetrated on the objects by means of other objects so that *it*, not the victims, was visually re-presented. The later work of *Unland* radically transforms not the theme but the mode of representation. The difference is that the later work operates entirely by means of duration.

In Salcedo's *Unland* work, *duration* has become the major tool for turning the direction of the narrative from third-person, out-there, concerning the other, to second-person, here, to touch the viewer in the most concrete bodily way possible. *Irreversible Witness* (1995–98; Figure 6) and *The Orphan's Tunic* (1997, Figure 7) are extremely fragile, nearly impossible to make, and nearly impossible to see. The material is still furniture – kitchen tables, a child's cot – but the signifying element is extreme in its finesse, fragility, and durability: human hair, and a bit of silk.

The Orphan's Tunic combines the silk and the hair to produce a surface that evokes death in its grey discoloration and is enduring in its shiny surface.

6 Doris Salcedo, *Unland: Irreversible Witness* (detail), 1995–98, wood, cloth, metal and hair, 112 x 249 x 89 cm

7 Doris Salcedo, *Unland: The Orphan's Tunic* (detail), 1997, wood, cloth and hair, 80 x 245 x 98 cm

9 David Reed, *#261*, 1987–88, oil and alkyd on linen, 65.2 x 255.4 cm

10 Jeannette Christensen, *Horizontal Vertical*, 1993, installation of 2 Jell-O ladders and marble chips. Each ladder 4 m long, total installation 20 square metres

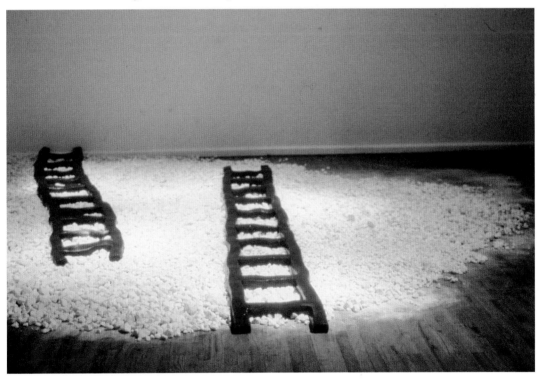

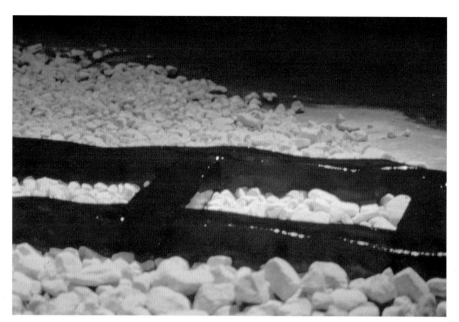

11 Jeannette Christensen, *Horizontal Vertical* (detail), 1993, Jell-O ladders, marble chips

12 Ken Aptekar, *Dad is showing me how to develop*, 1997, oil on wood and glass, four panels, 153 x 153 cm

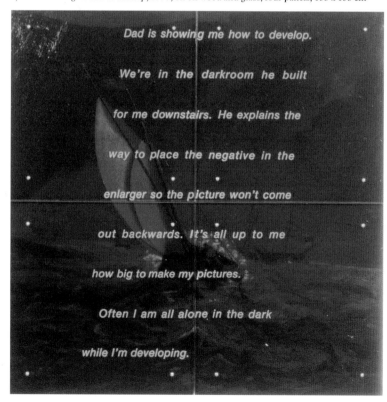

Dad is showing me how to develop.

We're in the darkroom he built

for me downstairs. He explains the

way to place the negative in the

enlarger so the picture won't come

out backwards. It's all up to me

how big to make my pictures.

Often I am all alone in the dark

while I'm developing.

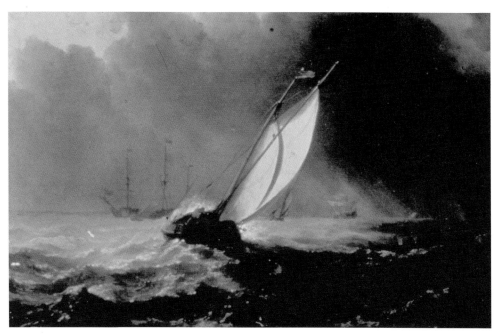

13 Willem van de Velde the Younger (1623–1707), *Before the Storm*, 1700, oil on canvas, 25.4 x 25.3 cm

14 Edouard Manet, *A Bar at the Folies-Bergère*, 1882, oil on canvas, 96 x 130 cm

15 Sylvie Blocher, *L'annonce amoureuse*, 1995, video installation, 14 minutes in loop. Screen 8 x 9 feet, 13 fake pieces of furniture in wood, painted in *Trompe l'œil*

16 Jacques Villeglé, *Carrefour Turbigo*, 1967, torn posters mounted on canvas, 126 x 156 cm

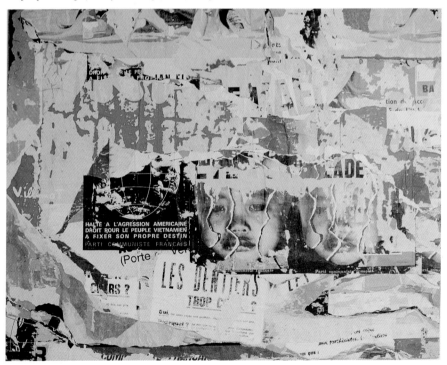

Irreversible Witness has sewn a metal child's cot onto a table using an intricate fabric of silk and hair. The sheer number of hairs used, while irresistibly operating the existential contiguity of indexical meaning-production, bear testimony to the time of the work's making as a homage to the dead, whose bodies remain remembered in their hair only. Hair is more durable than any body tissue, as durable as bone. But bone's relation to death is too ordinary and predictable. Hair is what was once lovingly combed, what shone and framed the face now gone. The fragility imposes respect and distance as an extreme form of the 'don't touch' taboo that applies in venerable art museums. But the most important performance of this piece is the near-impossibility of seeing.

In order to actually see what makes these ordinary tables different from the tables in our own homes, what makes them worth putting in a museum, the viewer needs to come closer, dangerously close, since awareness of the fragility of the objects makes approaching feel like violence. One gets closer and closer, feeling less and less comfortable and more and more voyeuristic, penetrating into the home of this bodily presence. And, even with forewarning, the actual perception of the details – the sewing, the braiding, the weaving of the hair – comes as a shock. Actuality comes out of its dreariness, is stretched out like the long hairs. Stepping backwards, then approaching again, the shock is just as intense.

Here, there is no longer any representational third-person narrative as it was present in the earlier works. The representation of the violation of lives, of homes, by the kitchen spoon or bones inserted within the wooden furniture is now replaced by the performance of *attention*. And, whereas the slow, myopic attention makes the viewer feel in her own body what intrusion into someone's life is, that attention does not repeat the violence; it counters it. Remembering the dead does not redeem them; reflecting on one's intrusion does not take the sting of voyeurism out of looking-in.[38] But between repetition and redemption lies the cultural activity of suspending the course of time that makes the passing of repetition too easy, offering it protection under the wings of redemption.[39]

More than any other works I have discussed here, these sculptures work on the basis of the *performance of duration*. They slow down to the extreme; they make you dizzy from the back-and-forthness between microscopic and macroscopic looking where no eyeglasses or contact lenses will quite do the job. Looking itself becomes tortuous, almost torturous. Like Caravaggesque confinement in a space of shadows and luminosity where body parts are so foreshortened as to enter the viewer's space, making her recoil, these surfaces, whose structure of microscopic detail conjures up such massive violence as to make it impossible for any historical or journalistic account to encompass it, so foreshorten time as to enter the viewer's life-time, breaking its linearity and regularity. They stick to you, long after the intense experience of time has faded back into everyday life.

On incarnation: Sylvie Blocher's *L'annonce amoureuse* and Édouard Manet's *A Bar at the Folies-Bergère*

Thierry de Duve

It is not only to exploit the coincidence that had brought me to the Tate Gallery twice within three months – the first time to give a talk on Manet's *A Bar at the Folies-Bergère* (Plate 14), the second time to attend the *Time and the Image* conference and deliver a paper on Sylvie Blocher's *L'annonce amoureuse* (Plate 15) – that I chose to introduce the latter with an allusion to the former. Nor is it simply because of the quite deliberate repetition in my titles, which both started with the phrase 'People in the Image/People before the Image'. I was hoping, that day, to suggest that both works shared a theoretical issue of some importance. The connection, I'm afraid, was largely lost on the audience. Re-reading my original text, I realised I had made it much too elliptical. Since then, two versions of my talk on *L'annonce amoureuse* have been published.[1] Neither makes the Manet connection. The talk on Manet's *Bar* was also published in the meantime, deliberately amputated, however, from the part that was crucial to the connection itself.[2] Carolyn Gill has agreed to publish here yet another version of my interpretation of *L'annonce amoureuse,* one that emphasises the Manet connection and takes it to previously uncharted territory; and Sylvie Blocher has agreed to replace her oral response at the Tate with her written reactions to this new version. I am grateful to both.

It is my intuitive conviction that the barmaid in Manet's *Bar* is blushing. Needless to say, I cannot substantiate this with any proof. She could be wearing make-up, and what is a painting if not made-up skin? If you cannot go to the Courtauld and verify my intuition with your own eyes, I beg you to grant it at least some plausibility. What happens if you do? The tricky mirror definitely shows a man standing in front of the barmaid, a man with whom we, as viewers standing in front of the painting, have a strong tendency to identify but in whose shoes we cannot stand. Indeed, the perspective of the painting places the viewer much further away from the picture plane, so that the man, or rather, his very absence, stands in the way between the painting and us. He is one spectator too many who

anaisoning

would block our view of the barmaid if it were not for the fact that he remains disincarnated. But does he, really? It is here that the barmaid's blush intervenes. Blushing is a totally involuntary phenomenon through which affects betray themselves outwardly: blood rushes to the skin and signals some emotional upheaval – whether modesty, shyness, shame, or anger is anybody's guess in the case of Manet's barmaid. Being involuntary, blushing is not addressed to anyone, unlike make-up, and unlike painting. But if my hunch is correct, Manet must quite deliberately have addressed the barmaid's blush to us. He meant it to convey that an indeterminate someone (identifiable as male thanks to the mirror) is standing in front of the barmaid, in the viewer's space, and has just addressed her, most probably not merely to order a drink. In persons prone to it, blushing is most often prompted by the very fact of being interpellated. And so, whatever the man just said to the barmaid and whatever her feelings are, it is his address to her that is expressed or betrayed in her blushing, which thus performs a mindboggling reversal of address. It is as if her carnation was his incarnation. Manet has invented what I would call 'incarnation in the second person'. More about this later.

Incarnation, of course, has always been and still is one of the major issues in painting, especially in the West. Traditionally, this issue is presented to the painter as a technical problem that translates into aesthetic appraisal: how to achieve the rendering of flesh, how to convince viewers that they should credit what is after all a mere flat surface covered with paint with the capacity to stand for the outer envelope of a body endowed with interiority, in both the physical and the psychological sense? In other words, how to induce in viewers not the belief (this would be *trompe-l'œil*) but the suspension of disbelief that makes them feel they see flesh where all there is to see is a skin-deep layer of pigment on a canvas or a wooden board? Renaissance Italians had a word for the successful rendering of flesh; they called it *morbidezza*. No doubt it has retained its seductive appeal, from Titian to Rubens to Renoir. The rendering of flesh can call on other effects besides *morbidezza* and seduction to prompt the viewer to suspend disbelief. Think of the abhorrent and repellent realism of Grünewald's *Dead Christ*, for instance. What matters here is that, as long as the issue of incarnation is spelled out technically as the rendering of flesh – that is, as representation, convincing illusion, mimesis – we as viewers are dealing with 'incarnation in the third person' *standing for* 'incarnation in the first person' – and this, precisely, thanks to our suspension of disbelief. The depicted body is a 'he' or a 'she' (not an 'it,' otherwise the rendering would not be successful) to whom we readily lend the capacity to stand up as an 'I,' and all the more so because we attribute this capacity to the skill and talent of the artist. It is *as if* the figure in the painting were coming alive before our very eyes, ready to speak, addressing us. In this 'as if' lies our suspension of disbelief. But for this to happen, the artist's skill and talent must be credible. And they are, because they are embedded in a long and strong tradition – the one Gombrich has described as the progress of illusionism, which happens to be the one Manet puts into doubt.

Manet's *Bar at the Folies-Bergère* offers a link with Sylvie Blocher's *L'annonce amoureuse*: a point of articulation that is both theoretical and historical with regard to the issue of incarnation. This is not to say that Manet was ever on Blocher's mind when she conceived and executed the piece. The way sensitive and historically conscious artists operate, the way they challenge and shoulder their tradition at the same time, the way they perceive meaning in and receive inspiration from the formal solutions they find in their predecessors' work is quite mysterious. The theorist may follow other paths, not necessarily less intuitive. I am convinced that Manet is of extraordinary relevance for the art of today, if only for his initiating position at the outset of the history of modernist painting – a history which we can and must look back upon from the vantage point of its apparent end (say: the 'last' monochrome). There are several artists who, it seems to me, are presently picking up on issues which were present in Manet but which the history of modernist painting on its way to abstraction left unattended. None of them works in painting, however, and all of them are using photography, video or cinema – figurative arts that have availed themselves of the pre-modern (indeed, the Renaissance) technology of the *camera oscura*, the very technology whose output modernist painting, starting with Manet, proceeded to deconstruct.

In 1992, as part of an installation comprising nine plywood volumes of various shapes, a video close-up of Sylvie Blocher's mouth silently articulating a text by Maurice Blanchot entitled 'Le partage du secret' was projected on a wall. The image was circular, tondo like. The piece itself, also entitled *Le partage du secret*, was part of a projected 'triptych' whose first part, also an installation comprising plywood volumes, was *Déçue la Mariée se rhabilla* (1991), an important turning point in her career.[3] The projected third part of the 'triptych' was to be a piece dealing with 'flesh.' It was itself to be a triptych composed of three tondoed video projections depicting close-ups of various body parts, male and female. Although the artist did some photographic test-shots, the piece has until now remained 'on the back burner', and only recently been realised. Her feeling, after having made *Le partage du secret*, was that if she was to go on using video, the image should be of someone else, not of herself, and should be given back its speech. She also gradually felt that this intrusion of 'the other' – an 'other' speaking on his or her own behalf – was a prerequisite to the work about flesh. Those thoughts crystallised in the concept of *Living Pictures*, which she elaborated in 1994. She embarked that year on a series of video works bearing that generic title, and for which she gave herself the following motto: *rendre la parole aux images* – to give images back their speech. The series contains nine works to date: *L'annonce amoureuse* (1995); *A quel point puis-je te faire confiance?/ How Much Can I Trust You?* (1995); *Entre tu y yo estramos nosostros* (1995); *Histoire de ma vie, histoire de ma pipe* (1994–96); *Warum ist Barbie blond?* (1996); *Gens de Calais* (1997); *Tell Me* (1997); *them(selves)* (1997–98); and *Are You a Masterpiece?* (1999).

Speaking in retrospect about the reasons that had made her postpone the making of the piece about flesh, Sylvie Blocher said that she could not give flesh a body if she didn't start by giving the model a face, *un visage*, adding: 'First, I had to

deal with addressed bodies.'[4] Obviously, the artist felt that she could not tackle incarnation head on. The approach had to be indirect, and its medium had to be speech. Addressed speech, that is. Addressed to the body, and addressed in such a way that it liberates speech in the addressee. This is what her concept of *Living Pictures* and her motto, *rendre la parole aux images,* entail. Giving images back their speech would not mean a thing if it did not mean giving the people in the images back their speech. It is a matter of those people's freedom. All of a sudden, the issue of incarnation had become ethical, as opposed to merely technical. At stake was the fact that the artist felt she could not 'render' flesh unless the picture came alive thanks to something which relies neither on skill and talent where the artist is concerned nor on suspension of disbelief where the viewer is concerned. Video would take care of the rendering of flesh. A video- (or cinema-, or photo-) camera is an instrument that automatically produces the kind of verisimilitude that we have come to expect from images since the invention of one point perspective in the Quattrocento. There is thus not much room left in automatic images for the qualitative difference that sets the *morbidezza* of a Titian apart from the illusion of flesh achieved by a run-of-the-mill painter. As to suspension of disbelief, that had to become a question of actual relationships between artist and models before it could be one of relationships between the work and its viewers. Blocher describes the gist of these relationships as such: both parties – the artist and the models – must relinquish part of their authority.

What Manet's relationships with his models must have been is a subject for meditation, speculative for the most part because testimonies are scarce, yet relevant because of the moving way they come across in the paintings. Whereas we can be content with 'penetrating observation' and 'deep psychological insights' when we discuss even the best portraitists, such blanket terms are notoriously insufficient when we talk about Manet. They are even false. There is virtually no psychology in Manet's painting (this is what puzzled contemporary viewers the most), and 'penetrating' is definitely the wrong metaphor if applied to *Olympia* and the other masterpieces for which Victorine Meurent was the model. No one will ever know the true nature of Manet's long-standing relationship with Victorine – whether amorous or not, sexual or not, merely professional or not – but it is visible in the paintings that it was a person-to-person relationship with none of the instrumentality implied in the 'use' of a model. Off and on, Manet worked with Victorine – who became a painter herself – for twelve years. Her features vary considerably from one painting to the next. Under the painter's gaze, she reciprocates with an authority of her own, looking out at the painter in full awareness that the beholder will soon take his place. Though she appears most often as a *character* in some fiction and only once as a *sitter* (in the marvellous little Boston portrait of 1862), she is always the *model* in the fullest sense. Manet has not simply modelled her, he seems to have modelled himself after her in some mysterious way. A great deal of humanity must have circulated between painter and model for it to be so palpable in the paintings.

Victorine may after all have been simply a very good and professional model. But a similar humanity of relationships emanates from most Manet models, even from background characters such as the gaping soldier in the *Scourged Christ*. I wonder if the most striking novelty of Manet's genre pictures from the 1860s, namely their *facingness*, is not the outcome of his human exchange with his models. Michael Fried has convincingly argued that facingness in Manet is not merely a quality we must ascribe to the faces or even bodies of his figures, but also to the painting as a whole.[5] To describe facingness as a combination of flatness of brush work, frontality of composition, and direct address to the beholder on the part of the figures is of course correct. To say that these are the result of the artist's skill and talent is correct too, but then only if the humanity of Manet's relationship with his models is integrated into the notions of skill and talent. (This may go without saying but it is so rarely said that I believe it deserves to be underlined.) But why would the humanity of human exchanges result in facingness? Probably because painting is a medium without soundtrack and because some specifically pictorial way had to be invented to make explicit the fact that human exchanges start with an address to the other and rebound with the other's address to me. The flow of time, and along with it, speech and storytelling, are out of the painter's reach. Manet understood this better than anyone, at a time when most painters thought they could still rely on Lessing or Diderot in order to tell stories using the representation of a single, pregnant moment. For all their stunning instantaneousness, Manet's pictures have not abandoned the ambition to tell stories, but instead of choosing to represent the climatic moment of a story, Manet opted for the initiating moment, the moment of the initiative, the moment of address. It need not be the instant when the story begins. Every address is such an initiative. Interpreters of Manet dealing with direct address to the beholder in his paintings often focus their comments on the gaze, forgetting that the figure's gaze meeting the beholder's is the only means painters have at their disposal to signify speech addressed to the audience.

Manet's problem is of course no longer Sylvie Blocher's. Video is equipped with a soundtrack, and it unfolds in time. It can tell stories. But this is beside the point. Her motto, *rendre la parole aux images,* would be futile if it simply meant adding movement and sound to a still image. Let us not forget that it came about as a step in the resolution of the issue of incarnation, and that the resolution had to be ethical rather than technical. Or ethical as well as technical, if we agree to see the human qualities of an artist as an integral part of his or her skill and talent. Before we investigate in what sense her work might take the issue a step further than Manet's, we must emphasise the ethical dimension already present in the latter. The artist and the models – so Blocher says – must relinquish part of their authority. Manet shared his authority with the model more, or more systematically, than most painters before or after him. And for him too, incarnation was at issue in this sharing. In his art, flesh is not just, indeed, not at all, a matter of rendering. The renderings admired in his lifetime are among the features of painting he discarded most explicitly – hence the fact that he was repeatedly accused of painting cardboard cutouts, rubber dummies or rotten

meat instead of bodies of flesh and blood. Vociferous critiques such as these – and there are truckloads of them – are enough to prove that his contemporary viewers were not at all willing to suspend disbelief in front of his canvases. Neither were they willing to relinquish part of *their* authority and habits of judgment. They were not ready to engage with the people in the picture on a one-to-one basis. No, these people had to be characters in a fiction from which they themselves were sheltered. Bred on the conventions of illusionism, Manet's detractors, ironically, could not accept the illusion because they failed to recognise the convention. (The counter-proof is that Manet's admirers saw nothing but the illusion and, praising him for his realism and spontaneity, could not see the new convention – if it is a convention.) Manet is the first painter, it seems to me, to have hinged the issue of incarnation on address to the other – his address to the model as well as the figure's address to the beholder – rather than on rendering and suspension of disbelief. It is as if he had felt the same necessity as Blocher – 'First, I had to deal with addressed bodies' – before he could lay claim to a new convention, that is, to a new pact with his audience. For the new pact is only now being sealed, in the work of those contemporary artists who are picking up on issues already present in Manet but left unattended by the history of modernist painting. In saying this, I am not in the slightest way robbing Sylvie Blocher of her own novelty vis-à-vis Manet. I am merely laying the ground for its presentation.

At the time the project of *L'annonce amoureuse* was maturing in her mind, Blocher became convinced that it was not enough to introduce 'the other' into her videos and to let him or her speak freely. She had to relinquish that part of her authority that has to do with casting. She decided not to choose the models appearing in her videos herself (Blocher tends to speak of 'models' rather than 'actors' – not an indifferent choice of words when it comes to designating the field in which she situates her work), but to let some haphazard circumstance decide in her stead. The first such circumstance to have cropped up was an invitation on the part of her gallerist at the time to design his stand at the Basel Art Fair. The rule of the game was that every artist in the 'stable' would in turn present the others. Blocher's turn came in 1995, and she turned the commission into a fully-fledged work, in which twenty-two out of the twenty-four artists represented by the Roger Pailhas Gallery appeared on eight video monitors, answering various questions, some trivial, some funny, some intimate, some very revealing, all about 'life' and none about art.[6] It was entitled *A quel point puis-je te faire confiance?/ How Much Can I Trust You?* and though it was produced a few months after *L'annonce amoureuse,* it was conceived before. It is this work that made the artist fully aware of all the implications of working with a group of 'models' brought together almost at random by virtue of one or another common feature. She first called such a group a 'fictive community' and, a little later, coined for it the expression 'pseudo-group' (*faux groupe*).[7] *L'annonce amoureuse* was also made in response to a commission and involves another pseudo-group. The organisers of the film festival, 'Actors Onscreen,' co-produced by the municipal and regional authorities of the Parisian suburb of Saint-Denis, asked Sylvie Blocher to create a trophy for the Michel Simon prize – a prize to be awarded to two (one male

and one female) among the thirteen young French actors and actresses nominated for having come to prominence within the past year (1994). Blocher agreed to make the trophy, but on condition that the organisers finance a video work for which the festival would be the occasion. The work, the idea for which she had been toying with for a while, and for which she had already done two screen tests, would now involve a pseudo-group consisting of the thirteen actors in the competition – a casting totally outside her control. Her proposal was accepted.

There is no indication that Manet ever relinquished that part of his authority having to do with casting. Most of his models – the women especially – were chosen from among his friends and family members, or from within the loose group of artists, writers and demi-mondaines he frequented. He preferred to work with models with whom he was well acquainted, as his faithfulness to Victorine confirms. He enjoyed a relaxed atmosphere in the studio and was known to be able to work while engaged in small talk with his models. When painting a portrait, he would put the sitter at ease. He himself was a Parisian *homme du monde* very much at ease in all milieux, including the night world where the social classes of his time rubbed shoulders with more or less openly avowed intentions. If, in his best genre pictures, he succeeded in capturing the moment of address and in conveying a sense of mutual otherness between figure and viewer, nothing leads us to suppose that he submitted himself to an experience of estrangement from the model to achieve that effect. Manet was a man of 'natural' authority, in full control of himself, and though a liberal politically, not a man to challenge the social order. He was willing to share his authority – his authorship – with the model for the sake of livelier painting, not to shed part of his authority – his mastery – for the sake of a new social pact.

Yet it is in the very nature of artistic conventions to be social pacts, which is why Manet was a revolutionary in spite of himself. Pacts sealed between the professional class of painters, on the one hand, and the social classes composing the public for painting, on the other. I say 'classes,' in the plural, because the number of visitors and the unbelievable mingling of social classes at the Paris Salon had set hitherto unknown conditions for the enjoyment of painting, conditions quite hostile from the vantage point of both serious professional tradition and cultivated connoisseurship. Indeed, the nineteenth-century Salon represents the very first instance of an art form being converted into mass entertainment, long before cinema. When Manet, already gravely ill, decided in 1881 to paint a large Salon picture that would crystallise a lifetime of efforts in view of an art truly responding to the conditions of his time, a picture that would be his pictorial testament, he chose to set the scene at the Folies-Bergère. Cabarets, the Folies-Bergère chief among them, were at the time another novel form of mass entertainment; one, however, that made no claim on high art and whose spicy appeal was precisely the mingling of social classes. Mingling, but not levelling. The men could belong to the upper classes, clearly the women could not. The bourgeois code of morality would not allow a virtuous woman to set foot in this shady world. The only women at the Folies-Bergère were the dancers performing on stage, the demi-mondaines sitting in the parterre, the

prostitutes haunting the hallways, and the barmaids behind their bars. It is known that Manet insisted on having a real barmaid from the Folies-Bergère play her own role. The casting process underwent some hesitation, for the moving Suzon (her name has come down to us) in the Courtauld picture was preceded by another woman, who posed for a preparatory canvas. She is in no way as beautiful and impressive as Suzon, whose statuesque presence in the painting enhances the privilege of having been elected, if not among all women at least among all barmaids working at the Folies-Bergère. If I am right in claiming she blushes, then her election by Manet is duplicated in her election by the man in the top hat standing between her and us. And even if I am wrong, his close encounter with her in the mirror lets it be guessed that he has just propositioned her. Male patrons in cabarets felt free to enjoy that kind of unabashed authority.

It slowly becomes clear on what sort of issues Sylvie Blocher radically parts with Manet. 'Feminism' is one one way of putting it, yet perhaps too easy and too ideological a way. Things are more subtle. There is the issue of authority and there is the issue of choice, of election; and they are linked. It is one thing for Manet to choose models with enough personality, autonomy and resilience to counter-balance his 'natural' authority while yielding to the authority of his trade, his social position and his gender. Gallantry is an elegant way of sharing one's authority if one can afford it. It is another thing for Blocher not to choose her models at all and to seek a loss of authority on both sides, artist and model. For it is part of the authority of professional models, and of professional movie actors, to yield to the authority of a painter or of a movie director. Even barmaids, and certainly prostitutes, who must both serve and yet resist their clients, enjoy the kind of authority that blooms in submissiveness. Actors are a strange breed, in that respect: they are never better than when they are a piece of clay in a director's hand. Yet they are not shedding their authority – and certainly not their part of authorship in the play or the film – when they let themselves be modelled. Quite to the contrary, that is when they exert it and share it with the director to his fullest satisfaction. Freedom is the true loss of authority for an actor. *L'annonce amoureuse* was initially not planned for a pseudo-group of actors. But when the opportunity to realise the piece arose thanks to the film festival, 'Actors Onscreen,' Blocher promptly understood that a group of movie actors was the ideal pseudo-group for what she had in mind. What was the history of cinema if not the *pictured* history of a single question: how to say 'I love you'? Thus she accepted as a given that the performers in her video-film would be the thirteen nominees in competition for the Michel Simon award. The fact that they had been made rivals by circumstance is secondary, much less so the fact that they had acted in different movies.[8] That is what made the cast a real pseudo-group. Nothing was binding them before the shooting except the profession they had in common, and nothing would bind them during the shooting either, since, as we shall see, they would not act together in *L'annonce amoureuse*.

When the artist approached them, one by one, she basically told them the following: that they would not be acting in a conventional film; that they would appear

alone in the frame, in close-up, one after the other;[9] and that they should address the camera and utter an 'amorous announcement'. She said '*annonce amoureuse*', allowing various related *annonces* to suggest themselves, such as '*annonce publicitaire*' (advertisement) or *L'annonce faite à Marie* (the Annunciation in Paul Claudel's eponymous play). Of course, 'declaration of love' was the primary meaning she attached to the expression, '*annonce amoureuse*', and she made that clear. 'A declaration to whom?', the actors would ask. 'That is up to you', she would answer, 'as long as you address the camera directly'. The issue would come up if addressing their beloved in life through the camera was not too personal, too indiscreet, too much like a psychoanalysis session or like a docu-drama or 'reality show' on TV. 'Neither psychotherapy nor docu-drama', she would answer, 'I'm not interested in your private life'. The issue of whether or not to act would of course also come up. Blocher would leave the issue totally open, fully aware that she could not prevent actors from acting if that is what they wanted to do, but confident, also, that the very nature of her request would somehow make acting impossible. Some of the young actors and actresses were puzzled and wary; others thought it was going to be a piece of cake. Isn't a good actor supposed to cheat naturally? It was for them that the experience proved to be the most difficult, for they did not realise that the injunction to imagine freely whomever they chose in place of the camera not only went against the grain of all their training but literally turned it inside out. They had been trained to be aware of the camera's presence but to ignore it; now they were asked to look into the camera while being oblivious of its presence. To address their partners on the movie set and no one outside; now their addressee would be their partner in life. Never to stare at the camera unless it personified a protagonist in the story; now the camera would personify a protagonist in their story who was never part of the script. The conventions they were asked to overturn were conventions governing not just their own trade, as actors, but the very social pact upon which fiction cinema rests.

For an actor to look straight into the camera, when the script makes it clear that no protagonist in the action is situated there, is of course to break the most powerful convention of fiction cinema, the very ground for suspension of disbelief in the movie theatre, namely, the convention whereby the spectators come upon a scene not intended for them. Sylvie Blocher is certainly not the first filmmaker to have asked her performers to break that convention and to address the camera directly. Inserted in an otherwise traditional feature film, a scene where the actor unexpectedly addresses the camera usually has a comical and distancing effect. The viewers' suspension of disbelief is taken by surprise, and they are suddenly reminded that they are sitting in a movie theatre. At best, this distancing results in self-awareness and meta-perception. The medium, instead of being transparent, has become opaque. Though rare in traditional feature films, this aesthetic strategy is almost the rule in modernist art, and Blocher is not the first artist to resort to such a strategy, if that is what she does. The thing is, that is not what she does. Distancing and self-referentiality of the medium are precisely the characteristics of modernist art that she feels

ought to be overcome. They have become the alibi for 'art', the smokescreen behind which late modernism hides its incapacity for dealing with *real* human relationships. When an actor is instructed by the film director to break the convention whereby the whole story unfolds unwitnessed within the screen, and to address the camera directly, it is the audience that he places in the camera's stead and addresses. Not so in *L'annonce amoureuse*. In the camera's stead is the beloved one. Or perhaps I should say that the beloved one is behind and through the camera, on the other side of it, in that space which, in the consciousness of an actor busy acting, normally presentifies the audience of the finished film. Who else is actually present there? It is an item of Hollywood folklore that the place behind the camera should be marked and occupied by a chair with the director's name on its back. Such is the place and the symbol of the director's authority, and what both the place and the symbol clearly stand for is not just his authority over the cast and the film crew but also his authority over the audience. To direct a movie is ultimately to take the audience by the hand, orient its curiosity, steer its imagination, and sometimes direct its conscience. Sylvie Blocher deliberately leaves the director's place empty when shooting a *Living Picture*. No chair in that place, nor anywhere. She monitors the image on a small screen from a position sideways to and slightly before the model, so as to make her presence felt while being out of the frame and to open a void in the back of the camera. And she doesn't sit, she stands there, never allowing herself a more comfortable stance than the model.

Obvious technical reasons make it hard to imagine Manet leaving empty the spot behind his easel to stand at the side of the model. Yet something similar happens in the *Bar at the Folies-Bergère*. Let us for a second imagine that Manet painted the couple as we see them in the mirror (with the barmaid's back turned toward us), but without the help of a mirror. He would have observed their encounter, mirror-reversed, from the man's position in the right corner of the canvas. There is strong evidence that Manet indeed projected himself into that position, symbolically. We know that he cast a painter, Gaston La Touche, in the role of the man in the Courtauld picture after having cast another painter, Henri Dupray, in the same role in the preparatory canvas.[10] Certainly the choice of a painter for the man in the couple was as deliberate as that of a real barmaid for the woman. We can take him to be a stand-in for Manet. *That* painter would then be looking obliquely through the picture plane from within the mirror, only to see himself (or is it another man? another painter?) facing the barmaid beyond the picture plane. The real Manet is of course not in the position of his stand-in, and neither is his 'real' stand-in, La Touche, the model. Manet is facing the barmaid from a distance and uses a mirror to project his viewpoint somewhere diagonally in her back.[11] And La Touche is standing at the right side of the bar, slightly in front of Suzon, and outside of the 'frame.' This is a position at once similar to that of Sylvie Blocher when she shoots a *Living Picture,* and quite unlike it. La Touche sees Suzon's face out of the corner of his eye, whereas Blocher looks away from the model. She has placed a video monitor at the foot of the camera's tripod and uses it

to repatriate her viewpoint from behind the camera. The void she has opened in the back of the camera is a strange place: it is where she ought to be sitting and sits by proxy (for she has not relinquished *all* authority; the camera may be left alone, she still controls the image on the monitor); it stands for the place where the audience will be, even though it does not presentify the audience for the performers any longer; and it is that imaginary space where the actors and actresses in *L'annonce amoureuse* project their beloved one. Indeed a complicated turnpike where several reversals of address and transferrals of authority take place and, needless to say, an uncontrollable measure of transference (in the psychoanalytic sense) as well. To say 'I love you' is not as easy and banal as 'Pass the salt,' and to demand it of someone else is not as innocuous.

The shooting of *L'annonce amoureuse* proved to be extraordinarily strenuous. Excruciatingly long shooting sessions were necessary before the image was 'in the can.' In one instance, the camera ran for seven hours for a result amounting to no more than a minute or two. One girl could not bring herself to say anything, and indeed she appears engulfed in embarrassed silence in the final cut. Another found a way around the instructions by singing a love song in a foreign language, very beautifully. Jalil Naciri (who won the Michel Simon award), very nervous but intensely absorbed in his amorous address, broke into Arabic at some point and instantly relaxed, ending his performance in entranced elation. Mathilde Seigner (who also won the award) resisted with all her might, telling the camera she would never 'say it', never, and finally broke into tears, mumbling 'I guess I still love you'. She appears twice on the tape (a unique exception), the sequence where she resists and the sequence where she cries edited apart from one another in reverse order. The boys visibly had to overcome considerable shyness or embarrassment, which one of them could only do with an obscene gesture. Another boy, quite confused by the fact that the artist begging him to do such a thing was a woman, would not perform unless she did it first (she did). And so on. Attempting a description of the piece is useless. Its aesthetic form is disarmingly simple. The thirteen 'announcements' were spliced together end to end in editing, the artist having allowed herself the choice of a sequence within each take but not the possibility of cutting and choosing within that sequence (another shedding of her authority). The frame is tight, the editing too. Silences are long and inhabited. The visages are unshielded and naked, and yet very physical. The eyes are naughty, or sexy, or downright sexual. Or shy, or cocky, or desperate, or packed with seduction, or full of demands. There are raucous shouts and tinkling giggles on the soundtrack, and innumerable slips in the expressions. The sensation of being addressed is incredibly strong, yet that of being addressed as the beloved one is totally absent. The content of *L'annonce amoureuse* makes it a very moving work for anyone who has not repressed his or her own capacity for being in love, but its form forbids romantic identification with the beloved ones. The more receptive you are to its content, the more alert you are vis-à-vis its form. Which is why the tape usually splits the audience into two clear-cut categories: those who are touched and those who are not. The

latter can't seem to be seeing beyond the loose conventions of contemporary art that have made 'sociological' casting and direct address fashionable. Not to be able to decide whether the people in the image are acting or not is intolerable for some and deeply disturbing for most. Upon learning who the performers are and what the circumstances determining the casting had been, they would not attribute the qualities of the film to the artist's skill and talent but only to the youth and naïveté of the inexperienced performers. One is reminded of Manet's contemporary viewers and their failure to allow suspension of disbelief if they clung to the convention, or their failure to sense the new pact if all they saw was the artist's spontaneity. Viewers of *L'annonce amoureuse* from outside the art world are on the whole much more receptive than insiders, for whom distancing and self-referentiality of the medium are the only signs by which they recognise the self-awareness they expect from works of contemporary art.

To be or not to be touched, that is the great divide. And touch, of course, is a key word when it comes to the issue of incarnation, to which we must now return. As I said before, to a painter this issue is presented as a technical problem, that of the rendering of flesh. The painter's touch carries the responsibility of ensuring that the viewer is being touched. *Morbidezza* is just one of the names art history has given to the mysterious alchemy, thanks to which an active gesture on the part of the painter translates into quasi-passive receptiveness on the part of the beholder. Especially true for the rendering of flesh, this is in fact valid for all renderings in the best figurative painting. (Think of Chardin, where even milk pots have flesh.) But in Manet's painting, touch – masterful and magnificent as we may have learned to see it – no longer holds the secret of the rendering of flesh. Rather, the obverse is true: the rendering of flesh – or the lack thereof: cardboard cutouts, rubber dummies, rotten meat and so on – signals the enigma of touch (not its secret, though; there is none). The name of that enigma is reversal and transferral of address. I address the canvas with a touch of paint and, stepping back, I let the canvas address me in turn. I let myself be touched, or not be touched. And so on with the next touch, and so forth until the final touch, when I declare the painting finished. My intercourse with the canvas is as literally close to physical love as is possible – 'physical', for to touch and to be touched are things that happen to bodies; and 'love', for it is love that makes body contact touching. Love is addressed, and so is the demand for love. Every brush stroke is a caress addressed to the canvas *as if* the canvas were a living body capable of an erotic response. A caress or a blow – a *stroke* of the brush in English, *un coup de pinceau* in French – no matter; eroticism is not always gentle. What matters is that the canvas does respond because it is *felt* to respond by the sensitive painter; not because it is actually alive (this would be superstition), and not because of the painter's suspension of disbelief either. Only mediocre painters indulge in the fantasy that their skill and talent are *a priori* credible simply because they are embedded in the long and strong tradition of illusionism. The best painters would never let the suspension of disbelief they seek to obtain from their audience enter the studio. And the very best know that suspension of disbelief is the wrong expression.

Touch at the level of the brush stroke is not available to artists working in media such as photography, video or cinema. But if touch is (in Titian or Chardin) the secret of incarnation, and if the enigma of touch is reversal and transferral of address, then incarnation in photography, video or cinema will hinge on reversal and transferral of address, at the level of the image. For in those media the image is automatic, ready-made, not built up by a succession of brush strokes. Video, cinema and photography are 'cynical' media by virtue of their technique. They cannot help but treat the bodies of people as the stuff images are made of, and then discard them. Bodies are the residue of images and, as such, fall into mere matter as soon as they have entered the image. An artist really committed to formulating anew the issue of incarnation ought to distrust the camera's capacity for automatic rendering and to take an ethical stand against the 'cynicism' of the technology. Hence Blocher: 'First, I had to deal with addressed bodies.' It was a matter of making sure from the very outset that the level of the image would be the level of the *people* in the image, and that these people's bodies were not just captured by the camera but would show themselves as having been addressed, first. So, she addressed her models or actors first. One might argue: so does every filmmaker; how otherwise would you instruct your actors about the role they have been cast in? But here the casting was not done by the filmmaker; the actors had no role to play; and what you have by way of instructions is a demand whose very substance is the reversal and the transference of the initial address. Begging each of the actors and actresses to utter their love, Sylvie Blocher was begging for love herself, yet not *for* herself. Complying with her demand, the actors addressed their significant other through the camera with a declaration of love which, in most cases, and not surprisingly, carried an intense demand for love. Finally, when the tape is projected, we as viewers come to occupy the place of the absent beloved, a place which, however, remains uncannily empty. We are physically facing the people in the image and receive a demand for love not addressed to us. We are the recipients though not the addressees of a message resulting from a chain of reversals and transferrals of address. Conversely, we are the addressees of a work entitled *L'annonce amoureuse,* and become its true recipients only when touched. The troubling beauty and extreme fragility of *L'annonce amoureuse* make it plainly visible, as if it were its theme, that the work succeeds in as much as the viewers answer a demand for love with their love for art.

Judging from his reception at the time (cardboard cutouts, rubber dummies, rotten meat, again), Manet seems to have thought that touch was already no longer available to him. He would quote Titian but not try to emulate his *morbidezza* brush in hand. He brought the enigma of touch into the open negatively, so as to transfer it from the level of the brush stroke to the level of the figure where it positively reacquires its human, not merely its technical, meaning. For touch had lost its humanity, along with its enigmatic character, in the academicism of Manet's time. It had lost it, for example, in the hands of those painters of *Ingresque* obedience such as Gérôme, Alma-Tadema or Bouguereau, all of them masters of rendering, who were flaunting their technique in order to impress rather than touch while seeking

to touch by bathing their figures in suave sentimentality. In the face of such deca-
dence, Manet must have felt he had to dissolve traditional rendering, as if to remind
the viewer negatively of what touch had always meant to the sensitive painter, and
to introduce him or her positively into the triangular relationship between painter,
model, and canvas, where the enigma of touch plays itself out as transferral or
transference. To have a touching model in the studio, like Victorine or Suzon, cer-
tainly helps. To be facing the model and to transfer facingness to the whole canvas,
as Manet did, enhances the otherness the canvas incarnates, and that helps too. A
model seen in profile would lessen the intensity of Manet's human exchange with
the model. Facingness is what results at the apex of the triangle. Not only does it
sum up the myriad passive-active reversals of address having occurred between
painter and canvas at the level of the brush stroke, it also coalesces the myriad trans-
ferrals of address, from model to painter to canvas, into one global *transference* of
address taking place at the level of the finished figure facing the beholder. When
painting turned modernist and abstract, the model vanished, and the touching
qualities of the painter's touch had to be transferred to the surface of the canvas
without the mediation of the figure. Figuration disappeared but incarnation
remained. Of course, it takes more than raw sensitivity, more, even, than familiarity
with modernist painting; it takes a lot of culture and love for painting of all times to
see incarnation in, say, the 'last' monochrome. Perhaps it is the sense of exhaustion
of modernist painting that drove some contemporary artists working in the new
media back to Manet, consciously or not. Or perhaps it is Manet's shifting of the
issue of incarnation from the level of the brush stroke to the level of the figure that
accounts for his relevance today. Hence the fact that the great divide now hinges on
what we deem to be important in Manet. Is it the negativity of his break with the
traditional rendering of flesh, or is it the positivity of the new pact he sought to
establish between the painters and their audience?

 Think of it. If you were an artist working in today's mechanised media and con-
vinced that negativity is essential to 'advanced' art, you would think the lesson to be
learned from Manet lies in his own negations. You would deny flesh with contem-
porary means and push the denial to where actual rubber dummies and rotten meat
show up in your images. You would emphasise the prosthetic dimension of your
medium and scoff at the idea that you are engaged in something like amorous trans-
ference when you are working in the medium. And if you were actually working
with people not of your choosing, and if you actually allowed them to speek freely of
the most intimate matters, you would see to it that their identity itself is made pros-
thetic. In fact, you would dread the idea that anyone might be genuinely touched
because you value the opacity and self-referentiality of your medium more than the
opaque mystery of other peoples' otherness. I will not mention names. I only want
to make clear how radically opposed to such practices is the work of Sylvie Blocher,
and to underline the level of her ambition as an artist. The more I delve into the
comparison between her work and Manet's, the more I am convinced that some-
thing unique, with far-reaching consequences of all sorts, is happening in her

Living Pictures. There is no way around Manet if we want to understand that something. And so the question is, again: what did Manet positively bring into the open regarding the issue of flesh?

I suggested an answer at the start of this chapter when I said that Manet invented 'incarnation in the second person'. The blushing barmaid in *A Bar at the Folies-Bergère* is the last, the most explicit and the most elaborate instance of it. As I said, I cannot prove that she blushes. All I go by is my sensation or my feeling that she does: she moves and touches me the way a blushing woman would and a made-up woman wouldn't.[12] I realise that I am asking you, dear reader, to suspend disbelief in order to see Suzon blush like I do. But this is because I cannot bring the painting *in the flesh* before your eyes. If you go to the Courtauld and check for yourself, it will not be suspension of disbelief which will make you accept or reject my reading. You will either be touched like me or not. Rendering alone will not tell whether blood rushes to Suzon's cheeks or rouge was applied to them. If I am right, Manet must have chuckled when he painted her rosy face; with it he managed to 'squeeze' suspension of disbelief in the wittiest fashion. He also managed to make me engage with the figure in the painting as if she were a living person. The two are linked. Suspension of disbelief is operative only as long as you are looking at a painting – or a theatre stage, or a movie screen – as a scene where characters interact with one another whether you are there or not, and thus as a fiction or a reality from which you yourself are sheltered. The minute I let myself be touched by Suzon's blush, I am no longer sheltered. I must not only shed the expectations of the nineteenth-century viewers, who were accustomed to a story staged inside the painting without the beholder's presence being acknowledged, but also the modernist habit that makes me see paint on canvas no matter whether it stands for blushing flesh or made-up skin. Even though I know Manet addressed the painting to me, I must suspend even my speculations about his intentions. I am in a state of receptiveness that makes me the recipient of an involuntary message sent by Suzon's body and which, as such, was not addressed to me or to anyone. Notice the similarity with what happens to me as a spectator of *L'annonce amoureuse.* There too, I am the recipient though not the addressee of a message whose amorous content is of no concern to me but whose physical, involuntary manifestations touch me: Mathilde Seigner's tears, Jalil Naciri's sudden change of expression when he breaks into Arabic, Mathieu Demy's moody pouting lips, this boy's lost gaze or that girl's happy wrinkle at the corner of her eye; and fleeting shadows, uncontrolled giggles, slips of all sorts and this extraordinary over-all nakedness. There is even a boy who is blushing to the point of gleaming when, after a long and crushing silence, he lets out: '*T'es belle*'. No more than I identify with this boy's sweetheart do I identify with the customer in the top hat when I feel touched in a way that prompts me to say the barmaid blushes. His presence in the mirror is no more than the enigmatic denial of his absence before the barmaid. A 'proof' in the double negative.

In *A Bar at the Folies-Bergère,* Manet staged the 'dialectic' of reversal and transferral of address that is the essence of touch in a way so explicit as to become almost

didactic. We must follow it in reverse order because everything proceeds from my being touched, that is, from Suzon being touching. My sensation or feeling convinces me that she blushes, and from her blush I conclude that she too has been touched. It does not really matter, theoretically, whether she blushes out of modesty, shyness, shame or anger. Prompted by the fact of having been interpellated, her blush betrays the presence of someone who addressed her face-to-face. The reflection of the couple in the mirror makes that presence explicit (hence the quasi-didacticism) and identifies her addresser as the man in the top hat, who is thus definitely a character in Suzon's story. But he is standing our side of the bar and thus of the picture plane. I said at the beginning: it is as if her carnation was his incarnation. Let me now add: and his incarnation my own presence as a viewer. With Manet's invention of incarnation in the second person, incarnation steps out of the painting. We should not be too surprised at this, for everything that was said above about the enigma of touch leads to a definition of flesh as received speech incarnated by a body. Flesh is a body that has been addressed and that manifests it – which is both what Suzon is when she blushes and what I am when I feel touched and manifest my feeling with my aesthetic appraisal. As a result, my physical presence before the painting comes to incarnate the man in the top hat who is so obviously missing from my space. And the chain of transferrals of address comes full circle: why not say, to take a shortcut, and with a touch of humour, that without identifying with the man in the slightest, I am the one who makes Suzon blush? (Indeed, this is most probably what you, dear reader, will have concluded if you do not share my feeling.) I am the one who spoke to her, and the painting now speaks to me. There is apparently a 'chicken-egg' problem in this reciprocity, accounted for, in fact, by the reflexivity of aesthetic judgment. There is also the problem of how far we should stretch metaphors. Neither the man in the top hat, who is just a character in Manet's fiction, nor I when I am standing before the barmaid at the Courtauld, need to 'really' speak – no more than flesh in a painting is 'really' flesh. Defining flesh as received speech incarnated by a body, I must trust the word 'touch' to be precisely the metaphor that allows bodies to register speech, including metaphorical speech. A caress in lovemaking is a word the body understands. Let us imagine any great painter at work, any painter with the skill and talent to create flesh (Titian or Chardin, for example), as he is engrossed in his intercourse with the canvas. At any given moment, the dialectic of reversal and transferral of address at the level of the brush stroke revolves around the point where I, the painter, regard myself as a 'you', thereby transferring the authority of the speaking 'I' to the canvas itself and behaving like a body expecting to be touched. When I declare the painting finished, I step into the shoes of the addressee one last time and then abandon the canvas to the appreciation of others. Manet is much more, or more explicitly, the painter-beholder (as Michael Fried called him) than Titian or Chardin, which also means that Manet demands that the beholder be much more the beholder-painter, so to speak, than in front of a Titian or a Chardin. Incarnation always steps out of the painting. Manet is the painter with whom this truth of all great painting comes into the open, and has to, because he lives in a time of decadence when

suspension of disbelief will simply not do. This truth made visible is a result of his having shifted the dialectic of reversal and transferral of address from the level of the brush stroke to that of the figure, where it actually continues to play itself out between the people in the picture and the people before the picture, after the painter has withdrawn.

There is more than similarity, here, there is a structural identity with the situation in *L'annonce amoureuse.* Video being a technology that produces ready-made images, the artist has withdrawn from the very outset from the face-to-face the painter at work has with his image. She is even more the artist-beholder than Manet. And like Manet, she has split the couple whose story is told in the work on either side of the picture plane. The originality of *L'annonce amoureuse* is that the film is made of thirteen love stories of couples, only one of whose partners appears on the screen. The other is outside, that is to say on the same side of the screen as the audience. But from here on, the differences between the two works come to the fore. Can it be said, just as with the *Bar,* that the actors' carnation – say, Mathilde's tears or this other boy's blush – is the incarnation of their beloved, the way Suzon's blush is the incarnation of her addresser? Hardly. Can I pretend, even with a pinch of salt, that it is I who troubled them, the way I claimed to have made Suzon blush? Certainly not. The 'chicken-egg' circularity of the phenomenon is cracked open, perhaps even also the reflexivity of the aesthetic judgment, in as much as otherness – real otherness – gets in the way of the, after all, rather narcissistic love affair painters have with their medium and beholders with the works the painters abandon to their aesthetic appraisal. The models on the screen are so visibly in love, or in want of love, that I do not need to infer their emotions from my own. In fact I surmise that it is not from having been interpellated by their partners in life, let alone by me, that they come to appear so vulnerable and moving. It is rather from having been addressed by the artist who approached them with the uncanny demand of telling the camera something that amounts to 'I love you'. Did Manet ask Suzon to blush? Did he somehow make her blush? The question is not as silly as it may seem if we take Manet's stand-in, the painter Gaston La Touche, to represent in the painting the man whom Suzon's blush incarnates, in the second person, before the painting. In that sense Suzon's blush is the last touch on the painting: it captures the moment when Manet, still the painter-beholder, steps down to make room for the first beholder-painter facing his finished canvas. But if this is true, a lot hinges on this moment and, humour notwithstanding, I will not escape that easily the ideological implications of my claim that it is I who spoke to Suzon and made her blush. The blushing woman is such a cliché of male pride that one feels embarrassed for Manet for having resorted to it in order to make incarnation step out of the painting. The art historian I am may file his embarrassment away, claiming that he has stepped into the shoes of a man of the 1880s. Sylvie Blocher may find the comparison with Manet embarrassing for her. Perhaps it doesn't matter, *theoretically,* whether Suzon blushes out of modesty, shyness, shame or anger. But it probably matters to Sylvie Blocher, *ethically,* that the procedure of incarnation in the

second person in Manet's painting should be so indifferent to the model's feelings. Now, in *L'annonce amoureuse,* it does not matter either whether the actors and actresses express bliss or suffering, shared love or jealousy, elation or resentment. But I have never felt that anything ethically problematic was at stake in this indifference. The reason is that, unlike Manet's stand-in, Blocher did not address her models from a position of authority of the sort enjoyed by patrons in cabarets; she did not interpellate them with the kind of dubious and unabashed proposition we might put into the mouth of the man in the top hat; she never thought to provoke in her models the bodily response that betrays their emotions, even though this is what touches us the most in the tape; she asked them to speak.

There is something deceptive in the disarming simplicity of Sylvie Blocher's works – and words. *Living Pictures,* for instance, sounds so naïvely utopian that it is easy to miss its theoretical and political ambition. Yet, as we have seen, what Blocher has achieved is truly to bring the picture to life with means that owe nothing to the conventionality of rendering, suspension of disbelief and the like. *Rendre la parole aux images* sounds equally naïve, until we realise that the expression ought to be taken literally, and that it is really a political motto. Or when she announces her intention to do a piece about *flesh,* we do not immediately grasp how much the concept of flesh (*la chair*), with its dated phenomenological connotations (in Merleau-Ponty), stands in opposition to the present obsession with the body or, for that matter, with virtual reality. It is not until she contrasts flesh with meat (*la viande*) and insists that flesh and meat, *which she sees as political notions,* always confront each other in works of art of all times and all media, including in her own, that the relevance of such a simple pair of concepts is driven home.[13] Sylvie Blocher is a conceptual artist in the sense that most 'theory-based' artists are not. They apply borrowed theoretical concepts ideologically; she retrieves political meaning from everyday words and coins poetical expressions that prove, upon analysis, to have profound and unexpected theoretical implications. A couple of years after having done *L'annonce amoureuse,* such a new poetical expression emerged in her vocabulary: *le double touché.* It is untranslatable. In French, the sense of touch translates as *le toucher,* and the painter's touch as *la touche.* (Manet, incidentally, chose a painter called La Touche as his stand-in in the *Bar.* I do not believe it is immaterial.) *Le toucher* is active and transitive, it is also masculine. *La touche* is feminine and designates the result, the product, or the remainder of the painter's activity. *Le double touché* is masculine and yet has replaced the infinitive in *le toucher* with the past participle, and thus the active with the passive. It also implies a duality, perhaps not devoid of a certain duplicity.[14]

Let us focus one last time on the technical though not at all literal notion of the painter's touch. Until now, I have described what I called the intercourse of painter and canvas in terms of alternation: the painter lays down a touch of paint on the canvas, steps back and contemplates the result, is or is not touched by it, corrects it with a new brush stroke, etc. In this description, the active and the passive, the intentional and the aesthetic alternate like the technical and the emotional parts of

this exchange – which is already a gross over-simplification. It is not only that painters do not stop and step back after each brush stroke, although speed of execution is what allows many to let loose. Or that painters are often taken by surprise by the unwanted results of their gestures and may acknowledge the surprise in raptures, although it happens. Or that there is passivity inside the active gesture of the painter and activity inside the receptiveness of the painter-beholder, although the passive and the active can be simultaneous. It is also that the description presents the active-passive swivel as if it were the seat of a reversal of address, which is true only of those painters who fall in love with their craftsmanship and seek total technical mastery. Those are the painters who address their brush strokes to their intended audience *via* the canvas; when they are touched by their own touch, they revel in the *effect* they seek to have on their audience. They want applause for their technical mastery, which is to say, for their authority over the beholder. They cling to their desire for possession: 'I have touched you, therefore you will love me – or at least my art'. The really sensitive painters do not address their audience via the canvas; they address the medium, of which the canvas is an instance. And even though they, too, expect to be touched by their own touch, they do not take the active-passive swivel to be the seat of the reversal of address implied in the reciprocity of their intercourse – I mean, their physical love affair – with the canvas. We might be well advised indeed to look at the issue of touch from the vantage point of love, thus bringing the explicit content of *L'annonce amoureuse* to it. The reversibility of active and passive in the metaphorical expressions 'to touch' and 'to be touched' sustains a potential reciprocity in human exchanges akin to the one (ideally) contained in 'to love' and 'to be loved'. Assuming that a touching person is a loveable person, 'to touch' would entail 'to be loved', while 'to be touched' would be 'to love'. There is a chiasma, here, in the reversal of active and passive which, if it does not always apply to human relationships, certainly applies to the love of art. Since declarations of love are most of the time demands for love (as certainly the performers in *L'annonce amoureuse* confirm), it is clear that the subtext of 'I love you' is more often than not 'Tell me that you love me'. Declarations of love have a built-in reversibility of address. A projected one, of course, desired, hoped for, begged for and often surreptitiously imposed on the addressee, as the imperative in 'Tell me' suggests.[15] Bad or academic painters impose such demands on their audience. Sensitive painters know both that every demand they address to the canvas (for every brush stroke is a demand if it is truly addressed) has this built-in reversal of address, and that there is no address – no 'Return to sender' – written on the envelope, so to speak, when they receive the touching message sent out by the painting. Their touches of paint are at once addressed and not addressed. They are demands for reciprocity, on the one hand, and they are unsolicited gifts, on the other. This, as a first approximation of Sylvie Blocher's notion of *le double touché*.

Should it or should it not be a point of theory that what touches is not addressed and cannot be addressed? I am hesitant because we are necessarily on *touchy* ground when we discuss the issue of touch. What touches the really sensitive person is that

part of the addressed message that escapes the will, the intentionality, or the direc-
tionality of the address. Better, it is what escapes the demand in the address. The
French language expresses this wonderfully with the word *maladresse.* Clumsiness
can be touching, but not when it is simply heedless. It must slip from within an
addressed gesture or message and betray – not express – the involuntary, uninten-
tional, inadvertent and perhaps unconscious dimension of an otherwise intentional
address. If a painter is too guarded against such 'slips of the brush,' no one really
sensitive will be touched. But he will be in control of his skill. If a painter knows or
thinks he knows whom he wants to address and how he will touch his addressees, he
is doomed, even though he retains his authority over his putative audience. Such is
of course the case of Gérôme, Alma-Tadema or Bouguereau. They were bound to
be academic because they sought to select their constituency from within the
masses flocking to the Salon, while Manet addressed the individual *in* the mass.
They were adroit but had not the slightest understanding of the new indeterminacy
of address that was the challenge of the times. Manet, seemingly less adroit, had
that understanding. The accusation of *maladresse* has accompanied the history of
modernist painting all along. It has been reclaimed as *deskilling* by the historians of
modernism who, incidentally, show with this choice of word how incapable they are
of formulating what they value in art in terms that are not negative. How much
more to the point is Blocher's poetic concept of *le double touché,* with its built-in
reversal of address, with its many dualities of active and passive, feminine and mas-
culine, positive and negative, and with its awareness of the duality and the duplicity
entailed. I will venture to say, by way of a second approximation, that there is at
once *tact* and *tactics* in *le double touché.* The painter's touch, the viewer's 'touched-
ness,' are constitutively dual. But we have not got to the core of the notion of *double
touché* yet. We might get closer if, remembering that Sylvie Blocher is not a painter,
we recall that her work demands that both the artist and the model relinquish part
of their authority.

Why all of a sudden introduce the model into a discussion of the face-to-face
between painter and canvas? For one thing, because it helps mesh the explicit con-
tent of *L'annonce amoureuse* with the issue of touch less metaphorically than I have
until now. Starting with Raphael and the Fornarina, the many love affairs between
painters and models may well be mythical allegories of what goes on between
painter and canvas – and reversible ones, too, for what goes on between painter and
canvas is the allegory of what goes on between the lovers. And more importantly,
because, as I said before, the triangular relationship between painter, model and
canvas is where the enigma of touch plays itself out as transferral, or *transference.*
The trouble with us modernists is that we tend to think of all painting as if it were
abstract painting, where the model has vanished; or at least, as if painters of all
times had been working the way we imagine the abstract painter to work. The pro-
gressive academicisation of abstract painting has made it increasingly more diffi-
cult to see the triangulation in the frontal face-to-face with the picture. I'm
convinced that in the best abstract painting, it is there nevertheless. Facingness is

the better word for what the canonical history of modernist painting (say, Greenberg's) has called flatness, and facingness in the first modernist painter (Manet) is, as I said before, what results at the apex of the triangle painter-model-canvas.[16] Leaping over the history of abstract painting to the present situation that makes Manet so relevant for a number of artists who are not painters, the structural identity of the video artist's position with the painter's comes to the fore again. As well as their difference, namely, that the video artist, contrary to the painter, has very little control of the image at the level of the brush stroke – that is, the pixel or the grain – and cannot engage in aesthetic intercourse with the image at that level. I have argued that Manet shifted the dialectic of reversal and transferral of address, which is the enigma of touch and thus of the issue of incarnation, from the level of the brush stroke to that of the figure. What remained to be done, after Manet, was to disentangle the reversal from the transferral in the address, so as to fully bring into the open the *humanity of relationships* incarnated in our dealings with those objects we call art. What remained was to confront us face-to-face with the unfathomable mystery that makes us love art, and to make it explicit, though, of course, not in the slightest way any less mysterious. For all its striving for explicitness and literalness, modernist painting from Manet down to the 'last' monochrome left *le double touché* implicit, or abstract, or unattended theoretically. Would you mentally conflate 'to address' and 'to feel addressed' (the reversal) with 'to love' and 'to demand to be loved' (the transference) – which is exactly what *L'annonce amoureuse* wants you to do – and then ask yourself what happens to the issue of touch when you are touched, you would put your finger on the exact spot where Sylvie Blocher parts with Manet.

 L'annonce amoureuse, I said before, succeeds in as much as we, the viewers, answer a demand for love with our love for art. In other words, in as much as we are touched by the art in the work, by the global *form* the artist has given it and has intentionally addressed to us. Yet that form is anything but formalist; it cannot be separated from the demands for love which are the *content* of the work and which, though intentionally addressed by the young actors and actresses, were not addressed to us. Their expressions, voices, palpable emotions, tears and laughter, their involuntary, inadvertent and perhaps unconscious slips – indeed, in the case of this shy boy who breaks a long silence with '*T'es belle,*' their *blushing* – all these manifestations of their flesh are the things that touch us. *L'annonce amoureuse* has made *le double touché* explicit. It has disentangled the chain of transferrals that starts with the artist's address to her models, rebounds with the models' amorous address to their beloved, and ends with the work's address to the viewers, from the built-in reversals necessarily implied at every link in the chain by the fact that an address is inevitably a demand. Sylvie Blocher could have chosen another subject matter for her piece, a less intimate or a less touchy or a less romantic one, than a declaration of love. The piece would not have been as successful. She had to aim at a demand of maximum intensity (a demand, not a desire; there is desire too in the piece, and it is also made very explicit, but the novelty of the piece is not there), in

order to make us touch *le double touché*, conceptually, while we are being touched emotionally. She had to bring into the open the repressed romantic content of modernism so as to make it its form. Love, *as transference*, is of course both a content and a form. Yet *L'annonce amoureuse* leaves no room for confusion between form and content. The way the work has introduced me, the viewer, into the triangular relationship between artist, model, and video screen, posits me as separated from the addressed beloved, in a place where my physical presence before the screen incarnates received speech addressed to someone else. We might say that *L'annonce amoureuse* casts a shadow of obsolescence over such romantic myths as Raphael and the Fornarina, or that it brings indiscreet speculation about Manet's relationship with Victorine to a halt. I think Sylvie Blocher is engaged in the vast enterprise of lifting the romantic mortgage of modernism – and I am thinking here essentially of Hegel's heritage. Love is a political affair for her, not a religious one.

It has been hard to eschew the religious issue in the writing of this chapter, whose object is a work of art entitled *L'annonce amoureuse*. It has been hard not to allude to the Christian doctrine. Incarnation proceeds from the Annunciation; it has hinged on address to the other long before Manet or Blocher made that explicit in art. I must have irritated some readers by silencing the Christian subtext of *L'annonce amoureuse*, as if I wanted to protect Sylvie Blocher from unwanted associations. Or by speaking of incarnation as if it were merely a technical problem, the better to present Manet's treatment of the problem as an absolute invention. Or by taking Gombrich's account of illusionism for granted, as if it sufficed to sum up the long and strong tradition in which Titian's *morbidezza* is embedded. Was I ignoring the extent to which the history of Western painting is inextricably entangled with that of Christianity? Of course not. To disentangle that history is an enormous task for which I am not equipped.[17] I do believe, though, that *L'annonce amoureuse* offers a few tools. It is my intuitive conviction that this work is a radically non-religious Annunciation or, better said, a radically post-Christian one. Sylvie Blocher is actively involved in the search for the narrow passageway beyond which art's ethical and spiritual dimensions would cease to be mortgaged by its association with religion. She is also very aware of the difficulty. I will save the religious issue in *L'annonce amoureuse* for another paper, but not without announcing from where I will take my clue. Incarnation summons both sexes. The religion of incarnation has given all authority to the Father's word and has confined women to the role of image-breeding images, an unbearable condition for all women and for women artists in particular. A twin concept to *le double touché* has emerged in Sylvie Blocher's vocabulary around the same time, that of *le double sexué*. There lies my clue.

8–15 Sylvie Blocher, *Living Pictures/L'annonce amoureuse* (details), 1995, video installation, 14 minutes in loop. Screen 8 x 9 feet, 13 fake pieces of furniture in wood, painted in *Trompe l'œil*

Le double touché, or: gendering the address

Sylvie Blocher

Translated by Simon Pleasance

I should like to extend special thanks to Carolyn Gill, for offering me the chance, once again, to reply to Thierry de Duve. I should also like to thank Thierry de Duve for his keen interest in *L'Annonce amoureuse* and for his amazing analysis of the transferral of address in Manet. This discussion is a source of real pleasure.

Two years ago, at the *Time and the Image* conference, Thierry de Duve and I failed to reach any agreement about the concepts of naïveté, perversity and the validity of the barmaid's blush in Manet's *A Bar at the Folies Bergère*. Our many conversations since have been quite fascinating. They have shed light on certain real agreements in our respective attempts to get away from an instrumentalised and prosthetic postmodernity. But these attempts, which continually pass by way of a 're-reading' of modernity, have also crystallised certain disagreements, principally to do with the gender of address, and its consequences in the re-reading of the feminine. My answer is in no way intended as a critical and historical analysis, but rather a series of working notes.

I came across the term 'living picture' in 1992, at the flea market in New York. I had stumbled upon a black-and-white photographic picture, dating back to before World War II, showing the face of a little girl aged about eight. When you moved the cardboard frame, the face started to move and the mouth ostensibly uttered a word that was incomprehensible. Beneath, you could read the words 'Living Picture'. On the back, 'Made in Germany'. The face was arresting, even disconcerting, in its extreme contradiction between life and silence. Now, I was born in Alsace, and my mother's family suffered through both world wars. So, that strange 'Made in Germany' happened upon in New York, struck me as an irony of history. The image teetered between photograph and cinema, representation and presentation. For me, who had spent several months thinking about how to 'give speech to the face' this general title 'Living Picture' was like the penny dropping. As I read it then, the word 'picture' applied ambiguously to the field of images. It was, and is, a

non-specialised, and so extremely free, term. The word 'living' helped me switch from the idea of representation to that of presentation.

A body addressed is a figure with a face. The face spells out its identity, replies and exposes itself, whereas the figure slots itself into anonymity and cannot be addressed. The figure is immortal. The face, on the other hand, requires a body and a mortal skin. The ethical issue of a 'we' made up not of figures but of faces is the utopian challenge of the *Living Pictures*. At this juncture I would like to say something about *Nuremberg 87*, the film Gérard Haller and I made in 1987. We asked the German actress, Angela Winkler, to recite three hundred male and female first names over images of the empty stadium at Nuremberg. At that time, we wanted to focus on a non-fusional 'we' fragmented and aware of its history – the murder of six million people. The Nazis called the people they were going to exterminate Figuren, in other words 'forms' (faceless puppets). The death camps were places where people killed 'faceless forms'. We wanted that unnameable thing to be shouldered by a 'we all' and not just by the Jewish community. The first names replacing the family names of those who had died made it possible for everyone to 'recognise' a face, to stand before history face-to-face and take part in it.

It was during that shoot that the challenges of addressed speech and its reception were set up in an extreme way. Angela Winkler told me that she could not possibly utter all those first names; that she alone, as a German woman, could not carry the weight of all those deaths; that she could not use her skill as an actress to utter them without being obscene. Nor, she added, could she pronounce them like a politician at a war memorial. I replied that I wanted us not to come through the experience unscathed. She recited those first names just once, experiencing all the happy and sad emotions of her own memory, struggling fiercely against her actress's skill. In this fragmented 'we', each and every first name had started to exist, detached, unique, in its differentness and integrity. Something that permitted the encounter with history. Or with its facingness? The *Living Pictures* are the political outcome of this experience of the 'we' where the 'I' has a face.

'Giving speech to the face' is giving speech to the model and envisaging a relationship between artist and model based on the postulate of authority shared. It is also abandoning the figure for the singularity of faces and voices. The *Living Pictures* have to do with the singularity of speech as opposed to the effectiveness of discourse. A kind of infiltration of the 'we'. Unlike discourse, which must be productive, always interchangeable, and subject to the law of effectiveness, speech is not subordinate to anything. It is non-productive and singular. It is uncontrollable. It doesn't communicate, it offers itself. It is, *per se*, hazardous matter. The *Living Pictures* have to do with pseudo-groups. They are the presentation of a sum of several 'I's which do not form one and the same body. They are a kind of gymnastics of otherness. The face versus the anonymity of the figure.

Modernity has done away with faces. It has done so in favour of a self-reference to the medium and a collapse of what Thierry de Duve so rightly calls a humanity. Modernity may indeed have opened up possibilities, but one of its major failures

has been its relationship to authority and the feminine. This is one reason why modernity has had constant recourse to the strategy of exclusion, in order to lend credence to its promises of happiness, and 'used power' instead of 'having authority'. The fathers of modernity have smothered or slain their feminine side. Not 'women', but rather the feminine that they bore within them. Like Freud, who wrote at the end of his life: 'But what does woman want', instead of having the courage or perspicacity to write: 'But what does the feminine in me want?' The feminism of the 1970s was blinded by the rigours of the struggle and often claimed the same power; in so doing, it cut off the feminine aspect, suspected of being too fragile, too aware, too submissive. A feminine permeated with 'sensibility', perceived like a virtue in intimacy and like a disease in the social body. For the shooting of *Nuremberg*, I read the statements of extermination camp survivors. I also read Goebbels' writings which, on top of their murderous anti-semitism, all revealed one and the same obsession: a visceral hatred of the feminine – the particular feminine that posed a threat to the virility of heroes and to the strength of men, which weakened and softened up soldiers' bodies, worming its way like a disease into education, religion, the army, art. A feminine seen as the absolute evil that had to be eradicated by the violence of discipline, and the continual surveillance of the body … but also by the murder of this hated double, the other in oneself, one's own feminine. The outcome was the extermination of so many homosexuals (of both genders). Goebbels was the extreme, fascist version of a predominant trend that is found in larval form in lots of men and women and which modernity has never seen fit to challenge. It is a trend that would have 'the feminine' seen at once as a 'submissive thing' prompting the renouncement of grand designs and as 'dangerous matter', threatening for those (of both genders) who would accede to power. It is the predominant idea of the 'Eternal Feminine' which imprisons the feminine between virginity and debauchery and instrumentalises it. The installation *Décue la mariée se rhabilla* (*Disappointed, the Bride Got Herself Dressed Again*), which I made in 1991, tried to talk about all of this, about this non-heroic and troubling feminine, with no eternity, which I feel close to. My bride used the recurrent motif of disappointment, of loss of energy (she lives eight hours a day and dies every evening), of fragility, to contrast with virile, all-conquering potency. The utopia to which the disappointed bride lays claim was '*le double touché*', the address to the other, itself doubly gendered. We = I we are (*Nous = je nous sommes*). I did not feel 'feminist' but wilfully 'feminine', in other words, creating an offshoot of feminism supporting an alternative position with regard to the issue of power and murder.

Great women artists are few and far between, because they do not have the murderous instinct, it is said. They lack the impulsive and creative force of Thanatos! What a fuddy-duddy modernist truism. Let us stop muddling woman and feminine. I think that the feminine has a link with murder that is as violent and head-on as the masculine, and the myths prove as much, time and time again. I think, quite simply, that men and women who 'expose their dual identity' (*le double touché*) have a chance to use awareness of murder in a distant relationship. They, whether men or

women, can thus create outside its aesthetic fascination: the murder of themselves and of others. Making art is an activity that inevitably flirts with the desire to reduce the other to a pure form: to dominate, manipulate, void otherness, confiscate bodies, use truth, stratagem, diplomacy and cynicism. Being aware of this distance, and overturning it completely, may open up new artistic avenues. Art, in this case, would no longer contribute to the myth of a promised land often taken by force, but would rather venture into the delights of roaming and would be open to the novelty of both meeting and sharing.

Power is authority to which force, or might, is added. Power makes authority spectacular. Sharing authority is to accept the ongoing squaring-up of the two parts of oneself. I = I we are two. Such is the minimum script. It is to choose not to kill the other part of oneself; it is to accept one's own otherness when confronting the other. It is to accept, finally, to fight against this innate need for control, which bolsters our fears and our terror of death; to discover something else, less comfortable, more disconcerting, but so much more adventurous: bodies exposed twice over, touched and non-heroic.

Thierry de Duve is quite right: I did not have Manet's picture in mind at the moment of *L'Annonce amoureuse*. But very early on I had two powerful experiences 'with Manet'. The first was my discovery of what the enigma of flesh might be, by looking at *The Dead Torero*, whose elongated, oblique body offered me, in the facingness of its light, a living flesh, reversing the passage from life to death. My second experience had to do with disappointment in front of the *Déjeuner sur l'herbe*, where I admired the address to the viewer, but hated the conventional version of the nude woman. I would have wanted both the man and the woman to be naked. In my personal mythology, Manet is the forerunner of the 'anti-romantic' cinema, where nostalgia is replaced by a complex humanity, and where the models are not psychologically-inclined actors, but voice-bearers. I have Antonioni and Casavetes in mind here … In a masterful way, Thierry de Duve shows us how Manet sabotages illusionism and, by means of a masterly technique, invents an incarnate, but not deified flesh. He shows us above all how Manet reinvents a form of address that is as old as the Fayoum portraits. But Manet forgets to gender the address, he forgets 'to double touch himself' (*de se double toucher*). He does not allow himself to feminise the sharing and paints his model in a state of submission. Making Suzon blush in a social relationship, as precise as the one he shows us in the picture, forces the address. We dominate Suzon. Thierry de Duve explains to us that this is the only way for a painter, in Manet's day and age, to get the beholder to understand the moment of the address. If he is right, this is a pity. The man whom Manet paints obliquely is a visual passer in the remarkable machinery addressing the viewer. His is no longer the romantic logic of the 'monk by the sea' (Caspar David Friedrich), through whose body the viewer must pass to 'reach the landscape'. The viewer acquires his or her freedom. The man whom Manet paints looking at Suzon drags us along, and gets us to assume a position opposite her because of the void opened up in the composition. But this void remains totally private, triangulated, like in a reality show where the

protagonists share with us their privacy by leaving the spectator off-stage. Suzon actually 'stays in her place'. And Manet paints her so that she will stay there. What a curious and already such a modernist contradiction … when Manet feels the absolute need to humanise the relationship with the model, and avoids gods and heroes, yet does not question his own position. What if Suzon had been painted not blushing but her mouth half-open, as if talking? Might we not have imagined and fantasised a question or an answer, and plunged into the enigma of her soundless voice? But Manet does not let Suzon slip through his fingers.

The *Living Pictures* also try to confront the issue of the power of technique as a method of exclusion. The shooting arrangement that I set up is simplified to the limit while eschewing the demagogic position of 'technique available to one and all'. Brought to the fore, the set-up is discussed as soon as the models arrive and present themselves in front of the camera. There is nobody behind the camera, except that absence of the other to whom they will talk and whom they instantly size up. I like the word repatriation used by Thierry de Duve, for he is talking about displacement. The void behind the camera involves a displacement of the protagonists. It creates the possibility of transferring the address. My position, sideways and close to the model (we almost feel each other's bodies), but out of the frame, upsets the triangulation and 'facialises' the relationship with the spectators, even though they are not the immediate addressees.

I do not know the models. They arrange an appointment and I do not make any choices. They come into the studio and a strange meeting gets under way. Ambiguous questions further heighten the fragility of the situation. I seek distance, the oh-so-particular proxemics where you know you are at once too close to and too far from the other. What I call tragic distance. A kind of unprotected place, in constant displacement, where anything can happen, from welcome to murder. A place always in motion, where bodies expose themselves and resist. The model speaks, and my questions lead to answers. It is after many long hours of filming that the astonishment of speech sometimes looms up. That is when the models, with whom those participating identify, step aside and when they, in turn, become their own models. I don't represent them; I present what literally overwhelms them. Their radical singularity. A series of utopias, 'treasures of nothing' as Deleuze would say, a strange relationship between theft and sharing – the sharing of a fiction. Then I put the bits together. An uncertain story takes shape …

The video medium calls for not much light and protects from bedazzlement: neither incandescence in the whites, nor romanticism in the blacks. The size of the pixels gives depth to the skins and suspends the cleanness and the smoothness of the image. I work with poor framing, editing and light. I keep in the image what people usually wipe clean. I use video as a medium of trace, an average medium and not 'reality 24 times a second', as Godard would put it. I use it for its fluidity, its off-the-cuff quality and for the length of time that can be set up in it. I like the fact that there are too many pixels. I use a video technique which introduces a disconcerting physical aspect, and a non-idealisation of bodies. Video is a hands-on medium of

closeness, of encounter. Perhaps the disconcerting medium that shows 'being together'. Everything that modernity has obscured.

Thierry de Duve talks of the disarming simplicity of the actors in *L'Annonce amoureuse*. What if we changed this a bit and said they are disappointing, and that it is not easy to forgive them for not being heroic, for showing their feminine side, their *double touché*. This is what involves or disinvolves us: the acceptance or the refusal of opening up to our own otherness, in all its strength and weakness. In its mortality. Art that impresses, refers us to the authority of the spectacular. Art that touches, involves us and refers us to the strangeness of the event. These are two families which have been at political loggerheads with each other for a long time. The first thinks it rules the world, the second tries to subvert it.

IMAGES UNFOLDING IN TIME:
THE CINEMA

The index and the uncanny

Laura Mulvey

I recently began to pay attention to the aesthetic and theoretical issues raised by the arrival of digital and computer generated imagery for photographic media. My reaction to the new technologies has not been to look forward or even to attempt to analyse the complexities of the present, but to look backwards. To paraphrase, that is, Salman Rushdie's question in *The Satanic Verses:* 'How does newness come into the world?' and to ask: 'How does newness make oldness come into the world?' How does the new inflect one's perception of the present, so that aspects of it suddenly seem no longer to belong to now? What changes of perspective or scale are needed in order to adjust to new forms of representation? Something that may, until now, have had little ideological, aesthetic or political value attached to it, small in the scale of things, may gradually take on new significance, enlarged under the magnifying glass of changing intellectual priorities.

So, for example, new technologies, capable of both creating a perfect simulacrum of a photograph and also of altering photographic images imperceptibly, summon up, as from the grave, old questions about the indexical aspect of photographic media. During the period leading up to the general diffusion of computer generated imagery, theorists and practitioners concentrated on demystifying the photograph's transparency and its ability to give a convincing representation of an apparently essential, graspable reality. It was pointed out that the photographic negative is inherently open to physical manipulation just as its apparently innocently analogical appearance is subject to all kinds of political and ideological inflection. This position also coincided with the revulsion against the aesthetics of realism that, with different accents and emphases, marked the theoretical avant-garde of the 1960s and 1970s. Given the thrust of this debate, the indexical aspect of photography tended to disappear under the photograph's other properties of similarity and analogy. Its literalness could easily seem banal especially compared to cultural and political questions of code and making of meaning.

Although my present interest in the index may be a response to the sudden diffusion of new technologies and the images they produce, it should not imply any essential opposition between photographic and computer generated imagery. There has always been a grey area between the composed, perhaps 'painterly',

photograph and, on the one hand, and on the other, the particular style of imme-
diacy represented, for instance, by the school of 'the decisive moment'. There is,
of course, the vast mass of everyday, amateur photographs in which the hand that
'pushes the button' has little power to intervene in the process. Professional pho-
tographers have always had the power to manipulate their images; the question is
rather one of choice and visibility. Computer generated images bring back the
'painterly', composition, the hand and eye of the artist developing the work over
an extended period, and the relation between photography and time is not a key
aesthetic issue. It is this that has taken me back to the index and its connotations,
as one particular property of the photographic sign but one which encapsulates its
relationship to time. A return to the index is a return to the negative, to the
moment of exposure.

Generally speaking, the indexical aspect of the photographic image has been
associated with the question of photographic truth. The moment of exposure was
also one which inscribed reality. The dissociation between 'reality' and the photo-
graphic image, between photographic appearance and evidence, for which the
1960s and 1970s avant-garde campaigned so vigorously, both in its theories and its
practices, has now been unquestionably achieved in the CGI (computer generated
imagery) era. And intellectual, political and aesthetic priorities changed. However
correct it has been to question, for instance, the validity of the photographic image
as evidence, the index now takes on a new intellectual, political and aesthetic signif-
icance. As D. N. Rodowick puts it: 'Any sign can be stored digitally and reconsti-
tuted in another form; thus indexicality is no longer the measure of truth of the
image. The figural enonce is virtual; it does not necessarily derive from any prior
existence.'[1]

But this chapter is not about the politics of the photographic index, however
important an issue that might be in its own right. From my present perspective, the
photograph's meaning and its relation to a true or constructed reality is irrelevant.
For this 're-evaluation' of the index, I have returned to two well-known and often
cited essays: Andre Bazin's 'Ontology of the Photographic Image' first published in
1945 and Roland Barthes's *Camera Lucida* first published in 1980. Colin MacCabe
has pointed out that Barthes's reflections on photography in *Camera Lucida* are
strikingly close to, but fail to acknowledge, the 'Ontology' article and he empha-
sises the different agendas behind the two essays. Bazin was writing, implicitly,
about the cinema. Barthes was writing explicitly not about the cinema. I want to
return to the parallels between their arguments, especially as they relate to the
index and time. For both, this property of the photograph also inscribes a ghostli-
ness and the presence of death. I hope I will be forgiven for rehearsing probably
familiar points, which provide a necessary basis for considering the photograph
and its indexicality from a psychoanalytic point of view.

I will be tracing the connections between the following six points:

1 The index
2 The index and the photograph

The index

C. S. Pierce's semiotic proposed that signs, in their 'second trichotomy', may be one of three kinds: an icon is a recognisable sign: it refers to the 'thing' it represents through similarity; a symbol is a decipherable sign: it refers to the 'thing' it represents by means of conventions or codes; an index, however, is a sign produced by the 'thing' it represents. The indexical sign could be recognisable as, for instance, in a fingerprint, or it could be decipherable as, for instance, in the shadow cast by a sundial; something leaves, or has left, a mark or trace of its physical presence. Whether it persists, as in the then-ness of a preserved fingerprint, or not, as in the now-ness of sundial's shadow, the 'thing' inscribes its sign. As a result, the index has a privileged relation to time and to the moment and duration of its inscription. The three different aspects of the sign may, of course, overlap and they do so most strikingly in the case of photography and the cinema.

The index and the photograph

While the photographic image, in semiotic terms, may often include the iconic and symbolic aspects of the sign, it is distinguished by its indexicality. Peter Wollen, in his pioneering application of Pierce's semiotic to photography and cinema, points out that Pierce himself had made the necessary connection:

> Photographs, especially instantaneous photographs, are very instructive, because we know that in certain respects they are exactly like the objects they represent. But this resemblance is due to the photographs having been produced under such circumstances that they were physically forced to correspond point by point to nature. In that aspect then, they belong to the second class of signs, those by physical connection.[2]

This emphasis on the index, on the 'physical connection', and on the trace and its inscription, lie at the heart of Roland Barthes' essay, *Camera Lucida*. He describes the photographic process as the printing of luminous rays emitted by an object on photosensitive material. Thus, in spite of all possible human interference, it is this characteristic that differentiates photography from other forms of representation. 'It is as if the Photograph always carries the referent within itself'.[3]

Without using the semiotic terminology of *Camera Lucida*, Bazin is clearly evoking the indexical aspect of the photograph and his interest is close to Barthes': 'The photograph as such and the object itself share a common being, after the fashion of a finger print. Wherefore, photography actually contributes something to the order of natural creation instead of substituting for it.'[4]

For both Bazin and Barthes, the photograph's beauty and emotion lies in its 'thereness', the fleeting presence of a shadow, which is captured and saved. Bazin says: 'all the arts are based on the presence of man, only photography derives an advantage from its absence. Photography affects us like a phenomenon of nature, like a flower or a snowflake whose vegetable or earthly origins are an inseparable part of their beauty.'[5]

The index, the photograph and time

When rays of light inscribe an object's image onto photosensitive paper at a particular moment, they record the object's presence but they also inscribe that moment of time, henceforth suspended. Although, once again, Bazin does not, in so many words, draw specific attention to the temporality of the photograph, its importance recurs implicitly throughout the 'Ontology' essay and specifically as an aspect of indexicality:

> The photographic image is the object itself. The object freed from the conditions of time and space which govern it … [the photographic image] shares, by virtue of the very process of becoming, the being of the model of which it is the reproduction: it is the model.
>
> Hence the charm of family albums. Those grey or sepia shadows, phantomlike and almost indecipherable, are no longer traditional family portraits but rather the disturbing presence of lives halted at a set moment in their duration, freed from their destiny; not however by the prestige of art but by the power of an impassive mechanical process: for photography does not create eternity as art does, it embalms time, rescuing it simply from its own proper corruption.[6]

In *Camera Lucida* Barthes reflects on the photograph's relation to time but also to tense. He suggests that the photographic image records absence and presence simultaneously: 'What I see has been here, in this place which extends between infinity and the subject (operator or spectator); it has been here and immediately separated; it has been absolutely irrefutably present, and yet already deferred.'[7]

Barthes also identifies an affinity between photography and the deictic aspect of language, the point, that is, where tense and gesture nearly meet and which gives a grammatical form to actual physical relations of time, space or person. The terms 'this' and 'that', 'here' and 'there', 'now' and 'then' inscribe given spatial relations at a specific moment of time, governed by the position of the speaker. Barthes points out that the photograph travels across space and time so that deictic reference becomes merged or superimposed: then it was 'there' at its moment of registration, that moment is now 'here'. He sums up photography's essence as the 'what has been' (the 'That-has-been').

Ann Banfield, writing from a linguistic point of view, suggests that this is a point at which spoken language may simply not be adequate to the complexity of the photograph's tense: 'Like Proust, Barthes's effort is to find the lingusitic form capable of recapturing a present in the past, a form that it turns out spoken

language does not offer. This *now in the past* can be captured not by combining tenses but by combining a past tense with a present time deitic: the photograph's moment *was now*.'[8] She draws on novelistic tense structure to argue that the 'was' needed to imply 'a now in the past' would become: 'This was now here.' These markers of time and place return to Barthes' original conundrum: the photograph is 'an emanation of past reality'. She says 'This was now here' stands for "an emanation of past reality".[9] The photograph pushes language and its articulation of time to a limit leaving the spectator sometimes with a slightly giddy feeling, reminiscent of a *trompe l'œil* effect.

The photograph, time and death

In the 'Ontology' essay, Bazin begins by identifying the origin of art, of the making of likenesses, as the human being's attempt to overcome death. Then he identifies the death mask as the origin of images made from a direct imprint, tracing the practice back to the 'mummification' of bodies in ancient Egypt. The death mask is, of course, an indexical sign; the image is left by an actual imprint of the original object. He says: 'Death is but the victory of time. To preserve the bodily appearance artificially is to snatch it from the flow of time, to stow it neatly away, so to speak, in the hold of life'.[10] This process, holding time and preserving the actual features of the dead person through an imprinted image, would, Bazin argues, be realised finally and perfectly with photography. Photography would thus take over a function that art had struggled, in the meantime, to fulfill. This sweeping history of art, its relation to death and to photography, takes up only a few paragraphs of the 'Ontology' essay.

In *Camera Lucida*, the presence of death in the photograph is a pervasive and recurrent theme, approached from different angles. But at one point Barthes makes a rare move into comment on the history of photography, reflecting on the coincidence of its origins with the decline of religion and suggesting that, with photography, death is inscribed into life without the mediation of religion or ritual:

> All those young photographers who are at work in the world, determined upon the capture of actuality, do not know that they are agents in the capture of death … for my part I should prefer that instead of constantly relocating the advent of photography in its social and economic context, we should inquire as to the anthropological place of death and the new image. For death must be somewhere in a society; if it is no longer (or less intensely) in religion it must be elsewhere; perhaps in this image which produces death while trying to preserve life. Contemporary with the withdrawal of rites, Photography may respond to the intrusion, in our modern society, of an asymbolic death, outside of religion, outside of ritual, a kind of abrupt dive into literal death. Life/Death; the paradigm is reduced to a single click, the one separating the initial pose from the final print.[11]

Camera Lucida gradually reveals its emotional core. Barthes uses his mourning for his recently deceased mother as the context for his reflections on photography. The

themes of time, the photograph and then death become clearer or, rather, more closely interwoven. Not only is the essence of photography, the 'That-has-been', subject to the passing of time within in the course of life, but this 'presence of absence' goes through a sea-change after the death of those depicted. 'That rather terrible thing that is there in every photograph: the return of the dead.' For both Barthes and Bazin, photography's inscription in time, its actual literalness, touches an essential human aspiration to do with death. For Bazin, it is to transcend death; for Barthes it is the dive into death.

Death and the uncanny

The simple paradox of the photograph, that the moment of time it preserves becomes an image of life after death, has attracted the attention of many commentators. As Raymond Bellour puts it: '[The photographic instant] can only be called meaningful in relation to the reversal of time and the generality of death of which it is the trace and the trauma, the secret subject that doubles the apparent one'.[12] Photography blurs boundaries so that the question of time in the photograph, which leads to the presence of death in the photograph, then shifts towards the presence of life after death. In his 1919 essay ' The Uncanny', Freud identifies this boundary between life and death as one at which the human mind, even the least superstitous, baulks so that it becomes the site of intractable uncanniness.

Freud starts by taking issue with Ernst Jentsch's 1906 article 'On the Psychology of the Uncanny'. Jentsch had argued that 'intellectual uncertainty' was a key element in creating the kind of shudder that he was attempting to analyse. He concentrates particularly on the 'doubt as to whether an apparently living being is animate or, conversely, doubt as to whether or not a lifeless object may in fact be animate.'[13] An interesting number of the examples he uses are from the entertainments of illusion that proliferated in the nineteenth century: 'The unpleasant impression is well known that readily arises in many people when they visit collections of wax figures, panopticons and panoramas. In the semi darkness it is quite often difficult to distinguish a life-size wax or similar figure from a human person.'[14] He also mentions the uncanniness of automata in both life and as an effect in fiction.

In the first section of his article, Freud argues that Jentsch's emphasis on novelty and unfamiliarity is misplaced and, implicitly, unpsychoanalytic, due its lack of attention to the past in the formation of the individual unconscious. He emphasises the importance of 'return' in the uncanny and, rather than arising from present confusion, it 'leads back to what is old and long familiar, lost through repression.' For instance, he goes to some length to argue that the uncanniness at the heart of E. T. A. Hoffmann's 'The Sandman' is due to castration anxiety not to the presence of the beautiful automaton, Olympia, who for Jentsch would represent the blurred boundary between the animate and inanimate, the organic and the inorganic. This concern leads Freud away from illusions and inventions back to the more ancient

symptoms of a popular uncanny. Here he moves closer to Jentsch. Both identify belief in a spirit world, ghosts and an animistic understanding of nature as belonging to the intellectually unsophisticated. Freud argues that, alongside the legacy of the individual psyche, uncanniness may return in beliefs or thoughts that have persisted from our pre-history: 'Nowadays we no longer believe in them, we have *surmounted* these modes of thought; but we do not feel quite sure of our beliefs, and the old ones still exist within us ready to seize on any confirmation. As soon as something *actually happens* in our lives which seems to confirm the old discarded beliefs we get a feeling of the uncanny.' [15]

As Freud almost acknowledges in this passage, new inventions, technologies that are difficult to grasp immediately, may precipitate a resurgence of irrational belief. Although Freud, of course, does not mention photography there is a key passage in 'The Uncanny' in which he acknowledges that in the human attitude to death: 'discarded forms have been so completely preserved under a thin disguise'. And he goes on to say, in an interesting reference to his own contemporary, not primitive, society:

> It is true that the statement '*All men are mortal*' is paraded in the text books of logic as an example of a general proposition; but no human being really grasps it, and our unconscious has as little use now as it ever had for the idea of its own mortality ... In our great cities, placards announce lectures that undertake to tell us how to get in touch with the souls of the departed; and it cannot be denied that not a few of the most able and penetrating minds among our men of science have come to the conclusion, especially towards the close of their own lives, that a contact of this kind is not impossible.[16]

Finally, he comments towards the end of the article, with an implicit return to Jentsch's original argument: 'Are we justified in ignoring intellectual uncertainty as a factor, seeing that we admitted its importance in relation to death?' [17]

Tom Gunning, in his fascinating study of ghost photography in the mid-nineteenth century, has analysed the way that new technologies can, paradoxically, enable and revive irrational belief. He points out that The Spiritualist Movement related their revelations to new technologies, to electricity, telegraphy, chemistry etc. It was precisely the strangeness of photography as a new technology that allowed Spiritualists to make, and for their followers to believe, in ghost photographs. This sense of a 'technological uncanny', always only a passing moment, chimes with Jentsch's 'intellectual uncertainty'. Gunning comments:

> It is hardly surprising that Spiritualism would eventually intersect with photography. That photography could create a transparent wraith-like image (if the plate were double exposed or if the figure moved before a full exposure had been made) ... That such images could display the iconic accuracy and recognisability of photographic likenesses and at the same time the transparency and insubstantiality of ghosts seemed to demonstrate the fundamentally uncanny quality of photography, its capture of a spectre-like double.[18]

While the Spiritualists could enable the bereaved to exploit their 'intellectual uncertainty' about the finality of death, while Freud could see that 'intellectual uncertainty' allowed the ego to cling to its fantasy of immortality, Barthes finds, in the photographs that move him, a presence of life after death and, in photographs of himself, an intimation of his own mortality.

The uncanny and the index

Expressions of paradox and ambivalence recur throughout both Bazin's and Barthes' essays. For Bazin, the photograph is 'an image that is a reality of nature, namely an hallucination that is also a fact'.[19] To recapitulate passages quoted earlier, Bazin's use of language indicates the way in which, for him, the photograph's indexicality almost literally 'haunts' the blurred boundary between life and death. He uses words and terms that evoke the ghostly, for instance: the shadows, phantom like ... the disturbing presence of lives halted ... the mechanical process, which embalms time against corruption. For Barthes, his persistent astonishment at the photograph; 'reaches down into the religious substance of which I am moulded; nothing for it: Photography has something to do with resurrection: might we not say of it, as the Byzantines said of the image of Christ which impregnated St.Veronica's napkin: that it was not made by the hand of man, *acheiropoietos*?'[20]

It is difficult to encapsulate Barthes' very complex line of thought. His ideas forge links between: the indexicality of the photograph, its inscription in and of time, to hallucination, the photographic image as a 'return of the dead', and a resonance between photography and religion itself. In the process, he takes his argument from the photograph on the side of a material trace of the natural to the photograph on the side of 'intellectual uncertainty'. From, that is, a usual association between the photograph and its 'being there', its assertion of a once upon a time moment that existed in the world, to human perplexity in the face of death which is always drawn towards irrationality and the need to believe.

Bazin's 'Ontology' article is almost like a manifesto for his realist aesthetic. Although his main area of interest and passion was the cinema, the 'Ontology' article reveals, crucially and explicitly, the foundation of his aesthetic on photographic indexicality. And fundamental to his evaluation of the index was his Catholicism. Peter Wollen has pointed out the logic behind these connections, one that pre-supposes the place of God in nature and the soul in man. He says:

> Realism, for Bazin, had little to do with mimesis ... It was the existential bond between fact and image, world and film, which counted for most in Bazin's aesthetic, rather than any quality of similarity or resemblance. Hence the possibility – even the necessity – of an art which could reveal spiritual states. There was for Bazin a double movement of impression, moulding and imprinting: first the interior spiritual suffering was stamped upon the exterior physiognomy; then the exterior physiognomy was stamped and printed on the sensitive film.[21]

It is possible to imagine that Barthes had Bazin in mind when he makes this commitment of principle: 'Nothing can prevent the Photograph from being analogical; but at the same time, Photography's *noeme* has nothing to do with analogy (a feature it shares with all kinds of representations). The realists, of whom I am one ... do not take the photograph for a 'copy' of reality, but for an emanation of *past reality*: *a magic* not an art.'[22]

It is the *indexical* aspect of the photographic sign, located as it is in a preserved moment of time, that allows these movements to take place across the boundaries between the material and the spiritual, reality and magic and between life and death. From this point of view, the most material aspect, the physical link between object and image gives rise to the most elusive and ineffable properties of this particular sign. The photographic index, the most literal, the most banal of signs, inscribes into itself the clouded point at which even Freud allows that the uncanniness of intellectual uncertainty persists into the frame of 'civilisation'.

The camera machine makes its own contribution to the photographic uncanny. Both Bazin and Barthes dwell on the fact that the photograph: is 'not made by the hand of man' and is 'a mechanical reproduction in the making of which man plays no part'. In her discussion of *Camera Lucida,* Ann Banfield argues that the lens always sees more than the photographer: 'This sight is a sight reduced to the simply seen, from whose subjective image – the this-was now here – all subjectivity that requires a subject, an I, is eliminated.'[23] She suggests that, just as the photograph's relation to time goes beyond a simple equivalence in the grammar of tense, so the autonomy of the camera eye displaces the grammar of person.

In the last resort, the relation between photography and the uncanny must lie in the conjunction of two ideas. The 'intellectual uncertainty' of death, itself beyond meaning or understanding, merges with the 'intellectual impossibility' of reducing the photograph to language and meaning. Barthes' concept of the 'punctum' brings the two, roughly speaking, together. The studium coincides with the photographer's intention and the intrinsic, unified, interest the photograph represents as a whole. The punctum is outside the photographer's control and emanates out of the inscription of time and thus death, on the one hand, and, on the other, some detail, mechanically recorded by the camera, unnoticed by the photographer, which captures and fascinates the spectator. It is Barthes' punctum that proves that the photograph 'affects us like a phenomenon of nature' (Bazin) and 'is not made by the hand of man' (Barthes). Once again, the punctum touches emotion and fascination that can be evoked but, ultimately, cannot be put into so many words. Ann Banfield cites Barthes: 'Something in the image, as revealed by the photograph, leads one "to confront in it the wakening of intractable reality".'[24]

Coda

Jeff Wall's use of the studio, constructed tableaux and computer generated images in his photographs, is, for me, reminiscent of the painterly tradition that followed

photography's birth. Helmut Gernsheim points out that the pictorialist Henry
Peach Robinson's procedure in constructing, for instance, 'The Lady of Shalott' in
1861,

> was to build up the picture in stages. After making a preliminary sketch of the compo-
> sition he photographed individual figures then cut them out and pasted them sepa-
> rately onto the separately photographed foreground and background. After careful
> retouching … the whole picture was rephotographed for the final version'[25]

Robinson had been a painter before he started to work with photography. He used
photography to emulate the Academic aesthetic of the period and, unlike many
other contemporary practioners, he was quite indifferent to its relationship to time.

However complex his procedure, Jeff Wall uses and reflects on time in photog-
raphy. He uses the painterly possibilities of new image- making technologies not to
capture an instant but to analyse and reflect on the significance of the instant for
photography. For example, 'A Sharp Gust of Wind (After Hokusai)' (1993), creates
the illusion of a 'perfect moment'. As in the Hokusai original, the wind has sud-
denly disrupted the passers-by on a little bridge; one turns to watch his hat blow
sky high alongside an 'arabesque' of floating papers. While the image seems to refer
to the tradition of Cartier Bresson, the decisive moment then strikes the spectator
as being too perfect. The apparent spontaneity of nature is being performed in a
staged tableau. A celebration of photography's unique relation to time is trans-
formed into a creative reflection on time and photography by complex staging and
subsequent manipulation. The photograph makes the spectator hesitate and assess
its *trompe l'œil* effect. Furthermore, as in my own case, the source of the *trompe
l'œil*, the 'too perfectness', may be difficult to understand at once, and I felt a sensa-
tion similar to the intellectual uncertainty Jentsch associated with the uncanny.
Uncertainty about the technology gave way to an intellectual curiosity about the
photograph's central idea.

In a number of his photographs, Jeff Wall touches themes close to the popular
uncanny, particularly the blurred distinction between the animate and the inani-
mate, for instance, with *A Ventriloquist at a Birthday Party in October 1947* (1990) and
The Vampires' Picnic (1991). However, for me, *Dead Troops Talk (A Vision After an
Ambush of a Red Army Patrol, near Moqor, Afganistan, Winter 1986)* (1992), an ani-
mated conversation between corpses juxtaposes and references the index and the
uncanny. Such a representation of the 'living dead' evokes, almost parodies, the pres-
ence of the living dead that both Bazin and Barthes see as specific to the photograph's
temporality and indexicality. This kind of reflection back on photography can, per-
haps, only be achieved in an image in which 'that was now' is no longer of the essence.

Time, image and terror

Peter Wollen

I had been leafing through some German essays on art history when I came across a 1799 translation of Goethe's 'Observations on the Laocoön' – the great Hellenistic sculpture now in the Vatican Museum (Figure 16). This essay was originally published as the lead article for the first issue of Goethe's own short-lived journal, *Propylaen*, which had appeared the previous year, in October, 1798.[1] It is generally regarded as a rearguard defence of neo-classicism in the face of the ever-rising wave of romanticism. In this reading, Goethe sets out to show how the neo-classical ideals of grace, beauty and dignity are quite compatible with the representation of tragic suffering. The facial distortion caused by a scream of agony would be incompatible with the requirement of serene and harmonious beauty – and yet the terror experienced by Laocoön can still be adequately represented.

Goethe, I learned, had already written on the same subject thirty years earlier, back in 1767.[2] At that time, he explained Laocoön's apparent calm on more mundane terms – 'To lessen the pain, the lower part of the torso was drawn in, which made screaming impossible.' Now, faced with the need to defend neo-classical aesthetics, he took a different line. When I first read Goethe's article, however, I was struck by a rather different observation. Going back to Aristotle (as a neo-classicist should), Goethe temporalised the statue of Laocoön in his description of it. He characterised the sculpture as representing a subject 'in motion' rather than 'in repose' and then differentiated it into three separate moments, corresponding to the three figures shown in the work – Laocoön himself, shown in the centre, and his elder and younger sons, shown respectively to his left and to his right (the reverse, of course, for us as viewers).

When 'a work ought to move before the eyes', Goethe noted, 'a fugitive moment should be pitched upon; no part of the whole ought to be found before in this position and, in a little time after, every part should be obliged to quit that position; it is by this means that the work be always animated for millions of spectators.' There seems to be nothing very new here – Goethe's 'fugitive moment' is plainly Lessing's 'pregnant moment' (defined in his own famous text on the Laocoön sculpture)[3] and, in our time, we recognise it as Cartier-Bresson's 'decisive moment' – although I was struck by the phrase, 'millions of spectators'. More so when I read the next paragraph:

To seize well the attention of the Laocoön, let us place ourselves before the group with our eyes shut, and at the necessary distance; let us open and shut them alternately, and we shall see all the marble in motion; we shall be afraid to find the group changed when we open our eyes again. I would readily say, as the group is now exposed, it is the flash of lightning fixed, a wave petrified at the instant when it is approaching the shore. We see the same effect when we see the group at night, by the light of flambeaux.

It is the movies, of course – the alternating light and darkness, the to and fro of the shutter, the flickering image. The statue appears to Goethe somehow as if it were a freeze-frame, grabbed out of an ongoing sequence present in the imagination – even, perhaps, the perception – of the viewer. I was reminded of Jonathan Crary's chapter on Goethe and 'subjective vision', in his book, *Techniques of the Observer*.[4] Crary places Goethe at the 'threshold of modernity' in his realisation that 'knowledge was conditioned by the physical and anatomical functioning of the body and, perhaps most importantly, of the eyes.' Crary is particularly attracted to Goethe's interest in after-images, but his physiological-optical approach to the Laocoön

16 *Laocoön*, Hellenistic original,
1st century, marble, 210 cm,
Vatican Museums and Galleries,
Vatican City, Italy/Index

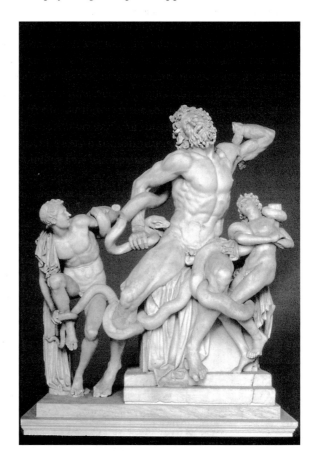

sculpture is plainly in the same family. As Crary points out, it is linked to the stroboscope, the zoetrope and the other optical devices which eventually led to the cinematograph.

Goethe pushes his temporalisation of the sculpture still further in the analysis of its dramatic structure. He describes the three figures as caught in successive stages of the serpents' attack which will eventually kill them all. The elder son is 'only interlaced at his extremities'; the younger son is in a worse situation – one of the two serpents has wrapped itself around his upper body and he is attempting to fend off its attack, as it prepares to bite him; the father, finally, is locked in a fierce struggle with the other serpent, which is already biting him. Goethe is surprisingly specific about the bite – 'the serpent has not bit, but he bites'. The father's physical posture can be explained by 'the momentaneous sensation of the wound'. What we see, in fact, is Laocoön's instant reflex reaction to the sensation of the bite – 'the body flies towards the opposite side, and retires; the shoulder presses downwards, the chest is thrust forward, and the head inclines on the side which has been touched'. The instant of the bite is the pivotal moment.

Goethe is extremely insistent on this point: 'I repeat it – the point of the bite determines the actual movement of the members; the flight of the inferior part of the body, its contraction, the chest which advances, the shoulder which defends, the movement of the head, and even all the features of the countenance, are, in my opinion, decided by this momentaneous, painful and unexpected irritation.' The feet and arms, however, still reflect an earlier stage of the attack, as Laocoön struggles to free his limbs from the serpent's coils.

Following a similar train of thought, Goethe characterises the responses and postures of the two sons in terms of 'graduated situations' (Goethe's own term). The younger son has not yet been bitten, not yet been fatally wounded – he is making an unavailing effort to alleviate a 'present evil, and prevent a greater one' (that is, to prevent the second serpent's bite). The elder son is not yet in pain, only his foot is caught. His role is primarily that of an observer ('a witness who takes part in the action'). His response is determined by the sight of his father's agony. 'The movement of the father', in Goethe's words, has 'inspired the eldest son with horror'.

It is at this point in his analysis that Goethe goes back to Aristotle. He shifts his focus from the temporal structure of the participant's involvement in the action in order to discuss the dramatic effect on the spectator. As we would expect, here too he proposes a tripartite structure – the specific situation of each of the three victims provokes a different response from the viewer. I shall quote this section at some length, because it is central to the argument I hope to develop:

> In his own sufferings, and those of another, man has only three sensations, fear, terror, and compassion: he foresees with inquietude the evil which approaches him [i.e. fear], he perceives on a sudden an evil which strikes him [i.e. terror], and he takes part in the suffering which yet remains, or which has already passed; all the three are represented and excited by this monument, and even by the most suitable gradations.

The arts of design, which always labour for the moments when they choose a pathetic subject, will seize that which excites terror, poetry on the contrary, will choose those which excite fear and compassion. In the group of Laocoön, the sufferings of the father excite terror to the highest degree; sculpture has done in it all that it could do; but, either for the sake of running through the circle of all human sensations, or of moderating the violent impression of terror, it excites compassion for the situation of the youngest son [trapped], and fear for that of the eldest [threatened]; leaving yet some hope for this last. It is thus that the ancients gave, by variety, a certain equilibium to their works; that they then diminished or strengthened an effect by other effects, and were able to finish an intellectual and sensible whole.

The temporal equation runs as follows:

> Evil which directly threatens its subject – fear [as displayed by the younger son]
> Evil which suddenly strikes its subject – terror [as displayed by Laocoön himself]
> Evil witnessed, inflicted on another – pity [as displayed by the elder son].

The witness, it goes without saying, cannot as yet be severely threatened himself or he would not be able to identify with the suffering of another, because he would necessarily be preoccupied with his own fate. It is also worth noting that Goethe makes no clear distinction between 'fear' and 'inquietude' or anxiety. I shall return to this point later. For the moment, however, I want to stress that, despite his commitment to the concept of the 'fugitive' or pivotal moment, Goethe still sees the Laocoön sculpture in both narrative and dramatic terms, describing the spectator's response in terms of a graduated series of emotional states, provoked in turn by the specific temporal situation of each participant in the action. It is this which enables him to accept 'terror' as the primary emotion – the one we feel for Laocoön himself – since it is moderated by the successive emotions of 'fear' and then 'compassion' which we feel with the two sons. Thus the neo-classical aesthetic appears to be saved.

Goethe, however, raises a rather different issue when he invokes the distinction between 'the arts of design', on the one hand, and poetry, on the other. This distinction, of course, is the central motif of Lessing's great work on Laocoön, first published in 1776, just over twenty years before Goethe's text. Lessing's book was subtitled 'Laocoön or the Limits of Painting and Poetry'[5] and set out to show the differences between the arts of space and simultaneity, on the one hand, and those of time and succession, on the other. Painting represents 'subjects which, or the various parts of which, exist side by side'. These subjects we may call 'bodies'. Poetry, in contrast, represents 'subjects which, or the various parts of which, succeed each other. These we may in general call "actions"'. Bodies, then, are the proper subjects of painting and the spatial arts, the arts of design. Actions, conversely, are the proper subjects of poetry and the temporal arts.

This is all very clear-cut and logical. Lessing goes on, however, to muddy the waters a little. 'Yet all bodies', he observes, 'exist not in space alone, but also in time. They continue, and may appear differently at every moment or stand in different relations. Every one of these momentary appearances and combinations is the

effect of one preceding and can be the cause of one following, and accordingly be likewise the central point of an action. Consequently, painting can also imitate actions, but only by way of suggestion through bodies.' It is from this proposition, of course, that Lessing goes on to develop his idea of the pregnant moment, 'from which what precedes and follows will be most easily apprehended', thus reintroducing the temporal dimension into the spatial arts. He later continues his argument in an unexpected direction, when he comes to discuss ugliness. The problem which he faces is that fear, terror and compassion all follow from unpleasant events, the representation of which could be considered ugly.

The subjects of tragic suffering, then, are inevitably ugly to look at and their representation, we might therefore be tempted to conclude, should be restricted to the temporal arts where, in Lessing's words, 'the ugliness of forms does by the transmutation of their co-existing parts into successive parts lose its unpleasant effect almost entirely; from this point of view, it ceases, as it were to be ugliness, and can therefore ally itself more intimately with other appearances in order to produce a new and distinct effect'. Not so with painting or sculpture, where the unpleasant imagery will inevitably get the upper hand and end by disgusting the spectator.

It is at this point that, remembering Goethe's stroboscopic perception of the Laocoön sculpture, I would like to turn to the question of cinema and the moving image. Cinema, evidently, is a mixed art, which combines both simultaneity in space and succession in time, in which, therefore, terror can be represented without simply causing disgust, in Lessing's terms, at least. In fact, when we look at the early history of the cinema, we find a positive predilection for terror, running from Porter's *Life of an American Fireman* (1906) up to and including Griffith's *Birth of A Nation*. This sequence of films is characterised by scenes of terror, suspense and then rescue. Indeed, when Griffith first auditioned Lillian Gish, he conjured up for her just such a scene – she is trapped in a room, violent intruders are breaking through the wall, she is cowering in the corner, they are going to seize hold of her … all the while firing a gun in the air and not satisfied until she burst into tears. Terror is inscribed in narrative film from its very earliest years.

In fact, I would like to argue that the language of film itself derived largely from the need to represent terror both in space and time. As Stephen Bottomore has pointed out,[6] the firemen-to-the-rescue film played an absolutely crucial role in the development of continuity editing and Porter's *Life of An American Fireman* is a standard example of what André Gaudreault has called 'rudimentary cross-cutting'.[7] Griffith simply developed the same trend further, to great dramatic effect. In Griffith's films the close-up is associated directly with terror – we might remember Jacques Aumont's description of 'Brown Eyes, the heroine of the "Saint Bartholomew" [massacre] episode in *Intolerance*; at the moment when she is about to die – think of her eyes, those of a strangled rabbit, rolling in the corners of their sockets' or the same author's invocation of their 'obscenity' or, as with

Lessing, their 'horrible ugliness'.[8] The function of the close-up in Griffith's films is to focus our attention purely on the movements of the individual face, its specific response to terror, while interrupting the flow of 'whole-body' and group action and abstracting us spatially from deep space as a container of objects and characters.

The same trend can be seen to good effect in the films of Alfred Hitchcock, the cinema's supreme master of pure film technique. His films typically revolve around scenes of terror. The most notorious, of course, is that of the shower-bath murder in *Psycho*, in which the motel murder of the heroine is represented by a staccato series of close-ups, culminating in those of the heroine-victim's terrified face. According to Janet Leigh, the actress playing the part, her character, Marion, a thief, 'had decided to go back to Phoenix [the scene of her theft], come clean, and take the consequences, so when she stepped into the tub it was as if she were stepping into the baptismal waters. The spray beating down on her was purifying the corruption from her mind, purging the evil from her soul. She was like a virgin again, tranquil, at peace. If I could convey this to the audience, the attack would become even more horrifying and appalling.'[9]

In the shower-bath sequence Hitchcock combined shock, creating terror, with mystery, creating anxiety (or inquietude) and suspense (creating fear and pity). Hitchcock distinguished carefully between mystery and suspense – 'mystery is an intellectual process, like in a "whodunit". But suspense is essentially an emotional process. You can only get the suspense element going by giving the audience information.' The Hitchcockian distinctions between mystery, suspense and shock run in close parallel with the distinctions which Freud (ever the philologist) made, in 1920, between anxiety, fear and fright. 'Fright, fear and anxiety', Freud wrote in *Beyond The Pleasure Principle*, 'are improperly used as synonymous expressions; they are in fact capable of clear distinction in their relation to danger. 'Anxiety' describes a particular state of expecting the danger or preparing for it, even though it may be an unknown one. 'Fear' requires a definite object of which to be afraid. 'Fright', however, is the name we give to the state a person gets into when he has run into danger without being prepared for it; it emphasises the factor of surprise.'[10]

In this Freudian schema, anxiety is clearly the emotional state which corresponds to mystery, where the source of danger is unknown; fear corresponds to suspense, where the source is known; and fright corresponds to terror, where danger is run into without any emotional preparation. Anxiety, Freud believed, helped ward off fright. In the absence of the kind of preparedness for danger which anxiety produced, fright was much more likely, and, following the experience of fright, which disabled the psychic defences of the sufferer, lasting trauma could result.

This analysis also corresponds quite closely to Goethe's distinction between terror, which comes from surprise and lack of preparedness, and fear, which derives from a known and imminent source of danger. Pity, it is perhaps worth adding, was regarded by Freud as having a narcissistic origin. He pointed both to

the etymological sense of 'mitleid' or 'sympathy' – literally, 'suffering with' – as well as his analysis of a patient whose pity for cripples he related to his neurotic fear of his father as a possible future castrator. For Hitchcock, of course, 'suffering with' was also an essential component of the suspense mechanism, as the viewer identi-fied with a potential victim in the face of impending danger.[11]

Looked at in this way, Goethe's analysis of the Laocoön can readily be translated into Freudian terms – the father, Laocoön himself, is suffering from traumatic shock, following the emotion of fright, produced by the serpent's unexpected attack. The elder son is suffering, as Goethe described, from fear and the younger, potentially under attack himself, diverts his own narcissism into compassion for his father, whose agony he witnesses. In fact, the Aristotelian underpinnings of Goethe's analysis can also be transposed into the Freudian register – tragedy then becomes structured around the trauma caused by unexpected calamity (or shock, in Freud's sense). Witnessing this trauma then evokes fear and pity – narcissistic fear that the same fate could strike the observer and pity, its projective translation into compassion for the other.

The underlying question still, of course, remains – how can narrative function effectively except in a time-based art such as film or the novel. Even within the Aristotelian context, how can an atemporal art represent reversal ('peripeteia') or tragic downfall. Lessing and Goethe, for instance, both assume that the viewer already knows the story of Laocoön, having once read the classical texts – and yet how many people today, including connoisseurs of art, understand even that, for Lessing and Goethe, it was Laocoön's tragic downfall that led directly to the cata-strophic Fall of Troy.

Laocoön, in the Virgilian version of the story known to them, was a Trojan priest who had warned his fellow-citizens not to permit the wooden horse to enter Troy. The snakes were sent, by Apollo and Artemis – pro-Greek – in order to destroy Laocoön and thus persuade the Trojans to admit the horse and seal their own fate. In fact, the assumptions of Goethe's interpretation seem to imply a pro-Trojan reading of the work – presumably a Greek would be pro-serpent, hence unlikely to see Laocoön as a tragic figure. Since the sculpture itself dates from Roman times, this might make more sense. After all, Aeneas, the founder of Rome, was a Trojan, who, I suppose, may himself have watched Laocoön's death from the battlements, felt the pity and the fear.

Goethe's doctrine of the pregnant or fugitive moment presupposes a complex dramatic reading of the Laocoön sculpture, one which is enriched by our ability to place the story in a narrative context, with a before and an after. His resort to the Aristotelian concepts of terror, fear and compassion more or less assumes that we should look on the sculpture as if it was founded on the practice and precepts of tragic drama. In a classical drama – or, indeed, in its twentieth-century equivalent, a moving picture – the scene of Laocoön's death would be the culminating pivot of the narrative, with the drawn-out siege of Troy as its premiss and the downfall of the city as its immediate aftermath.

It is at this point that we need to look more closely at the way in which drama and narrative function within a timeless representation like a sculpture. To do this, we need to return to Goethe's description of the work and to look at its semantic implications. The serpent 'has interlaced' the elder son's chest – an event has been completed. The son 'endeavours' to free himself – a process is ongoing. The serpent 'is on the point of sliding' underneath his hand – a process is anticipated. The father 'would employ force' – anticipation again. He 'grips one of the two serpents' – an ongoing state. The serpent, 'being now irritated' – an ongoing state resulting from a past action – 'bites him in the haunch … the serpent has not bit, but bites' – an ongoing process, begun but not yet completed. The bite has thus caused a series of movements, characterised as ongoing states or processes. Now the younger of the sons 'would extricate himself … would alleviate the present evil' – both goal-driven actions.

These distinctions are all aspectual – they depend on whether we read the visual forms as representing states, processes or events. Verbal aspects, in Bernard Comrie's formulation, 'are different ways of viewing the internal temporal constituency [or contours] of a situation'.[12] Aspectual differences include those between punctual and durative situations (with or without duration); between telic and atelic situations (with or without a goal); between continuous states and dynamic processes; between unbounded processes and events with beginnings and endings, and so on. Essentially, Goethe reads the sculpture in aspectual terms, distinguishing what he sees happening into categories such as I have just described. Conventional narrative, in contrast, tends to foreground tense as the primary temporal category – this happened, then that happened, until finally this other thing occurred and it was all over.

Narrative, in fact, tends to assume continuity and eventual completion. This is not the case with aspect. In fact, according to Talmy Givón in his analysis of tense, aspect and mode (in both Creole languages, with relatively basic syntactic structures, and in current English), past or anterior tense markers are more characteristic of the main line of narrative, a string of events related in their natural sequence of occurrence, whereas aspectual forms are more likely to be found in subsidiary descriptions or 'side-trips' within the narrative, or in short-term or habitual situations which form the 'background for the main events'.[13] It seems that, in the case of visual representations of narrative scenes, these typically backgrounded forms are now foregrounded. Static visual representations favour aspect rather than tense, presumably because they refer us specifically to conceptual types of action in time rather than to their specific location in a chain of continuous events. Such non-punctual types of action, moreover, can imply not only duration, but also change, causation, anticipation, and other more complex types of temporal category.

Thus, even in relation to a static representation we can properly use concepts such as suspense, anxiety, fear, and so on, which have a definite temporal dimension or 'constituency'. Time does not disappear from static forms like painting,

photography or sculpture. It simply appears in a form which precludes a consecu-
tive string of completed events. Instead it favours pivotal moments which carry
with them their own temporal presuppositions and implicatures. Indeed,
Goethe's mode of interpretation reduplicates the cinematic and temporal logic of
the Kuleshov effect, another crucial moment in the development of film language.

Kuleshov, many of you will remember, constructed a short film–strip which jux-
taposed images of an impassive 'mask' face with images of a bowl of soup, a coffin, a
young child, and so on, and elicited responses from viewers who described the
same 'mask' face as showing (respectively) hunger, grief and delight.[14] Thus
Laocoön's countenance, his facial expression, which Winckelmann described as
'without passion'[15] and Lessing worried might mistakenly be seen as 'stoic', could
be described by Goethe in the following terms: 'Methinks I also see the inquietude,
the fear, the terror, the paternal affection, moving in those veins, swelling in that
heart, wrinkling that front' although, as he immediately admits, the artist has rep-
resented 'the most elevated degree, both of corporeal suffering and of intellectual
sufferings.' Kuleshov would have been delighted – the 'highly elevated' mask-like
face is nonetheless read as representing extremes of emotion.

Before concluding, I would like to take a leaf from Lessing's book. In Section
XX of his *Laocoön*, he begins, 'I rather turn gladly to my own road, if a rambler can
be said to have a road.' I want to conclude my own rambling path by retracing my
steps to Goethe's idea that the Laocoön sculpture was best seen by the flickering
blight of flambeaux. In fact Goethe subsequently planned to write a full article for
the *Propylaen* on the subject of viewing statues by torchlight. As I noted near the
beginning of this talk, his interest in the flicker effect of alternating light and dark-
ness, relates both to the beginnings of the cinema and to the development of an
active, rather than passive, theory of human perception. I believe that Goethe's
mode of interpretation reflects the same kind of impetus.

In contrast to Winckelmann or Lessing, Goethe, despite his neo-classicism, is in
fact interested in giving a dramatic, rather than an aesthetic interpretation of the
sculpture. He wants to vitalise it, to animate it, to create a lively sensation of the
dramatic nature of the event, rather than a formal crystallisation. He believes that
he is right to do so. He wants, in fact, to cinematise it, to see there in movement the
dramatic climax of a tragic narrative. In his use of the term 'fugitive moment', he
has already made a significant departure from Lessing's 'pregnant moment', one
which pre-supposes an accelerated sense of time passing, which takes us away from
the neo-classical concept of harmonious beauty towards the impression of
shocking and suspenseful terror.

Lessing believed that 'as this single moment receives from Art an unchangeable
continuance, it must not express anything which thought is obliged to consider
transitory. All phenomena of whose very essence, according to our conceptions, it is
that they break out suddenly and as suddenly vanish, that what they are can be only
for a moment – all such phenomena, whether agreeable or terrible, do, by the per-
manence which Art bestows, put on an aspect so abhorrent to Nature that at every

repeated viewing of them the impression becomes weaker, until at last the whole thing inspires us with horror and loathing.' As a result, artists should restrain from showing fugitive moments which can only appal us when they are represented in an unchanging medium. Goethe, in contrast, sought to intensify the effect of fugitive flickering, to anticipate a time when images would actually move. I believe that Goethe might even have appreciated the shower-bath murder in *Psycho*.

AN INSEPARABLE LINK
BETWEEN TIME AND
THE IMAGE

'Time in the pure state': Deleuze, Proust and the image of time

Patrick ffrench

The distinction between philosophy and literature is one which the style of Gilles Deleuze makes it difficult to maintain with the certainty that the one is not internally inhabited by the other. If only one of Deleuze's books bears a title which marks it as concerning a single literary text, *Proust and Signs*,[1] the literary corpus, and significantly, Proust, return within other writings which bear titles marking them as dealing with other concerns. In this chapter I want to investigate the status of this return of fragments of the Proustian corpus, which do not function as a form of exemplification;[2] the fragments I will be looking at here are not signalled as coming from 'somewhere else' but are part of the texture of the writing on Leibniz, for example, or on Bergson, or on the cinema. They are sometimes signalled as citations, but without attribution, or appear seamlessly as part of the text. What is the status of these fragments of the Proustian body in Deleuze's writing on Leibniz, on the Event, or on Cinema?

One could postulate that a common concern, with time, characterises Deleuze's thinking about Leibniz, Bergson, and Proust. The early book on Proust elaborates a perspective on the novel that is Leibnizian and Bergsonian, while the book on Leibniz (the most recent in terms of chronology)[3] picks up elements from the earlier reading of Proust to illuminate and generate its conceptualisation of the monad and of the event; the second Cinema book,[4] which structures itself like the first around commentaries on Bergson, reactivates the earlier writing on Proust and time in its consideration of the *crystal image*. Fragments of the Proustian corpus thus function in a kind of constellation of conceptualisations of time, with Bergson, Leibniz and the cinema of the Time-Image (the films, to name only a few examples, of Ozu, Welles and Resnais). I deliberately resist here the postulation that the early reading of Proust functions as a kind of 'primal scene' which gets repeated, returns, symptomatically, in later writings by Deleuze. Indeed I want to confront two possible theorisations of temporality: the first is Bergsonian, elaborated by Deleuze, which culminates in the notion of the *crystal image*, a point of bifurcation and indiscernability between actual and virtual, between the present and 'its' virtual past, contemporary with it. The second is Freudian, a temporality of haunting and return, of trauma and symptom. Both of these conceptualisations of time are

present in Proust's *In Search of Lost Time*; and they would give differing readings of the presence of Proust in Deleuze's work: symptomatic return, or crystal image of time?

Two fragments in particular are repeated: originally cited as part of the commentary on Proust's novel, *Proust and Signs* (1962); they return, unattributed, in *Cinema 2: The Time-Image* (1985), and in *The Fold: Leibniz and the Baroque* (1988). The phrases in question are: 'a fragment of time in the pure state',[5] and 'real without being actual, true without being abstract'.[6] The original context of Deleuze's commentary on them in the book on Proust will be elucidated in order better to negotiate their return in the subsequent works.

Deleuze, like other readers of Proust, conceives of *In Search of Lost Time* as the narrative of an apprenticeship, an orientation towards the future, a search for truth which is organised around different kinds of sign. Proustian 'truth', for Deleuze, is the result of an 'encounter', a violence done to thought through the sign. Involuntary memory, 'fortuitous yet inevitable',[7] expresses the force of this encounter. Voluntary memory, the intelligence, the will, are deficient, as Beckett had also affirmed;[8] truth is only accessible through an activity of translation which the subject is obliged to undertake subsequent to the encounter. *Proust and Signs*, originally published in the context of the rise of structuralist and semiological method, in the early 1960s, appears in one sense as a permutative, tabular model of different levels of sign and of time in the book. The apprenticeship moves through different levels of signs – worldly signs, sensuous signs, the signs of love, the signs of Art, the subject learning to decipher them, and different levels of temporality are associated with these signs. Thus: the worldly sign is a sign of 'Time that Passes'; the sign of love is a sign of 'Time Wasted'; the sensuous sign is a sign of 'Time Recovered at the Heart of Lost Time'; the sign of Art, at the top of the hierarchy and at the end of the apprenticeship, is a sign of an Original, Absolute Time.

The signs of art are superior in the hierarchy because they are signs of essences, while the other signs refer to or are associated with material things. Involuntary memory, the experience of the *madeleine*, for example, is still secondary, because the *madeleine*'s taste is still materially connected to the essence it contains: Marcel's childhood home Combray. The sign of art, on the other hand, is made of a spiritual matter '[so] ductile and kneaded' (*'si bien malaxé et effilé'*),[9] that it 'refracts' the pure light of essence.[10] The signs of art are made from a material peculiar to each essence, out of sound, for the musician, out of colour, for the artist, out of words, for the writer. We can recognise two such privileged signs of art in Proust's novel as the 'little patch of yellow wall' in Vermeer's painting 'View of Delft', and the 'little phrase' in Vinteuil's sonata.

It is, however, in relation to an experience of involuntary memory through the sensuous sign, rather than as a sign of Art, that Marcel uses the phrase 'a fragment of time in the pure state' (*'un peu de temps à l'état pur'*), in *Time Regained*. Sensuous signs are associated predominantly with the recovery of time at the heart of time lost. The experience of involuntary memory – *madeleine*, paving stone, starchy towel, establish

an identity between two moments, two presents, one that is now and one that has been present but is now past. The sensation includes within it, as if sealed within a hermetically sealed vessel,[11] the essence of a place: Venice, Combray, Balbec. This essence, however, is not just 'the past'. The ineffable joy that results is not simply due to the recovery of lost time. The essence recovered is not linked to any present that has been, but is a more original past, the pastness of the past which has never been present: the past itself. Marcel writes of the experience of involuntary memory that it reactivates a moment of the past, but hesitates: 'A moment of the past, did I say? Was it not perhaps very much more: something that, common to the past and to the present, is much more essential than either of them?'[12] The Bergsonian concept of the virtual, which is crucial to Deleuze's consideration of the Event and the crystal-image, lies behind Deleuze's reading of Proust here, and is explicitly noted: 'That the past does not have to preserve in itself anything but itself, because it is in itself, survives and preserves itself in itself, such are the famous theses of *Matter and Memory*. The being of the past in itself is what Bergson called the virtual.'[13] Deleuze thus forges a link between the Proustian 'past in itself' and the Bergsonian 'virtual'. If, as for Bergson, time is in constant bifurcation between the actual and the virtual, the Proustian experience of involuntary memory is the re-actualisation of the virtuality of a past present, the past 'as it survives and preserves itself in itself.' 'Time in its pure state', here, though it depends on a sensuous sign and on memory to bring it into the light, is equivalent to the virtual, or perhaps, more specifically, to the indiscernability between the actual and the virtual, the point of bifurcation, which Deleuze theorises in *The Fold* as 'the Event'. Time in its pure state is thus linked to the second phrase reactivated in Deleuze's writing, which occurs in the following context: 'But let a noise or a scent, once heard or once smelt, be heard or smelt again in the present and at the same time in the past, real without being actual, ideal without being abstract, and immediately the permanent and habitually concealed essence of things is liberated and our true self, which seemed – had perhaps for long years seemed – to be dead but was not altogether dead, is awakened and reanimated as it receives the celestial nourishment that is brought to it.'[14] The phrase expresses the idea that the essence recovered by the experience of involuntary memory is not simply the past moment that has been lost. We are not dealing with the simple remembering of a moment that is past but was once present, but with the 'very being of the past in itself', the virtual. It is real, because it is an experience, a Truth, but not actual, since not 'in' the present; it is ideal, since it derives from essence and from Truth and is independent of the material, but not abstract, since it is Real and experienced. Such a concept enables Deleuze to conceive an image of time as a series of forking paths or bifurcations between the 'actual' and the 'virtual' from the point of an original Event or pure state of time.

The temporality of the Event, of the indiscernability between actual and virtual, seems, though, to contrast with the temporality of return, of haunting, which has a more Freudian resonance. Walter Benjamin, in the essay, 'On some motifs in Baudelaire', and Jean-François Lyotard, in *Heidegger and 'the jews'*, elaborate a

perspective on memory, and specifically on Proustian involuntary memory, which draws Proust nearer to Freud than to Bergson. On the experience of shock, Benjamin writes: 'Put in Proustian terms, this means that only what has not been experienced explicitly and consciously, what has not yet happened to the subject as an experience, can become a component of *mémoire involontaire*'.[15] Lyotard, in *Heidegger and the 'jews'*,[16] drawing attention as I have to the potential tension between a Deleuzian vision of a time and a Freudian one,[17] points to Deleuze's book on Proust and specifically to its recognition of 'a past that is not past but is always there'.[18] The 'Proustian' hypothesis, as Lyotard calls it, is that an effect 'comes back' from a first blow or shock whose excess made it not 'have time and place in the psychic apparatus'.[19] In this conception, the fragment of time in its pure state is an element of experience which was not experienced 'in the present', not registered in consciousness. It functions something like 'shock' or 'trauma': it happened, was not represented, registered in consciousness, but leaves a trace, which is reactivated and 'experienced', as if for the first time, later. Such a pattern can be recognised in Marcel's recovered memory of his grandmother's death, some time after her 'real' death, instigated by the gesture of bending to tie his bootlaces, at Balbec.

One can ask here: is the experience of 'time in its pure state' the experience of a return of experience that was not registered or named, but nevertheless left a trace? The 'virtual', in this parallel, would correspond to the repressed, traumatic experience which exists alongside conscious representation, and which returns to disrupt it. These terms are also resonant with those of Derrida, in *Specters of Marx*,[20] for whom the spectre is 'beyond the living present', opens up the present to the haunting of the past and the future of what is 'to come' (*à-venir*).[21] The question remains if the Bergsonian terms of virtual and actual (and the Leibnizian notion of a multiplicity of possible worlds, which I discuss later) are congruent with the broadly psychoanalytic, post-structural temporality of repression, haunting and spectrality, in which what is not 'present' (conscious) is repressed, in which time is a time of return or of the trace.

Another contemporary French philosopher, Alain Badiou, has written, in a different manner and without explicit reference to Proust, on the status of the 'Event'. For Badiou the Event is unpredictable from within the order of Being and Knowledge,[22] yet it derives from 'the situation' without belonging to it. One can recognise the same gesture of 'being included yet not belonging' in 'real without being actual' or 'experienced without being represented'. All of these conceptualisations of temporality – in Badiou, in Deleuze (writing on Proust and Leibniz), and in Lyotard and Derrida, designate the Event as something incommensurable with the present situation in which it arises, without being the mark of an intrusion by a transcendent outside or beyond. It is immanent, related to an originary bifurcation or difference of possible worlds ('incompossible worlds' for Leibniz), or to a temporal delay determined by the 'unpreparedness of the psychic apparatus for the "first shock"',[23] or, as for Badiou, the Event is a futural intrusion of the immanent Truth of the situation it disrupts, and related to a *decision* or a *fidelity* on the part of

a subject, who nevertheless only perceives the Event as Truth of the Situation *after
the event*. While there is a post-structural motif common to these versions of tem-
porality – truth arising not through the visitation upon the subject of a transcen-
dent presence, but, through a complexification of time, arising immanently,
through the 'fold' of time upon itself', – there remains a distinction between the
conception of the Event as a virtual/actual bifurcation or as traumatic return. In all
of these readings, however (not all of them explicitly readings of Proust, of course)
Proust's 'Platonism' is deflected through a reading of 'essence' not as transcendent,
but as an originary difference, bifurcation, or deferral.

There is, though, a suggestive parallel here between the Bergsonian (and
Deleuzian) thesis and the 'Freudian' one (through Benjamin and Lyotard): can we
not associate the experience that was not experienced when it happened, but is , for
the first time, later, with the virtuality of a past present, which, 'preserved in itself',
is reanimated later around an analogous sensation in the present? Both conceptions
of temporality depend on the 'return' of a virtual, reserved experience. Both also
depend on memory, and on the sensuous sign to reactivate and 'associate with the
predicate of existence' the virtuality or the promise of experience.

This is where we must reaffirm the distinction between the sign of Art and its
Original, Absolute Time, and the sensuous sign with its Time Recovered at the
Heart of Lost Time. For Art, and Original Time, do not depend on memory for
their experiencing, nor on the contingent materiality of a sensation. We must draw
a distinction then, both in Deleuze's work on Proust, and in our own consideration
of temporality, between the temporality of return, dependent on deferral and its
delayed realisation, and a temporality of the Event.

It is over this point that the debate between psychoanalytic (but not necessarily
Œdipal) and Deleuzian (Leibnizian and Bergsonian) conceptions of temporality
may be resolveable, or at least illuminated. For if Proust's involuntary memory *does*
involve the return, in consciousness, of an experience that was not registered by it
when it happened, due to the protective shield of habit or preoccupation, and can
thus be interpreted in relation to a temporality of delay, repression and traumatic
return, the work of art – Vermeer's *View of Delft*, Vinteuil's 'petite phrase', the
novel itself, or the 'crystal-image' in the films of Resnais, Welles, Ophuls and others
(for Deleuze) – brings together both past and present, the virtual and the actual, in
a 'small internal circuit', condense the experience of the present with the 'other'
temporality of truth and its return in the same object or image. The work of art,
from this perspective, is thus indeed redemptive, for it reduces the distance
between visual or sensual experience in the present and the encounter with truth,
traumatic or otherwise. Psychoanalysis can thus inform our interpretation of
memory and its temporality, but, as Deleuze proposes, memory, in Proust's world,
is subservient to the truth of Art.

Deleuze's relation to psychoanalysis, from *Anti-Œdipus* onwards, was always one
of a critique established in proximity to its object. In *Cinema 2* he deflects a reading of
the cinema in strictly psychoanalytic terms. Accepting the general thematics of a

haunting, and an 'original crime', he is critical of the focus on a 'primitive scene', opening out the notion of the original crime to 'time itself'. It is not a question, then, of a subject haunted by a primal scene originating in the family drama. It is 'time itself' that is the crime anterior to all 'normal movement'. Following a quotation from the theorist of art Jean-Louis Schefer: 'cinema is the sole experience where time is given to me as a perception'[24] (see later), Deleuze writes: 'Certainly Schefer points to a primordial crime with an essential link to this condition of cinema [...]. It is a homage to psychoanalysis, which has only ever given cinema one sole object, one single refrain, the so-called primitive scene. But there is no other crime than time itself.'[25] Lyotard is close to this conception, but rather than like Deleuze deviating almost entirely from the Freudian corpus, he wants to keep the Freudian rhetoric and open it out beyond sexual difference to a more generalised notion of excess or 'initial overflowing'.[26] Both Deleuze and Lyotard develop a notion of traumatic haunting which moves beyond a limited Freudian frame towards other concerns, other metaphysics.

Deleuze's Leibnizian version of Proust entails following Deleuze to his consideration of Leibniz in *The Fold*; but Leibniz is already present in the work on Proust. Proust, in effect, despite the rhetoric of essence, is given a far more Leibnizian turn in Deleuze's book than a Platonic one. This is due to two factors: firstly, Proust's world is one of radical fragmentation. Swann, who Marcel knows first as the guest who interrupts the routine of the goodnight kiss, is radically not the same Swann as the father of Gilberte with whom Marcel plays later in the Champs Elysées. The name is all that connects them. The reason why a sensation can hold within it the memory and the essence of place is because it is like a 'hermetically sealed vessel' ('vase clos') without connection with the world around it, until it is opened up, when it releases the precious essence sealed within it. Vermeer's 'little patch', Vinteuil's 'little phrase', the 'bit of time in its pure state' are so many instances of a fragmented, monadic world, a world in which, moreover, a plurality of 'possible worlds' exist side by side. There is a world in which Albertine tells the truth, and an equally possible world in which she lies. The world in which she lies, moreover, is split into infinite permutations of true and mendacious, real and hypothetical versions. The true, in this scenario, has become a moment of the false.

 This Leibnizian turn enables Deleuze, in writing on Proust, to deflect the apparent Platonism of *In Search of Lost Time*. For Deleuze, essence is difference; radical, internal difference, and Deleuze's Proust is Leibnizian in that essence as ultimate difference is the quality of the monad, the hermetically closed, radically sealed simple substance which, as Leibniz reminds us, has no doors or windows. If essence is monadic, it is because it is an ultimate simple substance defined by an internal quality of difference which is without sympathy to an organic whole or Totality. Moreover, each monad is associated with a singular viewpoint 'to which it expresses the world'.[27] The fragmented, plural quality of monadic essence creates a world of fragments, radically separate from each other, which express the world to

a viewpoint. Proust's image of *vase clos*, hermetically sealed vessels each containing a precious essence, hanging at different levels,[28] suspended in time, corresponds to this monadic conception of the world. The 'bit', the 'little patch', the 'little phrase' are also monadic essences, fragments which express the world, their world, to the viewpoint of the artist.

Furthermore, still following Deleuze's Leibnizian reading of Proust, each essence, or monad, expresses an Original, Absolute time which is as if 'coiled' within it. Here Deleuze develops a neo-Platonist conception of time as an *originary complication*,[29] a time before time which is as if uncoiled, developed, explicated or expressed in time as movement and number; it is thus no coincidence that Deleuze highlights, in *The Fold*, the provenance of the term *monad* from the neo-Platonist Proclus, via Giordano Bruno.[30] The implication is that the monad expresses to its viewpoint, to the artist, an original absolute time 'in its pure state', the beginning of that world – for the monad is a world in itself, a 'birth of the world'. The trick, or the task of the writer is, like baroque anamorphosis, to find the right viewpoint, the line of sight as if emanating from that monad or simple world which expresses its truth, its Time. Viewed through this Leibnizian frame (*Proust and Signs* read through *The Fold*) Proust's world is one of fragments which express to the subject the birth of the world, every time; it is a world made up of 'bits', morsels' which force upon thought an encounter with an Originary, Absolute Time before time, 'bits of time in the pure state'.

The sign of Art, then, is like a Leibnizian monad; it has Time 'coiled within it' as an originary complication. It corresponds, and Deleuze develops this correspondance in *The Fold*, to the point of bifurcation between actual and virtual, the point at which Time divides. This is the Event. Under the title 'What is an event' Deleuze, reading first Whitehead then Leibniz, elaborates a vision of the event as a vibration in matter somehow produced out of chaos – the totality of what is possible – through a *crible*, of which the English translation would be a riddle, or a screening machine.[31] It is at this point that Proust intervenes again, as Deleuze writes 'A concert is being performed tonight. It is the event',[32] and proceeds to cite Marcel's description of the Vinteuil septet. The quotation ends: 'It was like the beginning of the world.'[33] In Deleuze's commentary upon it, part of the reading of Leibniz *with* Bergson, so to speak, the notes of the musical phrase are eternal objects, pure virtualities which are actualised in the sonorous matter of the instrumentation. The event here, is another intervention of time 'in its pure state'. The image of the *crible* and the vibration correspond to the notion, in Proust, of a specific material 'so ductile and so kneaded' that it 'refracts' the pure light of essence. Vermeer's little patch of yellow wall and Vinteuil's phrase are made of such material, such that they translate or refract the essence of time into an Event, they are 'the localised essence of time'.[34]

From this Leibnizian perspective, Proust's apprenticeship is one dedicated to the explication, or translation, of fragmented, monadic essences, to each of which corresponds a viewpoint. These fragments express a radical beginning, an

originary complication, a bifurcation between the actual and the virtual, the point at which, from the infinity of possible worlds, *this* world is drawn out, materialised. The Proustian morsel – little patch of yellow wall in Vermeer's *View of Delft* or 'little phrase' in Vinteuil's sonata – express truth to the viewpoint of the artist, whose task is it is find that point of anamorphosis, that secret line of sight which will enable him to see, or to hear, the image of time in its pure state. This is in effect mirrored in the novel itself: to echo the semantics of anamorphosis, we can briefly note the frequency of the hidden window enabling a line of sight which will reveal the secret – usually homosexuality or sadomasochism, the key which will unlock the narrator's understanding of the worlds he inhabits. Marcel witnesses Mlle de Vinteuil and her lesbian lover desecrate Vinteuil's photograph, through a side window. Marcel witnesses the encounter between the orchid and the bee, and Jupien and Charlus, from a privileged, invisible viewpoint. Marcel witnesses Charlus chained to his bed like Prometheus and being lacerated by a whip studded with nails through a lateral 'œil de bœuf'. Each of these acts of seeing occurs later-ally, from a hidden point, which reveals Truth.

This consideration of a 'secret' viewpoint as revelatory of the event of Truth paral-lels the phenomenal apparatus of the cinematographic image. Apart from the promise this sets up for a reading of the figure of the cinema in Proust's novel, or of the long-term influence of a Proustian imaginary in writing on the cinema in France, we are led to Deleuze's second book on the cinema. The thesis of this volume is familiar: Deleuze articulates how, through the presentation of 'purely optical situations', the cinema of the Time-Image develops radically from that of the Movement-Image. The cinematographic image presents not a sensory-motor situation but an image as such. Characters become not so much actors as viewers (*voyeurs*). The shift is not purely historical, although, given the focus on post-war cinema (Neo-Realism, Nouvelle Vague), it gives the appearance of being so. 'Before' Rossellini, Antonioni, Resnais, and so on, it is the Japanese director Ozu who 'invents' the purely optical situation in films characterised by empty spaces and still lives. It is in this context that the reader encounters a further return of the Proustian fragment, ' a bit of time in its pure state'. Commenting on a ten-second still shot of a vase inserted between the picture of a girl smiling and the same girl beginning to weep in Ozu's film *Late Spring*, Deleuze is prompted to write: 'There is becoming, change, passage. This is time, time itself, "a little time in its pure state": a direct time-image, which gives what changes the unchanging form in which the change is produced.'[35] The images of 'what changes' envelop the image of 'time itself' just as the sensations – starchy towel against lips in Paris and starchy towel against lips in Balbec – 'envelop' the blue, oceanic, essence of Balbec. The vase, in Deleuze's schema, is the visual presentation of the virtual past which is encountered through the link between the two sensations.

The distinct feature of the cinematic image is that it attempts to make this 'bit of time in its pure state' perceptible, to present an 'image of time': 'the direct

presentation of time.'[36] A reference to Jean-Louis Schefer is given to underline this quality: 'cinema is the sole experience where time is given to me as a perception.'[37] Cinema presents time, in this commentary, as an anteriority before all movement, all motricity. And in this sense the time of cinema, or again, of the cinema of the Time-Image, is the 'birth of a world'.[38] The vase is like one of the fragments – the patch of yellow wall or the little phrase in the sonata – which materialise time in its pure state. This is not time as movement, but time itself, in its pure state, the originary complication or beginning of the world.

Deleuze will use the figure of the 'crystal of time' to further conceptualise this notion of cinematographic time, relating it to the thematics of bifurcation, and to Bergson. Again, the Proustian fragment intervenes. Deleuze's argument runs as follows: in the cinema, the actual image is shadowed by its double – the virtual image: 'the actual image itself has a virtual image which corresponds to it like a double or a reflection'.[39] Earlier cinema had attempted to construct the largest possible distance between the actual and the virtual, between the present and 'its' past. The cinema of flashback is an expression of this, as in Carné's *Daybreak*, for example. Post-war cinema, excepting Ozu, moves in the opposite direction reducing the distance between the actual and the virtual, or the 'real' and its imaginary shadow. Deleuze's commentary focuses on the mirror in Welles's *The Lady from Shanghai*, or in Resnais's *Last Year in Marienbad*, or the image of the ship in Fellini. The 'crystal image' describes such images. The crystal image is 'the smallest internal circuit'[40] between actual and virtual; 'In Bergsonian terms, the real object is reflected in a mirror image as in the virtual object which, from its side and simultaneously, envelops or reflects the real ... there is the formation of an object with two sides, actual *and* virtual.'[41] The virtual and actual are in continual exchange and are indiscernible: 'the actual and the virtual are exchanged in an indiscernability which on each occasion allows distinction to survive.'[42] The crystal image is the indivisible unity of the actual image and 'its' virtual image.

Deleuze then follows through the Bergsonian implications of his distinction between actual and virtual. 'What is actual is always a present'.[43] But the present is always, as such, both present and past: 'The image has to be present and past, at once and the same time. The present is the actual image, and *its* contemporaneous past is the virtual image, the image in a mirror.'[44] Moreover, resonant with Proust's experience of involuntary memory, Deleuze notes that Bergson sees the experience of *déja-vu* as simply making 'this obvious point perceptible.'[45]The present image is doubled by its virtual image, which is its contemporaneous past. But this virtual image does not exist in consciousness; and never has. The virtual image is the 'past as it is in itself, as it is preserved in itself'...[46] What Proust does, it seems, with the experience of involuntary memory is to make obvious the doubling of the actual by the virtual, through the linking of two moments, one in the present, one in the past. This explains why the role of memory is secondary, according to Deleuze, and why Proust's novel is in no sense about the recovery of lost time – for the sign of art does not have to rely on an accidental convergence of two identical sensations, one in the

present and one in the past. The sign of art, or the crystal image, bears its own internal circuit, between virtual and actual, within itself, in the present, and has no need to delve back into memory, voluntary or involuntary, to realise this circuit.

The crystal image, then, which is doubled by an actual, present side, and its virtual side which represents its contemporaneous past, is constituted by 'the most fundamental operation of time':[47] the splitting of time between what is actual (present) and what is virtual (the unrealised past, which is 'real without being actual'): 'We see in the crystal the perpetual foundation of time, non-chronological time, Cronos and not Chronos.'[48] The crystal image shows us the bifurcation or splitting of time, and this moment is the beginning of time as such, the point at which it divides. It is a 'perpetual self-distinguishing'.[49]

The phrase from Proust intervenes at this point in the commentary: 'The crystal image is, then, the point of indiscernability of the two distinct images, the actual and the virtual, while what we see in the crystal is time itself, a bit of time in the pure state, the very distinction between the two images which keeps on reconstituting itself.'[50] This point of indiscernability Deleuze calls the *crystal of time*. The crystal image, like Proust's fragment, shows the bifurcation between the actual and the virtual, or rather, it is the point of their bifurcation, the point of indiscernability at which time divides between what happens and what might happen or might have happened, virtually, other possible worlds, in the Leibnizian sense. The crystal image is a direct presentation of time in its pure state, at the point at which this world arises instead of other infinitely possible worlds. And if we compare the cinematographic crystal image or crystal of time to Proust's fragment, the fragment is 'the smallest internal circuit', defined by an internal limit between actual and virtual. Memory makes the circuit take place in time, in memory, but it is ultimately to be discarded in favour of those fragments which do not rely on memory for this circuit between actual and virtual.[51]

Time in its pure state is, then, time at the beginning – at the moment when what happens diverts from what does not happen, at which the pure virtuality of what does not happen is closest to the actuality of what does. It is this crystal, morsel, refrain, vessel, patch, fragment which enclose worlds at their point of birth. It is 'the event'. The 'morsel' or 'fragment' of time in its pure state, which is the little patch of yellow wall or the little phrase, express to the viewpoint which is the artist this point of indiscernability, this internal circuit. The crystal of time which the cinema of the Time-Image explores is the direct visual presentation of time in its pure state. In this sense we can say that the cinema is Proustian, and that it realises Proust's project to make time sensible, in the sense of visible and of sound. In this sense we can also propose that Deleuze's reading of cinema, as well as his reading of Leibniz, are also readings of Proust, in that, through extended commentaries on Leibniz and of Bergson, interwoven with fragments and echoes from *In Search of Lost Time*, they extend the reading of Proust offered in *Proust and Signs*.

Proust does not 'haunt' Deleuze. This is not an essay in the anxiety of influence, nor in the fate of a literary example for the philosopher. But, to repeat the question

posed at the outset: what is the status of the fragments of the Proustian corpus repeated in Deleuze's writing on other concerns? I will propose, to conclude, two possible responses, which do not exclude each other. First, Deleuze's style is transversal; it establishes itself and its particular dynamism as a line of flight across distinct spaces which draws one into the other. Distinct 'works' are not defined and limited by their explicit object, as distinct works, but form part of a dynamic philosophising which draws from different spaces or zones to move forward. The introduction to *A Thousand Plateux* states that: 'A book has neither object nor subject; it is made of variously formed matters, and very different dates and speeds ... when one writes, the only question is which other machine the literary machine can be plugged into, must be plugged in to, in order to work. Kleist and a mad war machine, Kafka and a most extraordinary bureaucratic machine.'[52] Proust and an extraordinary cinematographic machine? A second response recognises, from Deleuze's 'plugging in' of Proust to the cinema an extraordinary resonance between Proust and the cinema, a proximity which is almost historical. Deleuze recognises this directly in *Cinema 2*, when he writes 'the direct time-image always gives us access to that Proustian dimension where people and things occupy a place in time which is incommensurable with the one they have in space. Proust indeed speaks in terms of cinema, time mounting its magic lantern on bodies and making the shots coexist in depth.'[53] Proust in fact denigrates a 'cinematographic' literature,[54] but 'speaks in terms of cinema' in the sense that his novel traces a 'history of cinema' from the primitive 'magic lantern' to the presentation of time 'in its pure state'. The postulation either that the reading of cinema is haunted by the Proustian imaginary, or that the reading of Proust is conditioned, after the event, by the fact and the history of cinema, is one which merits further analysis.

14

On some antidotes to discontent: Delaunay, Cendrars, Villeglé

Timothy Mathews

Time and image have struck me as being in a self-evident partnership. Together, time and image weave a sense of self that reads like the sporadic, spontaneous multiplication of some organism without root, pole or dominant structure. But what I have in mind by way of reading the self is not expressed by a postmodernist vision of legion systems for the production of knowledge, each providing interactive environments for others – however energising such a model might be. The contingent is more than flotsam, it articulates a cultural and subjective reality; at the same time, any strategy for dealing with contingency is less like a synthetic overview and more like clinging on to the wreckage of social relation and of the you-and-I. The sense of self raps out its utterances from its impending collapse. My own identity, for example, could be reconstructed – that is, given the most provisional form – from the appeal of a host of images ranging from the male in general to the writing of literary criticism in partic-ular. And in the model of writing I have in mind here, vibrant in France from Montaigne to Cixous and from Stendhal to Barthes, voices emerge with all the spon-taneity of touch on the one hand, and on the other with the equally spontaneous but more troubling sensations of audience, spectators and imaginary readers. Image-making and especially an uneasy partnership of word and painting are an integral part of the miniature story of the tyrannies and pathos of selfhood that I have in mind here.

Words come to us with an inevitability on which we come to depend for our nur-turing and our sense of possibility. Notoriously, Beckett ends his trilogy of novels with what can be read as both a prescription and an injunction, an expression of both heroism and decay.

> perhaps they have said me already, perhaps they have carried me to the threshold of my story, before the door that opens on my story, that would surprise me, if it opens, it will be I, it will be the silence, where I am, I don't know, I'll never know, in the silence you don't know, you must go on, I can't go on, I'll go on.[1]

Leslie Hill describes the range of Beckett's strategies of indeterminacy, and his chapter on Beckett's translation casts all kinds of light on the micro-changes that

emerge in the passages between Beckett's French and his English.[2] Here, Beckett includes an 'I can't go on' in his endless ending which is absent in the French. This 'I can't go on' emerges as a statement of one alternative among many, with no edge on the statement of its opposite 'I will go on' – the implication of resolve there is in any case blunted in the French, where 'je vais' might act as a simple indication of the future rather than of any intent. Within and across the two language versions, each momentary discursive attitude is absorbed in the next in a process that reproduces the experience of time. The awareness of change emerges and disappears in the present utterance, distinction is indistinguishable from continuity. But a distinctive note does emerge from the 'I can't go on' and from its contiguity with 'you must go on' and 'I'll go on', a note of coercion that is not defused or undermined by the ways in which it eludes framing. This is a coercion intensified by the mobility of its forms, by its capacity to proliferate as well as to dismantle the voices of its own narration and of its history. As each new 'I' is established in Beckett's text, its forgetting is performed; these are also moments of identification, attempted synthesis, fruitless attempts to capture the past, to foretell as well as to forego the future. Beckett's endless endings and his inaugurations without beginnings, the stop-go rhythms of his narrative produce an inconsistent and yet living analogy with the distant and dominating experience of authority, ever-present in its elusiveness, asphyxiating in its expansiveness, and fluid beyond capture.

The story I have room only to sketch here is one of Paris-based modernism. Using this little reading of Beckett's prose as a prologue, I want to suggest a discovery of some power to resist or reform the skin of authority that descends on us with language. What power can artists from the early part of the twentieth century discover to break loose from the exclusion zones that seem to descend with every utterance and gesture, and that seem to be produced and not dissipated by engagement with others?

My sketch begins with a canonical moment in European modernism, Picasso's *Les Demoiselles d'Avignon* of 1907 and the Cubism it spawned. This dramatic picture is a systematic, comprehensive onslaught on the cohesiveness of the point of view in Western art. African masks are superimposed on European-style representations of the female nude which are no less recognisable, and immediately so, for being fragmented and broken up into some of their constituent parts. This fragmentation, in the end, is so self-conscious that the drama involved is less one of the shock of the new than of the familiar; not an invigoration but reminder of visual habit. The implanted allusions to African masks and shapes are less a primitivist – and patronising – attempt to return to some source of expression and feeling than an exploration of the appeal of forms to the Western eye – known forms through which the two-dimensional evokes not only spatial but temporal and psychological depth.

This endless and desperate effort to shed visual and expressive habit shows Cubism as humble rather than heroic or autocratic in its attempt to inaugurate a new modernity. The tyrannies of the point of view that cling to the lines of perspective are merely suspended rather than banished in the Cubist works that Braque as

well as Picasso produced in the years after the showing of the *Demoiselles*. The notion of the disruption of perspective, its ideological as well as its purely formal content, itself pre-supposes the continued pursuit of a dominant vantage point in seeing and organising. But even though synthesis is merely deferred, even though concepts such as 'abstraction' or 'cubism' re-emerge from their own ashes ready for further consumption, Cubist artefacts at least offer a suspension of conclusion, and in that time-lapse the picture's space is offered again to the viewer, offered as a gift through which viewers may acquire the artificial power to invent new beginnings.

Coincidentally with the writing of this chapter, the summer of 1999 saw an exhibition of the major works of Robert Delaunay at the Centre Georges Pompidou in Paris; and a commemorative flight across the channel in a biplane designed by Louis Blériot for the first such flight in 1909. Delaunay, Apollinaire and Cendrars all expressed a fascination with flight as well as countless other icons of modernity, and all sought to move the opportunities afforded by Cubist experimentation beyond the studio and into the general experience of viewers and practitioners alike. Even if only ironically, Apollinaire in 'Zone', the opening poem of *Alcools* published in 1913, invokes airplanes as carrying the new Holy Spirit of the modern age.[3] The apparent impotence of such icons in our own cyberspace age suggests more than nostalgia. It is the decay rather than the immortality of a dominant image that is the gift that art has to offer. But can it be accepted?

A closer look at Delaunay's involvement with this modernist ethos might give some idea. With other artists of the time, those I have just mentioned as well as Léger and Delaunay's own partner Sonia Delaunay-Terk, Delaunay sought to take the potential generosity of the Cubist conception of art beyond that Cubist anti-naturalist, anti-colourist revolution and into the speed and the morphological vibrancy of technological urban life. His formalist studies of the Eiffel Tower, that other icon of the epoch's modernity, are integrated in an increasingly generalised investigation of the processes of identifying and identifying with. Colour invades his pictures which investigate not only urban energy, but the articulation of sight in light. This is an investigation without hope of success, a confident admission that sight is deferred in light, absorbed in the objects and shapes we identify, themselves open to indefinite re-framing in terms that encompass the psychic and the ideological as well as the visual. In works such as the *Les Fenêtres simultanées* series of 1912, Delaunay uses primary colours – the colours of light, as it were – in constructions that evoke both the seamless quality of vision as well as the hiatuses in that which allow for interpretation and structure. In *Soleil, Tour, Aéroplane, Simultané* of 1913, the material analogy of his composition allows for a spectatorship that brings together in one hybrid viewing process the sensations of an ideological moment and an analysis of those sensations, or a further watching of them. Continuity and arrest interact, Beckett-style, to the point of indistinguishability; and still the guarantor of self-awareness in the viewer is the temporalised quality of this 'simultaneity'.[4]

How easily, though, might the pursuit of the simultaneous be allowed to banish the sense of time, and with it the sense of dialogue that these works both construct

and bear witness to. Delaunay's art of the period exhibits an increasing idolisation of the forms of a momentary modernity that his own art, in a different mode, does so much to discourage and dispel. In the *Équipe de Cardiff* paintings of 1912 and 1913, however much of a transition they signal from a figurative to a more purely visual style coming from Delaunay's palette, rugby teams and Ferris wheels, physical education and manifestations of technological dynamism develop into themes rather than places of self-deferring, self-scattering interaction and dialogue. The contingency of such charged events as Blériot's cross-Channel flight seems now impervious to transience, there seems no room for the decay of their visual and cultural impact. Delaunay's joy in symbolic manifestations of urban dynamism, at formal possibilities of transcending material, spatial and temporal limitations seems vulnerable to the lures of an all-embracing vocabulary of cultural reference and aspiration. A vapid heroism threatens to reassert itself over a constructed humility. Delaunay can fragment appearance indefinitely in bits of (visual) space and (analytical) time; and yet memory, it seems, will still fixate arbitrarily on any one configuration of objects or circumstance. Fashioning new beginnings may usher in the unpredictable and the indefinite; but endings and the resulting oblivion re-emerge spontaneously or even triumphantly. An abstract style may lay bare identification and the sensations involved; and yet that same generosity of style can drift into decorativeness – as in the *Hommage à Blériot* of 1914 – at almost any of Delaunay's own self-made junctures, speculative springboards and suspensions in represented time.

Blaise Cendrars seems to have sensed as much in his own participation in this modern Renaissance of the years prior to the First World War. As Apollinaire had done he chose to publish under a pseudonym, and yet his writerly persona lays great emphasis on the quasi-autobiographical, and on the material elements of the technology of his age rather than its aesthetic possibilities. Nevertheless, one of the exemplary artefacts of this modernism is his collaboration with Sonia Delaunay-Terk on a visual-pictorial text involving his own text *Prose du transsibérien* of 1913. Cendrars's poem, a mock-autobiographical odyssey with no conclusion or booty in the bank, unfurls vertically down a long page in apparent harmony with Sonia Delaunay's abstract movements of primary colour.[5] And yet even though Sonia Delaunay's design silhouettes urban shapes including the magnetic Eiffel Tower; even though these shapes emerge as they do in the mind rather than with the resistant literalness of vision, their dialogue with Cendrars's poem seems based on the most dramatic of misunderstandings. Cendrars's free verse does not free the mind from the mind-sets of moment and psyche. His Odyssey is not an imaginary voyage beyond the signs of culture and meaning but further into their distinctions, divisions and nascent conflicts. The collaboration of Sonia Delaunay and Cendrars was hailed at the time and has been many times since as a spectacle arising from a 'simultanist' conception of the arts, their relation to each other as well as to the world beyond – a conception which had found its first expression in Cubism. But Cendrars's text, in itself as well as in relation to Sonia Delaunay's, delves deep into the resilience of the

point of view rather than making a show of any mobility that might be found within it. Constriction rather than ubiquity seems to proliferate.

There is certainly a contempt in Cendrars's text for the restrictive literalness of autobiography. The text consists in a series of 'transsiberian' encounters that fail to tell the story of the narrating 'I'. The promise of narrative development, the trope of the *Bildungsroman* and the journey of discovery that dominates in a variety of Western literary forms from Homer to Swift to Proust is again called into question here. But the text lurches into verse in spite of the 'prose' announced in the title – the dominant narrative form of the time and since. Cendrars's proto-Surrealist jerks that rejuvenate how we might think of what we see in Paris or Moscow silence as much as suggest narrative revelation. Prose is disappointed here by verse, just as image is disappointed by word. This disappointment produces an energy that is as much depressed, and even impoverished, as enriching; that is what makes the text innovative rather than just modern. Each new 'simultaneous' coming-together of disparate elements in the poem is allowed to congeal as into a commodity, leaving the narrator and the reader with him to muse on the collapse of his expressive reserve. And the particular failure of this 'prose', the unpalatable and striking message for this 'modernist' to put forward, is the failure to establish dialogue.

At the formal and thematic levels, word and image pass each other by. Sonia Delaunay's design reaches across temporal as well as spatial difference; Cendrars's text charts collapse and decay. The unknown is continually appropriated by the temporal weight of the known, and erotic embrace is fatally interrupted as well. Like Baudelaire before him, Cendrars re-discovers the erotic sloth involved in amorous contact. Still his journey is with Jehanne, with his own construction of Jehanne de France, his imagining of Joan of Arc and the sense of community and nationhood that go with that. This is a journey with and within the inadequacies, temptations and potential violence carried in such a desire.

What hope of dialogue, an unfixed and mobile two-ness, rather than one-ness and tyranny? Such questions emerge from Cendrars's engagement with the optimistic modernism of the Delaunays, and they continue to haunt European thought and literature throughout the century. Cendrars himself pre-empts much of this troubling speculation in *Moravagine*, which marks his own definitive return to prose and to the novel form after the 1914–18 war.[6] Published in 1926, it is an uncanny anticipation of Freud's diagnosis in 1930, on the eve of unimaginable Nazi atrocity, of an incurable 'discontent' at the heart of Western civilization.[7] It distinguishes itself sharply from the ways in which André Breton drew on Freud in his own conceptualisation of a Surrealist revolt. Where *Nadja* – published in 1928 – is Breton's youthful and prolonged speculation on how to bring the unconscious out of the asylum, *Moravagine* is an equally prolonged but horror-struck meditation on having found the unconscious out there already, out there in the many failed attempts at human solidarity. Breton's narrator in *Nadja* follows the eponymous central figure in a series of encounters in amongst the signifying cornucopia of Paris, and discovers in that way his own sense of the interplay of conscious and

unconscious response.[8] But where Breton seeks various platforms for his rallying call against censorship, Cendrars explores the effects of repression in a social organisation that depends on repression to survive and that seems universal. And the un-strange bedfellow of repression is authority, the admiration and fear of it, the special loathing that only indispensable features of existence seem to attract: 'I must go on …'

Breton and Cendrars in the 1920s agree on the complacent authoritarianism of professional psychology:

> Learned as they are, the doctors of today … are drifting farther and farther from the study and observation of nature. They have forgotten that science must remain a kind of edification which is subject to the limitations of our spiritual antennae.
>
> 'Prophylaxis! Prophylaxis!', they cry; and to save face they ruin the future of the species.
>
> In the name of what law, of what society are they allowed to rage on? They intern, they sequester, isolate the most striking individuals. (p. 17)

Like many others, Cendrars seeks to expose the shrieks of men in white coats as they defend against – what? Only the unknown, it would seem. But Cendrars adds his own sense of the integration of psychology and physiology, culture and nature. The limits of 'our spiritual antennae', as he calls them, are characterised by polyvalence as well as determinism. In order to explore this paradox of social organisation, the narrator 'has let an incurable escape' (p. 24). That incurable is Moravagine.

> At last I would live closely with a great human wild animal, I would keep watch over, share, and be a companion in his life. Steep myself in it. Take part in it. Deviate and imbalanced he was, to be sure, but in what sense? Moravagine. Amoral. An outlaw. A case of impulsiveness, raw nerves, or too hectic cerebral activity? (p. 44)

By alluding in literary terms to the terminology of neurology, Cendrars is able to draw on his readers' capacity for outrage, on their capacity to imagine a situation not theirs and from which exclusion is threatened. His own voice in the modernist representations of the unconscious that span those of Joyce, Proust and Woolf cries out the against assimilation, the appropriation of the unknown in the known and in immobiling habits of reading, image-making and synthesising. In that way, this voice not only reflects but is implicated in the symptoms it alerts to:

> All things are in flux, in agitation, everything overlaps and joins with everything else. Even abstractions sweat and grow dishevelled. Nothing is motionless. There is no isolation. Only activity, concentrated activity: form. Every form in the universe is exactly calibrated and passes through the same matrix. It is obvious that the bone should hollow itself out, that the optic nerve should be ramified in a delta and stretch outwards like a tree, that a man should walk upright. That the taste of brine which rises from our entrails comes from our farthest piscine ancestors, from the depths of the seas; and this epileptic twitching of the epidermis is as ancient as the sun. (p. 44)

Cendrars's narrator here not only diagnoses but exhibits both the psychic and the ideological symptoms that appal him. Drifting between the holistic and the fragmented visions of human development, the narrator's voice enacts the powers supposedly, unstoppably attributed to the Word: the power to give recognisable shape to the unknown, to project thought into imaginary spaces; but equally to trap and absorb the undiscovered in the shapes of the known. Such is the ambivalent power of form: the ability to synthesise at a stroke, psychically to capture the un-narratable diversity of a social or an individual constitution; conversely, the power to clone or be cloned in an endless spiral of complacency and orthodoxy.

Such an account of the imaginary dimension of form is common to Sartrean phenomenology as well as Lacanian psychoanalysis. Cendrars, anticipating such thought here, discovers the ambivalence of form through his own literary practice, through his turning away from the 'simultanist' modernism of the arts in pre-1914 Paris, and through his own imagination of human psychology. The uses of form, the appeal of it and the dissemination of it are characterised by the narrator, in his own exploration of the mind, as oscillating between effects of plurality and determinism. This drama is at the centre of Freud's way of diagnosing civilisation's discontent. His disciplinary idiom in *Civilization and its Discontents* comprises human biology, animal biology, anthropology, literature, visual art, history, politics. And yet each theoretical sequin takes part in a mosaic illustrating a single story: suspicion and loathing of the other. Like Cendrars in 1926, Freud in 1930 reads even the evolution of the human form as both biological and social – as so many signs of egoistic will and desire sacrificed to the needs of survival in society. But this is a society that survives at the cost of an implacable repression of Oedipal desire. Each stage in this Freudian evolution beyond narration, and certainly without progress, from quadruped to technological wizard is less a confident appropriation of an ever widening environment, than an indefinite series of attempts to shore up the ruins of self-love.

The development of form generally as well as its ambivalence here can be regarded as a psychic mechanism for making unity out of diversity; order out of trauma and chaos. And yet order is also loathed, in this Freudian logic, for the authority on which it rests and which it imposes. The development of form in that way provides a further enactment of the fundamentally ambivalent procedures of an Oedipally structured Eros favouring both life and not life; survival and resistance to coercion. Synthesis is a particularly striking form in this regard. In *Civilization and its Discontents*, Freud suggests that synthesis is unconsciously hated, especially by the neurotic, for the capacity it implies to cede power to superior authority. At the same time, synthesis is desired for its potential fragility faced with the unpredictability of experience, offering ever new hope of the collapse of an existence only ever demanded of the ego, never given without being internalised as a Beckettian 'I must'. But then again, this fragility is also abhorred for the trauma it gives distant voice to. This sado-masochistic relation to others and the love of others is explored further by both Cendrars and Freud with reference

to communism and to technology. The former raises the prospect of global equality and peace. The latter promises freedom from material and natural constraint.

What hope of these promises being kept? In *Moravagine*, each suggests uniformity and tolerance, and each disappoints. The involvement imagined by Cendrars of Moravagine in the Russian Revolution is depicted by the narrator, Moravagine's liberator turned partner, as disintegrating rapidly into an anarchism that justifies enjoyment of the purest, most intransitive and unprogrammed acts of violence. Moreover, this decline from political idealism to the pursuit of an unquantifiable, motiveless destruction is accompanied by a resurgence in Moravagine of a desire to manipulate women sadistically. This emerges as symptomatic of the revolutionary impulse as well as of orthodox family structures and their effects on Moravagine, which are grotesquely parodied by Cendrars through a distant allusion to the Romanov dynasty: girls are exchanged in marriage and boys respond to the systematic orientation of their sexual desire by directing at girls and women acts of nostalgia, idolatry and murder.

The object of resentment hidden in amongst revolutionary as well as technological goals is the principle of utility: democratising, potentially, but levelling. Moving across the Pacific to the United States, Moravagine's narrator and collaborator is overcome by his first impression of the effects of that principle. Once again, the synoptic, 'simultanist' eye characteristic of this narrator-diagnostician at once reveals and colludes with the symptoms he attempts to break free from, and from which he would so evidently desire to extricate Moravagine and thus exculpate the human race as he sees it. The creative power imagined for his narrator by Cendrars allows him to capture developmental and evolutionary diversity. It reveals, creates and suppresses universal trauma, observes and re-triggers the psychic orientations that produce it all in one writerly gesture. This is a prosaic gesture, also, emphatically not a poetic one, in the sense that poetic ambition had been contaminated for Cendrars; he acquires a creative disappointment in the optimistic modernism of Robert Delaunay and Sonia Delaunay-Terk, in their pictorial attempts to bring the structures of psychic response quite literally to light. Cendrars learns, it appears, through both cloning himself with his narrator and then de-cloning. He finds in prosaic time an antidote to the ambition of artificial form to set free not only by revealing but by capturing the paradoxical fertility of constraint. But Cendrars also discovers the germs of that same ambition, the germination in his own fantastic allegorising of an impulse to ride over variation and to master it in a literary, formalised style.

Here is how the narrator expresses his first impressions of the United States:

> To modern man the U.S.A. offers one of the finest spectacles on earth. When one dreams within the carcass of a skyscraper or in the Pullman of an American supertrain, one makes the direct acquaintance of the principle of utility.
>
> The caveman making a handle for his stone axe, curving it gently to give him a better grip, polishing it lovingly, was obeying the same principle of utility that guides

the modern engineer when he builds a scientific curve into the hull of a 40,000-ton transatlantic steamer, bolting it inside to diminish resistance to the water, and incidentally giving this floating city a line that is pleasing to the eye.

Roads, canals, railways, ports, buttresses, sustaining walls and embankments, high-tension wires, water conduits, bridges tunnels, all these straight and curved lines that dominate the modern landscape impose upon it a kind of grandiose geometry. But the most powerful force in transforming our contemporary landscape is beyond a doubt specialisation in agriculture. (p. 127)

Such is the narrator's first impression, but it is also one that clearly spans various moments in the narrator's experience, as well as suggesting periods both before and after the 1914–18 war in spite of the fact that he has not yet accompanied Moravagine into the trenches. Impulsively, both spontaneously and unconsciously, the narrator drifts from contextual precision to atemporal, metaphorical speculation. The demands of his psychological diagnosis and of his cultural analysis draw him into a formal play of allusion and suggestion that is as entrapping as it is magnificent. The magnificently expressive forms generated by a sense of the modern Cendrars shares with the Delaunays, with Apollinaire as well as so many others in pre-1914 Paris, spur the ambition to reveal and capture its multiple stories in a singular story of its generation. Hence the thematic content of the narrator's hyper-energised musings. Like Baudelaire before, Cendrars senses not only the effects of the contemporary in technology, but also of the anthropological and the prehistoric. And he uses the voice of his narrator to dramatise the heroic and inculpating sensations of formalising that richness in a streamlined, unifying, almost lyrical shape. To describe, and even to move beyond literal appearance to the structural one, is to become implicated in that structure, and Cendrars needs a narrator to expose that, as the psychoanalyst needs the analysand, and as the narrator himself needs Moravagine and becomes increasingly unable to maintain his distinction from him or anyone. The formal power and alarming appeal of the narrator's literary diagnosing is the ingredient that lends authenticity to the diagnosis itself, which tells how Utility is admired for its power to impose shape – geometric, pleasing, immovable – to predict the evolutions of material and social structure, and thus to return to the ego an illusory, isolated but no less tyrannical power to stifle difference and to dominate time.

But only to disappoint – fortunately, perhaps. But the 'ego's era', as Teresa Brennan evokes it, does provide solidarity with the air it needs to breathe.[9] If the ego's insatiable desire to absorb the environment and neutralise its vitality once seems fulfilled, this mirage seems then to taunt the ego once again with its own impotence, is own lack of distinction. Once again, the narrator and Moravagine are drawn into symptomatic violence, this time involving the American Blue Indians, and the symbolic struggle continues between civilisation itself as colonisation, on the one hand, and the delusions of uniqueness on the other that colonisation more obviously affords the coloniser. In Cendrars's inexorable allegorising, Moravagine and his analyst-prisoner now become embroiled in the Great War: 'kill so that you

can be free, or eat, or shit.... . Stand against them all, young man, kill, kill, you are unique, you're the only man alive, kill until the others cut you short' (p. 190).

Uniqueness, uniformity, exclusion, isolation; such is the price of a fruitless and unending – 'I must go on' – resistance to dialogue and otherness at large. With an increasing inability to resist Moravagine, the narrator keeps in touch with him through his supposed trips to Mars, through medical diagnoses that speak in chemical formulae and in which any voice of interpretation has fled, until a Dadaist language emerges that can be interpreted at will:

> The only word in the Martian language is written phonetically:
> Kay-kay-kuh-kuh-ko-kex
> It means whatever you want it to mean. (p. 202)

Duchamp's *Readymades*, designating anything and everything as art, urinals, bottle-racks or what you will, might seem to have the power to free art from the discourses and the institutions of art. Instead, as Thierry de Duve has shown in many different ways, to designate as art designates the conditions of art still further; they proliferate rather than disintegrate. The insatiable desire to name, capture and dominate begins its cycles of despair and violence again, it would seem, ending up in Duchamp's case with his *Étant donnés*.[10] The title expresses the conditions of art and viewing. It is a work in progress within those conditions; conditions made up of viewing turned voyeurism, the collusions of representation and the ideology of gender, and the recalcitrant, endlessly codifiable quality of the material world. The deconstruction of the codes of reading and seeing, in any case endless, confirms rather than dissipates the coercions of code itself.

In 1920, before *Civilization and its Discontents*, Freud had proposed in *Beyond the Pleasure Principle* the child's game of throwing a cotton-reel away and bringing it back as a model for the child's relationship with her/his desire, with its dependence on parental presence and authority, and with social integration at large beyond that.[11] To espouse models and voices of authority promotes paranoia; to dismiss them, tyranny. 'You must go on, I can't go on, I'll go on': coercion and resistance to coercion battle it out endlessly in a labyrinth of symptoms and signs that are as unreadable as they are spontaneously articulated. If the thinking and sentient 'I' could be conscious of the unconscious, rather than unconscious even of that; if 'I' could accept herself or himself as a codified being, steeped in her or his own 'spiritual limitations' as Cendrars calls them, thinking only through representation and the spectatorship of others, then the sense of others and their difference would be spontaneously articulated and absorbed at every turn.

Such might be one of the lessons some would have us learn from the history of cultural thought from Saussure to Lacan. Roland Barthes, on the other hand, working within that history as well, reminds us that codes, in being read and in inviting reading, invite also the rapidity of perusal, mastery, a spontaneous absorption of all code, a stifling even of the sense of them: life. There can be no end to this tension, this dialogue of the deaf that enacts the anxieties it seeks to resolve.

Countless attempts to move beyond could be discussed here, attempts to rip away the skins of code without drifting into despotism, to abandon social masking without drowning in a sad but fascinating narcissism or an aggressive but alluring paranoia. I have tried here to outline some of the ways in which this drama is played out in the Parisian modernism of before and after the First World War, attempting to throw along the way some light on Cendrars's struggle in that cacophonous sweep from Cubism to Surrealism. By doing that, I have tried also to suggest the temptations involved in approaching the pictorial image, either as practitioner or as spectator, as though it offered the hope of revelation without mediation, capture without collapse; a suppression of time and the sense of it, and in that way a complacent and stifled sense of the unknown. But the Word, made of code and symbolism, is yet the product of an endless inner search to which Beckett's narrative testifies so strongly. Perhaps that is one way of saying the collusion of word and image, the unpredictable swerves of form that reignite the passion for the One. But together, some thought with time, some imagining with decay rather than through their suppression might yet still emerge – 'I'll go on'.

Many such stories could be told; much fumbling for something other than discontent and tragedy. I want to end by inviting my reader's engagement with Jacques Villeglé, *Carrefour Turbigo* of 1967 (Plate 16). It appeared in an exhibition in 1999 entitled *La Peinture après l'abstraction* (*Art after Abstraction*), a title which points to a renewed belief suggested in the work of Villeglé generally and of others exhibited there that pictorial forms can be dishevelled enough to resist conceptual self-involvement and keep viewers swimming in the material, even within the constraints of the prohibition on touch which establishes the art gallery as an institution.[12] The picture signals a formal and formalised decision to work in and with time, both in the sense of the precedents it alludes to and of the procedures it adopts. Villeglé in any case suggests an ironic, unsequestered approach to intertextuality in his *De Raphaël à Mathieu* of 1965, where the Renaissance Italian painter is given a playful verbal-visual reincarnation in the aperitif with a similar name – St Raphaël – and its insignia. The vibrancy of the colours in *Carrefour Turbigo* re-evokes for me the optimism with which Robert Delaunay sees colour not only as the articulation of light but of the psychic as well as cultural conditions of perception. And certainly Villeglé's choice of posters as the medium for his work breathes material, quasi-literal new life into the feeling voiced by Apollinaire in 'Zone' of 1912 that posters and newspapers would provide the impetus for a rejuvenated art. Villeglé literally rejuvenates posters by tearing them up and re-applying them onto a different surface, dadaistically challenging ideas of the media and subject-matter appropriate to gallery art. But Villeglé's art is exhibited in many galleries; and the effect is one of creative humility, rather than of pointless iconoclasm. The temporality involved in lacerating posters and working with the remnants suggests an effort not only to re-work that material, but also to re-work a subjective involvement in its appeal, its forms, its codes. Villeglé's works both with and against that investment. The formulae of market capitalism may be shredded at will, their

effects remain beyond the reach of that gesture, as well as of any formal evocation of them; this is the experience that Villeglé is working with.

While on the one hand artificially manufacturing the decay of commercialism and its imagery, Villeglé on the other includes the most readable element in the picture: the verbal exhortation from the Communist Party of France to support the Vietnamese struggle for self-determination against the Americans. More than a stand-off between clearly desirable liberation on the one hand and clearly confused and undesirable exploitation on the other, the picture offers a work in progress – a work towards progress. Fixed in the present as strongly as in its two-dimensional existence, relishing the present as well for its contingency and indefiniteness, Villeglé's picture works at reaching out to other moments in time, other cultural dimensions from within his own here and now, and in ways that Cendrars in *Moravagine* could only imagine as a science-fiction trip to Mars. The message could not be more evident to the eye nor more moving: circumstance implants response, codes live and breathe and stifle different ones with every movement of the lung. To deny it would deny the picture. But the picture allows spectators to imagine – differently; rather than believe in difference, or marshal it, or impose it, or loathe it. In that sense this is a lyrical picture. The aggressive nostalgias of subjectivity are silenced; as in any viewing, there is silence. But through a spectatorship such as this one here, voice might be rediscovered as it declines in time. It can be re-imagined as lacerated in dialogue – generous, contingent, light-hearted at last – with innumerable others, with innumerable other forms suggesting the most obscure, or the most deceptively evident objects of fascination, or of dread, or ...

Notes

Note to Introduction

1 Christian Nicholas and Eyel Weizman with essay by Mark Cousins, *London* (*Bridge*) (London, Architectural Association Students Union, 1998).

Notes to Chapter 2

1 Most notably, Rémi Brague, *Du Temps chez Platon et Aristote* (Paris, Presses Universitaires de France, 1982).
2 Translations from the *Timaeus* are my own, though I have consulted the existing translations by Bury, Cornford, etc. Subsequent references to the *Timaeus* will be given in the text by Stephanus numbers alone.
3 See Brague, *Du Temps chez Platon et Aristote*, pp. 44–7.
4 See Plotinus, *Ennead* III.7.1, 11.
5 See Brague, *Du Temps chez Platon et Aristote*, pp. 11–27.
6 *Ibid.*, p. 44.
7 Plotinus, *Ennead* III.7.11.
8 Augustine, *Confessions* XI.18.
9 *Ibid.*, XI.20.
10 *Ibid.*, XI.26.
11 Martin Heidegger, *Der Begriff der Zeit* (Tübingen, Max Niemeyer, 1989), p. 26. [*Zeit ist Dasein.*]
12 Heidegger, *Die Grundprobleme der Phänomenologie*, vol. 24 of *Gesamtausgabe* (Frankfurt a.M., Vittorio Klostermann, 1975), p. 402.
13 Heidegger, *Sein und Zeit*, 9th ed. (Tübingen, Max Niemeyer, 1960), p. 412 f. Translations mine. [*In seiner Geworfenheit ist es dem Wechsel von Tag und Nacht ausgeliefert. Jener gibt mit seiner Helle die mogliche Sicht, diese nimmt sie.*] *(p.412)* [*… das 'naturlichste' Zeitmass, der Tag.*] (p. 413).
14 Cited in Charles S. Moffett, 'Monet's Haystacks', in John Rewald and Frances Weitzenhoffer (eds), *Aspects of Monet* (New York, Harry N. Abrams, 1984), p. 148.
15 Wassily Kandinsky, *Complete Writings on Art*, Kenneth C. Linsay and Peter Vergo (eds) (New York, Da Capo Press, 1994), p. 363.
16 Cited in Moffett, 'Monet's Haystacks', p. 145.
17 Letter no. 1076 in Daniel Wildenstein, *Claude Monet: Biographie et catalogue raisonné*, 5 vols (Lausanne, La Bibliothèque des Arts, 1979–91), translation mine.

Notes to Chapter 3

1 Julien Green, *Le Revenant. Journal 1946–1950* (Paris, Le livre de poche, 1975), p. 164. Translation mine. [*Un journal où l'on pourrait tout dire, qui ne serait pas le journal du corps en rebellion contre l'âme, ni de l'âme oprimant le corps, mais le journal des deux, le journal de l'homme enfin reconcilié avec lui-même.*]

2 Roland Barthes, *The Pleasure of the Text* (New York, Hill and Wang, 1975), p. 3.

3 Immanuel Kant, *Critique of Pure Reason* (London, Macmillan, 1929), p. 169 [B 158]. In this and subsequent citations, translations have been modified when necessary.

4 Martin Heidegger, *Kant and the Problem of Metaphysics* (Bloomington, Indiana University Press, 1962), p. 97 ff.

5 Kant, *Critique of Pure Reason*, p. 378.

6 *Ibid.*

7 Walter Benjamin, 'Julien Green', in *Gesammelte Schriften*, vol. II.1 (Frankfurt am Main, Suhrkamp 1977, p. 331. Translation mine. [*So und nicht anders wären jede ihrer Gebärden, müßten sie als arme Seelen jenseits des Grabes diese Augenblicke von neuen durchleben. In der trostlosen Stereotypie aller wahrhaft schicksalhaften Momente stehen sie vor dem Leser wie die Figuren der danteschen Hölle in der Unwiderruflichkeit eines Daseins nach dem Jüngsten Gericht. Diese Stereotypie ist das Signum des Höllenstadiums.*]

8 Roland Barthes, *Camera Lucida* (London, Fontana, 1984), p. 5.

9 Maurice Blanchot, 'The Two Versions of the Imaginary', in *The Space of Literature* (Lincoln, The University of Nebraska Press, 1982).

10 Samuel Beckett, *That Time*, in *Collected Shorter Plays* (London, John Calder, 1984).

11 Kant, *Critique of Pure Reason*, p. 373 [B 415].

12 Blanchot, 'The Two Versions of the Imaginary', p. 254.

13 *Ibid.*, p. 257.

14 This event is also the event of the equivocal or the ambiguous. The ambiguous – the 'as-well-as' whose possibility is contained within an image which both idealises and dissolves its object – consists in the movement of sense. Sense moves between its infinite and immediate richness, and its sudden and unfathomable emptiness. Hence, the ambiguous arises as semblance. (See Blanchot, 'The Two Versions of the Imaginary', p. 263.)

15 'The event consists in the fact that no-one ever dies, but has always just died or is going to die.' (Gilles Deleuze, *Logic of Sense* (New York, Columbia University Press, 1990), p. 63).

16 Walter Benjamin, 'The Storyteller', in *Illuminations* (Glasgow, Fontana/Collins, 1973), p. 94.

17 *Ibid.*

18 Theodor W. Adorno, *Minima Moralia* (London, Verso, 1978), p. 81.

19 In an early text which deals with the vocation of life and with the distorted and indistinguishable lines of fate, Adorno attributes this redemptive function to names. He writes: 'When the lines of our fate weave themselves into an inextricable net, then names prove to be the seals with which these interwoven lines are regularly stamped. They protect the net from our grasp and prevent us from getting caught in it by holding out initials which we do not understand but which we obey.' (Theodor W. Adorno, *'Notiz über Namen'*, in *Gesammelte Schriften*, vol. 20.2 (Frankfurt am Main, Suhrkamp 1986), p. 198. Translation mine. [*Wenn die Linien unseres Schicksals zum*

unentwirrbaren Netz sich verstricken, dann sind Namen je und je die Siegel, die der Lineatur aufgeprägt werden; die sie vor unserem Zugriff schützen und uns behüten, darin uns zu verfangen, indem sie uns Initialien vorhalten, die wir nicht verstehen, aber denen wir gehorchen.] See also Alexander García Düttmann, *La parole donnée. Mémoire et promesse* (Paris, Galilée, 1989, p. 198.) The name appears here as a guardian. It guards against the graven image by hindering us from distilling a portrait of the self from the net woven by the lines of fate.

20 By interpreting the 'form of a judgment' as a promise, Adorno already condemns the promise of thought to failure. For a promise can only be made if an irreducible uncertainty remains as to whether it can be kept or not, regardless of the commitment involved. Does not a promise which has been kept outlive itself, thereby remaining a mere promise? The uncertainty which is constitutive of a promise reproduces itself the very moment the promise is kept. But once a promise has been kept, it survives as a utopian promise, as a promise that points towards a no-man's land. The fulfilment of a promise denotes the coincidence of fulfilment and failure, a coincidence which is not a state of affairs but a pure event.

21 Adorno, *Minima Moralia*, p. 80.

22 Adorno refers explicitly to Descartes in order to distance himself from his discourse. The term 'unregulated' [unreglementiert] echoes the Cartesian 'rules' [regulae] of the understanding.

23 Friedrich Nietzsche, 'Richard Wagner in Bayreuth', in *Untimely Meditations* (Cambridge, Cambridge University Press, 1983), p. 223.

24 Cf. Alexander García Düttmann, *Between Cultures. Tensions in the Struggle for Recognition*, London and New York, verso, 2000, p. 135.

25 At the end of the aphorism, the lifeline and the line of thought diverge from the parallelism of their analogy and intersect each other for the first time. The last sentence reads: 'Thought waits to be awakened one day by the remembrance of what was missed, and to be transformed into a teaching.' (Adorno, *Minima Moralia*, p. 81) The reference to that which was missed and neglected is, on the one hand, a reference to the absence of 'complete legitimation', an absence constitutive and essential to thought, and, on the other hand, a reference to that which life has been incapable of obtaining. This can be gauged from the context, that is from the sentence which precedes the last sentence and which extends the analogy. The image of an awakening resonates with the idea of a rescuing which would be free of semblance and hence in a position to rescue semblance itself. Adorno expounds this idea in his aphorism on Snow White (*ibid.*, p. 121 ff.). The elliptical and aphoristic allusion to a 'teaching' must probably be understood as an allusion to a sphere in which it is possible to do justice to the 'unregulated' aspect of life and thought. It is important to note here that Adorno does not speak of 'a' teaching, but of 'the' teaching. In a rather defensive paragraph from the story of his friendship with Benjamin, Gershom Scholem mentions the concept of *Lehre*: 'In these years – between 1915 and at least 1927 – the religious sphere assumed a central importance for Benjamin that was utterly removed from fundamental doubt. At its centre was the concept of *Lehre* [teaching] which for him included, yet definitely transcended the philosophical realm. In his early writings he returned repeatedly to this concept which he interpreted in the sense of the original meaning of the Hebrew *torah* as 'instruction', instruction not only about the true condition *and path* of men in the world but also about the transcausal connection of things and their rootedness in God. This had much

to do with his concept of tradition which took on an ever stronger mystical note.' (Gershom Scholem, *Walter Benjamin: The Story of a Friendship* (London, Faber, 1992), p. 55 f. Italics mine.)

26 Franz Kafka, 'Metamorphosis', in *Metamorphosis and Other Short Stories* (London, Vintage, 1999), p. 63.

Notes to Chapter 4

1 Since the publication of several essays on the Freudian/Lacanian notion of the drive, in *Reading Seminar XI: Lacan's Four Fundamental Concepts of Psychoanalysis*, ed. Richard Feldstein, Bruce Fink, Maire Jaanus (Albany, SUNY Press, 1995), and the publication of Jean Laplanche's *Seduction, Translation, Drives*, ed. John Fletcher and Martin Stanton (London, ICA, 1992), this situation has improved.

2 I am thinking here of Althusser's argument that the enslavement of positivism to empirical 'fact' is what renders it an *abstract* science. *See* the essays by Tom Gunning, 'Phantom Images and Modern Manifestations: Spirit Photography, Magic Theater, Trick Films, and Photography's Uncanny', (in Patrice Petro (ed.), *Fugitive Images: From Photography to Video* (Bloomington and Indianapolis, Indiana University Press, 1995) and Alenka Zupančič, 'Philosophers' Blind Bluff', in Renata Salecl and Slavok Žižek (eds), *Gaze and Voice as Love Objects* (Durham and London, Duke University Press, 1996) for the hilarious details of positivism's self-entanglements.

3 In *The Origin of Perspective* (London and Cambridge, MIT Press, 1995) Hubert Damisch points out that light passed into the perspective apparatus not through a 'pinhole' exactly, but through a lentil-shaped opening that could better accommodate the physical shape of the observer's eye. Damisch's book offers a welcome antidote to historicist analyses of Renaissance perspective.

4 Jonathan Crary, *Techniques of the Observer: On Vision and Modernity in the Nineteenth Century* (London and Cambridge, MIT Press, 1990), p. 47.

5 Sigmund Freud, 'Instincts and their Vicissitudes,' *The Standard Edition of the Complete Psychological Works of Sigmund Freud*, trans. James Strachey (London, The Hogarth Press and the Institute of Psycho-Analysis, 1957), vol. XIV, p. 118.

6 Jacques Lacan, *The Four Fundamental Concepts of Psycho-Analysis*, ed. Jacques-Alain Miller, trans. Alan Sheridan (London, The Hogarth Press and the Institute of Psycho-Analysis, 1977), p. 22.

7 In *The Visible and the Invisible*, ed. Claude Lefort, trans. Alphonso Lingis (Evanston, Northwestern University Press, 1968), Merleau-Ponty admonishes, 'We have to reject the age-old assumptions that put the body in the world and the seer in the body, or, conversely, the world and the body in the seer as in a box', p. 138.

8 Jacques Lacan, *Seminar XIII: L'objet de la psychanalyse* (unpublished seminar), 4 May 1966. I would like to thank Cormac Gallagher for allowing me to consult his unpublished English translation of this seminar. Further references to *Seminar XIII* will be to the date of the oral transmission.

9 Freud, *S.E.*, XIV, pp. 121–2.

10 An excellent, non-reductive introduction to the notion of infinity is provided by Mary Tiles, *The Philosophy of Set Theory: An Introduction to Cantor's Paradise* (London, Blackwell, 1989).

11 *Ibid*.; I have also relied on Rudy Rucker, *Infinity and the Mind: The Science and Philosophy of the Infinite* (Boston, Basel, Stuttgart, Birkhauser, 1982); and Shaughan Lavine, *Understanding the Infinite* (Cambridge, Harvard University Press, 1994) in this section.

12 J. V. Field, *The Invention of Infinity: Mathematics and Art in the Renaissance* (Oxford, Oxford University Press, 1997), p. 192. Damisch also cites this title, which he translates slightly differently: '*Universal Method for Putting Real Objects or Objects for Which Specifications Are Available into Perspective, Such That Their Proportions, Measurements, and Distancing Are Correct, without Respect to any Point outside the Field in Question*' (p. 50), to make the same point.

13 Lacan, *S XIII*, 4 May 1966.

14 The Euclidean phenomenon of 'infinite extension' seems to be displacing, by Lacan, in favour of a theory of corporeal vision; which makes no room for any notion of the body, but Frege's consequential set-theoretical re-definition of extension, the class to which objects belong, does not seem to be far from his mind.

15 *See*, Victor Tausk, 'On the Origin of the Influencing Machine in Schizophrenia', *Psychoanalytic Quarterly* (1933); this paper was first read and discussed at the Vienna Psychoanalytic Society in January 1918 and was published in German the following year.

16 Jacques Lacan, *Seminar VII: The Ethics of Psychoanalysis*, ed. Jacques-Alain Miller, trans. Dennis Porter (London, Routledge, 1992), p. 30.

Notes to Chapter 5

1 Gottfried Wilhelm Leibniz, *Philosophical Papers and Letters*, ed. and trans. Leroy M. Loemker (Dordrecht, Reidel Publishing Company, 1976), p. 534.

2 *Ibid.*

3 *Ibid.*

4 Gilles Deleuze, *The Fold: Leibniz and the Baroque*, trans. Tom Conley (London, Athlone Press, 1993), p. 60.

5 Leibniz, *Philosophical Papers*, p. 646.

6 Kate Ince, 'Operations of Redress: Orlan, the Body and its Limits', *Fashion Theory*, 3:2 (1998), 111–28. For other interpretations of Orlan's work *see* Rachel Armstrong, *Totally Wired: Science, Technology and the Human Form* (London, ICA, 1996), Teresa Macri, *Il Corpo postorganico: Sconfanimenti della performance* (Genoa, Costa & Nolan, 1997) and the contributors to Sarah Wilson (ed.), *Orlan* (London, Black Dog Publishing Ltd, 1996.

7 Emmanuel Levinas, 'Reality and its Shadow', *Collected Philosophical Papers*, trans. Alphonso Lingis (Dordrecht, Martinus Nijhoff, 1987), p. 3.

8 *Ibid.*, p. 7.

9 *Ibid.*

10 *Ibid.*, p. 8.

11 *Ibid.*, p. 9.

12 *Ibid.*

13 Orlan, *Conférence* in Sarah Wilson *et al.*, *Orlan* (London, Black Dog Publishing Limited, 1998) p. 83.

14 *Ibid.*, p. 84.

15 Levinas, 'Reality and its Shadow', p. 13.
16 Orlan, *Conference*, p. 90.
17 *Ibid.*, p. 88.
18 Gilles Deleuze, *Logic of Sense*, trans. Constantine Boundas (London, Athlone Press, London, 1990) p. 267.
19 Emmanual Levinas, *De l'obliteration* (Paris, Editions de la Difference, 1990), p. 26.
20 *Ibid.*, p. 28.
21 Orlan, *Conference*, p. 90.
22 *Ibid.*
23 *Ibid.*, p. 92.
24 *Ibid.*

Notes to Chapter 6

1 P. Adams and D. Ward, 'The light and the blue', *Portfolio*, No. 25 (1997), 54.
2 J. Lacan, '*Radiophonie*', *Scilicet* 2/3, Seuil (1970), 79. Translation mine. [*Ce qui du temps lui fait étoffe n'est pas emprunt d'imaginaire, mais plutôt d'un textile où noeuds ne diraient rien que des trous qui s'y trouvent.*]
3 M. Silvestre, *Demain Le Psychanalyse*, (Paris, Navarin, 1987), p. 76. Translation mine. [*Certes pas le silence de convention, car il faut bien se taire pour écouter l'autre qui parle, mais le refus de répondre la où l'analyste aurait quelque chose à dire, mais le silence de plomb venant redoubler celui de l'analysant, mais encore la question muette, écho angoissant de la limite du savoir de l'Autre. L'être de l'analyste est silencieux, par quoi il se fait présence, massive et enigmatique.*]
4 C. Solers, '*Le temps qui'l faut*', *La Cause Freudienne (Le Temps Fait Symptome)* No. 26 (1994), 25.
5 J. Lacan, *The Four Fundamental Concepts of Psychoanalysis* [1973] (London, The Hogarth Press and the Institute of Psychoanalysis, 1977), p. 112.
6 *Ibid.*

Notes to Chapter 7

1 André Breton, with reference to collage, in the foreward to *La Femme 100 Têtes*, Paris, 1929, trans. Dorothea Tanning, in *The Hundred Headless Woman* (New York, George Braziller, 1981), p. 8.
2 Robert Morris, 'Notes on Sculpture, Part 2' in *Continuous Project Altered Daily* (Cambridge MA and London, MIT Press, 1993), p. 15.
3 George Kubler, *The Shape of Time* (New Haven and London, Yale University Press, 1962). Kubler's work was often cited by Robert Morris and Robert Smithson among others.
4 Michael Fried, 'Art and Objecthood' in *Art and Objecthood* (Chicago and London, University of Chicago Press, 1998), p. 166.
5 *Ibid.*, p. 172.
6 *Ibid.*, p. 171.
7 Robert Smithson,'Letter to the Editor' (1967) *Artforum*, October 1967, in Jack Flam (ed.), *Robert Smithson The Collected Writings* (Berkeley and Los Angeles, University of California Press, 1996), p. 67.

8 André Breton, *Mad Love* (*L'Amour Fou*) trans. Mary Ann Caws (Lincoln and London, University of Nebraska Press, 1987), p. 10.

9 J. Breuer, 'Fraulein Anna O' in S. Freud and J. Breuer, *Studies on Hysteria Vol. 3*, (Harmondsworth, Penguin Freud Library, 1991), p. 96. The term refers to Anna O's habit of day-dreaming.

10 Robert Smithson, 'The Crystal Land', p. 7.

11 George Kubler, *The Shape of Time*, p. 17.

12 Robert Smithson, 'Quasi-Infinities and the Waning of Space', p. 36.

13 *Ibid.*, p. 37.

14 Also shown were Andre, Asher, Bollinger, Duff, Flore, Glass Jenney, Le Va, Lobe, Reich, Rohm, Ryman, Shapiro, Snow and Tuttle. The show was organised by Marcia Tucker and James Monte.

15 Robert Morris, 'Notes on Sculpture Part 4', p. 67.

16 Doug Johns quoted by Bill Barette, *Eva Hesse Sculpture Catalogue Raisonné* (New York, Timken Publishers, 1989), p. 212.

17 Bill Barrette makes this point *Ibid.*, p. 212.

18 Barette cites a loose page in the Hesse archive at Oberlin, *Ibid.*, p. 218.

19 Catherine Clément, *Syncope* (University of Minnesota Press, 1995), p. 5.

20 *Ibid.*, p. 125. I should note here that Clément herself is concerned to go beyond psycho-analysis to encompass Eastern mysticism, while I want to take account of the problem-atic place of the hysteric within psychoanalysis.

21 J. Breuer, 'Fraulein Anna O', p. 76.

22 S. Freud, 'Dostoevsky and Parricide' in *Art and Literature* (Harmondsworth, Penguin Freud Library), vol. 14, p. 447.

23 M. Fried, 'Art and Objecthood', p. 167.

24 C. Clément, *Syncope*, p. 7.

25 Robert Morris 'Notes on Sculpture', p. 26.

26 J. Breuer, 'Fraulein Anna O', p. 79.

27 Robert Smithson, 'Quasi-Infinitives and the Waning of Space', p. 36.

28 Rachel Whiteread interviewed by Helen Grille in D. Abadie and A. Spira (eds) *Un Siècle de Sculpture Anglaise* (Paris, Galerie National du Jeu de Paume, 1996), pp. 384–5.

Notes to Chapter 8

1 See W. J. T. Mitchell, *Iconology: Image, Text, Ideology* (Chicago, University of Chicago Press, 1986).

2 A decisively important publication that has stimulated thought on this issue is Arjun Appadurai (ed.), *The Social Life of Things* (Cambridge, Cambridge University Press, 1986).

3 I have coined the term 'paronthocentrism' by analogy with such terms as 'Eurocentrism' and 'heterocentrism', to refer to a blindness that takes the present as the outcome of evolution, and more generally, the vantage point and standard for looking at other time. *See* Mieke Bal, *Murder and Difference: Gender, Genre and Scholarship on Sisera's Death* (Bloomington, Indiana University Press, 1988).

4 See Mieke Bal, *Quoting Caravaggio: Contemporary Art, Preposterous History* (Chicago, University of Chicago Press, 1999).

5 See Svetlana Alpers, *The Art of Describing: Dutch Art in the Seventeenth Century* (Chicago, University of Chicago Press, 1983).

6 'A fabula is a series of logically and chronologically related events that are caused or experienced by actors.' For this and all narratological terms, *see* my *Narratology: Introduction to the Theory of Narrative* (Toronto, University of Toronto Press, 1997 (revised and expanded version of 1985 edition)). The definition of fabula is on page 5.

7 The notion of visual thought – the idea that images can be, in their own medium, as intellectual and philosophical as texts without being subsumed under language – has been developed by, among others, Hubert Damisch in many works, most notably *Le jugement de Pâris* (Paris, Flammarion, 1992). I develop this argument at greater length in *Reading 'Rembrandt': Beyond the Word-Image Opposition* (New York, Cambridge University Press, 1991) and more recently in 'Abandoning Authority: Svetlana Alpers and Pictorial Subjectivity', in *Travelling Concepts in the Humanities: A Rough Guide* (Toronto, University of Toronto Press, 2001).

8 On Reed's work, *see* David Carrier, *The Aesthete in the City: The Philosophy and Practice of American Abstract Painting in the 1980s* (University Park, Pennsylvania State University Press, 1994); Hanne Loreck, 'Explications', in *David Reed* (Cologne, Kölnischer Kunstverein, 1995) pp. 77–82, and my *Quoting Caravaggio*, ch. 6.

9 See Richard Wollheim, *Painting as an Art. The A.W. Mellon Lectures in the Fine Arts, 1984* (Princeton, Princeton University Press, 1987).

10 See the work of Johannes Fabian on the importance of an acknowledgment of coevalness in contact with 'others' – in Fabian's case, other cultures. He made the point in *Time and the Other: How Anthropology Makes its Object* (New York, Columbia University Press, 1983), and developed several distinct aspects of it in *Time and the Work of Anthropology* (Chur, Switzerland; Reading, Harwood Academic Publishers, 1991). An important connection to cultural memory and the need to establish the present as the realm where it happens is articulated in his 1996 *Remembering the Present* (Berkeley, University of California Press). Although I cannot develop this point here, it does underlie the argument I am making in this and the preceding paragraphs. See also Mieke Bal, Jonathan Crewe and Leo Spitzer (eds) *Acts of Memory: Cultural Recall in the Present* (Hanover, NH: University Press of New England, 1999).

11 See my *Narratology*, pp. 78–114, for the methodological tools for analysing narrative time in terms of sequential order, duration and frequency.

12 On second-person narrative, see Irene Kacandes, 'Are You in the Text? The "Literary Performative" in Postmodernist Fiction', *Text and Performance Quarterly* 13 (1993), 139–53, and 1994 'Narrative Apostrophe: Reading, Rhetoric, Resistance in Michel Butor's *La modification* and Julio Cortazar's *Graffiti*', *Style* 28 (3) (1994) 329–49. See also Brian Richardson, 'The Poetics and Politics of Second-Person Narrative'. *Genre* 24 (1991), 309–30.

13 On the iconography of these paintings, see the detailed analysis by Bert Treffers, *Caravaggio: Genie in opdracht. Een kunstenaar en zijn opdrachtgevers in het Rome van rond 1600* (Nijmegen, SUN (1991), 113–54). This painstakingly detailed analysis, while bringing in convincing evidence of the theological disputes that determined the relationship of the painter to his patrons, takes the works themselves out of time by bracketing all the other temporalities involved. See also Creighton E. Gilbert, *Caravaggio and His Two Cardinals* (University Park, Pennsylvania State University Press, 1995), pp. 135–58, for a somewhat broader picture of the painter's relation to patronage.

14 I am not claiming anything like 'influence' on Reed by Jarman, or, indeed, a direct and conscious influence by Caravaggio. The notion of influence, despite numerous contestations of it, is too much bound up with uni-directional agency of the past on the present to be useful in the reversal I am constructing. But the point about the bodiliness of Caravaggio's theatricality that Jarman made explicit in his film underlies Reed's further elaboration of what that bodiliness can be. For a critique of influence, see T. S. Eliot, 'Tradition and the Individual Talent' [1919] in *Selected Prose of T. S. Eliot*, edited and with an introduction by Frank Kermode (London, Faber and Faber, 1975), pp. 37–44 (first published in *Egoist*, September and December 1919), who started this critique, and Michael Baxandall, who needed to reiterate it in 1985, in *Patterns of Intention: On the Historical Explanation of Pictures* (New Haven, Yale University Press, 1985).

15 It also resists Michael Fried's somewhat obsessive binary opposition between absorption and theatricality, which Fried has recently also applied to Caravaggio, in 'Thoughts on Caravaggio', *Critical Inquiry* 24 (1) (1997), 13–56.

16 Gilbert, *Caravaggio*, p. 150.

17 He did this so well that even today, this story gets all the attention. But such iconographic analyses do not account for the *painting*, only for what is 'behind' it, outside of it. In other words, the most established of art-historical methods treats the painting as a text.

18 The term 'trisexual', not its content, has been borrowed from Christopher Bollas, *The Shadow of the Object: Psychoanalysis of the Unthought Known* (New York, Columbia University Press, 1987), ch. 5, pp. 82–96.

19 Johannes Fabian, *Power and Performance: Ethnographic Explorations Through Proverbial Wisdom and Theater in Shaba, Zair*. (Madison, Wisconsin, University of Wisconsin Press, 1990).

20 Reception theory's classical manifesto is Wolfgang Iser, *The Act of Reading: A Theory of Aesthetic Response* (Baltimore, Johns Hopkins University Press, 1978). Consequences of this thesis for feminist and postcolonial perspectives can be found in Mary Louise Pratt, *Imperial Eyes: Travel Writing and Transculturation* (London and New York, Routledge, 1992) and Jane P. Tompkins, *Sensational Designs: The Cultural Work of American Fiction, 1790–1860* (New York, Oxford University Press, 1985). Iser's thesis, which was based on phenomenological thought, has been taken up for visual art by Wolfgang Kemp, *Das Anteil des Betrachters: Rezeptionsästhetische Studien zur Malerei des 19. Jahrhunderts* (Munich, Maander, 1983). A clear case study along these lines in English is his 'Death at Work: A Case Study on Constitutive Blanks in Nineteenth-Century Painting', *Representations* 10 (1985), 102–23.

21 J. L. Austin, *How to Do Things With Words* (Cambridge, MA, Harvard University, Press, [1962] 1975).

22 An excellent early analysis of the debate, mainly between John Searle and Jacques Derrida, is offered by Shoshana Felman in *Le scandale du corps parlant. Don Juan avec Austin ou la séduction en deux languages* (Paris, Éditions du Seuil, 1980); see also Jacques Derrida, *Limited Inc*, trans. Samuel Weber (Evanston, Ill., Northwestern University Press, 1988).

23 This negative opinion was first aired by Caravaggio's rival Baglione, and became legendary. *See* Louis Marin 1977 *Détruire la peinture* (Paris, Éditions Galilée, 1977) (English: *To Destroy Painting*, trans. Mette Hjort (Chicago, University of Chicago Press, 1995).

24 For a more detailed analysis of Christensen's work and specifically its relation to Old Master paintings, see Mieke Bal, *Jeannette Christensen's Time*. In 'Kulturtekster' Series #12 (Bergen, Centre for the Study of European Civilization, University of Bergen, 1998).

25 George Kubler, *The Shape of Time: Remarks on the History of Things* (New Haven, Yale University Press, 1962), p. 13.

26 See my essay 'Larger than Life: Reading the Corcoran Collection', in *Ken Aptekar: Talking to Pictures* (exhibition catalogue) (Washington, DC, Corcoran Gallery of Art, 1997). For an analysis of Aptekar's relation to Caravaggio and baroque painting, see my *Quoting Caravaggio*, chs. 3 and 4.

27 Museum labels are of great concern to museum professionals. *See*, among others, Beverly Serrell, *Making Exhibit Labels: A Step-by-Step Guide* (Nashville, American Association for State and Local History, 1983) and, by the same author, *Exhibit Labels: An Interpretive Approach* (Walnut Creek, CA, Alta Mira Press, 1996). The difference between these two publications is an indication of the way thinking about this issue has developed over the past two decades. See also the analysis in Lisa C. Roberts, *From Knowledge to Narrative: Educators and the Changing Museum* (Washington, DC, Smithsonian Institution Press, 1997). For an analysis specific to label/work interaction in art museums, *see* my *Double Exposures: The Subject of Cultural Analysis* (New York, Routledge, 1996), ch. 3.

28 This issue was raised in the first painting of the show. See my essay in the exhibition catalogue (note 26).

29 The Van de Velde painting also forms the basis for one of a suite of prints that Aptekar has made under the 'Red/Read' heading (Riverdale, Maryland, Pyramid Atlantic, 1998). In this series, he further explores the implications of the simultaneous deployment of text and formal pairing, as well as the range of the colour red.

30 Kubler defines his project of writing the 'history of things' as follows: 'But the "history of things" is intended to reunite ideas and objects under the rubric of visual forms: the term includes both artifacts and works of art, both replicas and unique examples, both tools and expressions – in short all materials worked by human hands under the guidance of connected ideas *developed in temporal sequence*. From all these things a shape *in time* emerges' (1962, p. 9; emphasis mine).

31 See the catalogue of Dan Cameron (ed.), *Doris Salcedo (ed.)* (New York, New Museum of Contemporary Art, 1998).

32 An important collection on the public/private divide was edited by John Weintraub and Krishan Kumar, *Public and Private in Thought and Practice* (Chicago: University of Chicago Press, 1997).

33 Kubler, *The Shape of Time*, p. 17.

34 For a clear account and convincing argument in favour of alternative modes of 'keeping in touch' with the holocaust, see Ernst van Alphen, *Caught by History: Holocaust Effects in Contemporary Art, Theory and Literature* (Stanford, Stanford University Press, 1997).

35 The hostility against art that deals with the holocaust – understandable and made commonplace since Adorno first proclaimed it – is only reasonable within a formalist conception of art. Only within such a conception is art isolated from reality, hence, fictional, in a sense that opposes fiction from reality, and is pleasing, which was Adorno's point. See Ernst van Alphen, *Caught by History: Holocaust Effects in Contemporary Art, Theory and Literature* (Stanford, Stanford University Press, 1997).

36 Geoffrey H. Hartman, *The Longest Shadow: In the Aftermath of the Holocaust* (Bloomington and Indianapolis, Indiana University Press, 1996), pp. 99–115, esp. p. 106. This account of Hartman's view is taken from my introduction to the collective volume, Mieke Bal, Jonathan Crewe, and Leo Spitzer (eds.), *Acts of Memory: Cultural Recall in the Present* (Hanover, NH: University Press of New England, 1999).

37 This idea resonates with Lacan's remarks on mimicry in his essay on the mirror stage. Jacques Lacan, 'The Mirror Stage' In *Ecrits: A Selection*, edited and translated by A. Sheridan (New York, W. W. Norton, 1977), pp. 1–7. (French: 1966 '*Le stade du miroir comme formateur de la fonction du Je*' in *Écrits I* (Paris, Éditions du Seuil, Collection Points), pp. 89–97.

38 See Mieke Bal and Norman Bryson, *Looking In: The Art of Viewing* (Amsterdam, G & B Art International, in press).

39 See Leo Bersani's important caution against art as redemption: *The Culture of Redemption* (Cambridge, MA, Harvard University Press, 1990).

Notes to Chapter 9

1 '*Living Pictures* en particulier: Adresse et communauté dans *L'annonce amoureuse* de Sylvie Blocher', *Trafic*, 23 (Autumn, 1997); 'People in the Image/People before the Image: Address and the Issue of Community in Sylvie Blocher's *L'annonce amoureuse*', *October* 85 (Summer 1998).

2 How Manet's *A Bar at the Folies-Bergère* Is Constructed', *Critical Inquiry*, 25 (Autumn 1998).

3 Video made its first appearance in Sylvie Blocher's work in 1985, in an installation entitled *Lupe Velez/Spectacle pour rendre la vie présentable*. She has since then also regularly used the medium in short pieces of an intimate character, which she calls *Pratiques quotidiennes pour rendre la vie présentable*. In both *Lupe Velez* and the *Pratiques*, she has filmed herself; in the latter she remains silent, and in the former the text was a voice-over.

4 In conversation with me, 20 July 1999.

5 Michael Fried, *Manet's Modernism or, The Face of Painting in the 1860s* (Chicago, University of Chicago Press, 1996).

6 The sound was communicated through earphones. The questions were not audible but appeared as text on the screen in between answers.

7 Several of the *Living Pictures* besides *How Much Can I Trust You?* and *L'annonce amoureuse* rely on 'pseudo-groups', such as: the citizens of Bilbao or people Blocher met there by accident in *Entre tu y yo estramos nosostros*; the residents of a building in Düsseldorf in *Warum ist Barbie blond?*; the people of Calais who responded to a newspaper advertisement in *Gens de Calais*; students of the University of Honolulu in *Tell me*; Toronto taxidrivers in *them(selves)*; and a team of American football players in *Are You a Masterpiece?*

8 Four of them had acted together in André Téchiné's film *Wild Reeds*. The young actors and actresses competing for the Michel Simon prize were: Elodie Bouchez (*Les roseaux sauvages*, by André Téchiné), Marie Bunel (*Lou n'a pas dit non*, by Anne-Marie Miéville), Pascal Cervo (*Les amoureux*, by Catherine Corsini), Eloïse Charretier (*Rosine*, by Christine Carrière), Julien Collet (*L'histoire du garçon qui voulait qu'on l'embrasse*, by Philippe Harel), Mathieu Demy (*A la belle étoile*, by Antoine Desrosières), Frédéric Gorny (*Les roseaux sauvages*), Virginie Ledoyen (*L'eau froide*, by Olivier Assayas), Gaël

Morel (*Les roseaux sauvages*), Jalil Naciri (*Hexagone,* by Malik Chibane), Stéphane Rideau (*Les roseaux sauvages*), Mathilde Seigner (*Rosine*), and Veronika Varga (*Le roi de Paris,* by Dominique Maillet).

9 She also told them that the tape would be included in an installation work. The work was shown for the first time at Saint-Denis in March 1995, during the run of the festival, where it was set up as an installation with large-screen projection, in an old chapel that had served as a courtroom and a theatre before becoming an exhibition space. The screen was not 'onstage' (i.e. in the choir), but instead hovered in front of it, thin and translucent, unframed and apparently unsupported, hung from thin steel cables. It was also on a slight diagonal with regard to the axis of the chapel. On the ground, in half-darkness, stood seventeen plywood sheets cut into the sihouettes of furniture drawn in axonometric perspective, and held upright by little brackets. The furniture – a table, chairs, a bed, an armchair, a TV set, fridge, full-length mirror, couch, lamp, etc. – had been reduced to the merest stylisation and gave the impression of standard furnishings for a model apartment. Their measurements were taken from an Ikea catalogue.

10 And in the definitive canvas as well, at first. The X-ray of the painting shows the silhouette of Dupray underneath La Touche, another proof of hesitation in the casting.

11 To achieve this, the mirror of course has to be oblique, its right side pulled toward us. I have argued in my article on the *Bar* (see note 2) that the couple as seen in the painted mirror was indeed observed in such an oblique mirror and has been 'pasted' (as if with Photoshop) into the frontal mirror the painting displays. The important thing is that La Touche's image in the painting is compatible with both the frontal and the oblique mirror. In the first instance he is standing sideways to the bar and slightly in front of Suzon, outside the visual pyramid. In the second he is facing her across the bar.

12 Since I hinge my interpretation on my personal sensation or feeling, I shall refrain here from introducing contemporary opinions about flesh and make-up into the debate, though they are definitely on my mind. Particularly relevant are, of course, Baudelaire's 'In Praise of Makeup' in *The Painter of Modern Life* and Mallarmé's 'The Impressionists and Édouard Manet', which is partly an attack on Baudelaire's predilection for artificiality and where Mallarmé coins the expression 'flesh-pollen' to describe a woman's *natural* complexion. I certainly endorse the view that seeing the barmaid blush is more likely to be a masculine response to her movingness than a feminine, at least in the context of today's feminism. But I cannot and do not wish to detach my personal impression from my awareness of the historical context. For a thoughtful discussion of the implications of 'flesh-pollen' for the gendering of the faciality of Manet's paintings as *at once feminine and masculine,* see Michael Fried's footnote in *Manet's Modernism,* pp. 408–12.

13 See Sylvie Blocher's response to me in *Trafic,* 23, p. 81.

14 In the published versions of my talk on *L'annonce amoureuse* at the Tate Gallery, I have spoken of the artist's naïveté and 'perversity' (in quotation marks). Naïveté was in my mind, and still is, an unqualified compliment. Indeed I started the *October* version of the talk with a statement about my wish to attain a commensurate naïveté in theory. 'Perversity' was a compliment too (basically because I said: 'It's through the 'perversities' of this piece that something incredible opens up with true naïveté'), but it was a somewhat qualified compliment. I had my doubts at the time about Blocher's 'use' of actors and actresses too young to really understand what was happening to them. I no

longer have these doubts. In her written response to my talk (published in *Trafic*), Blocher shifted grounds and made it a gender issue: 'Finally, I'll suggest to Thierry de Duve to replace the notion of ingenuousness [*candeur*] with that of utopia and the notion of perversity with that of *double touché*, in order to rid us of this modernist language about women, eternally seen as candid and perverse.' I take the point.

15 One actor in *L'annonce amoureuse* addresses the camera with those words: 'Touch me', and then proceeds to list the body parts he wants his beloved to touch, starting with his eyes and moving down to his feet, not omitting his penis. In his imperious demand lies an allegory of what happens to the issue of touch when the actor will not relinquish part of his authority.

16 Michael Fried argues that in Manet, 'the ternary relationship painter/painting/model takes ontological precedence over the binary relationship painting/beholder'. (*Manet's Modernism*, p. 343). I agree, though I am not quite sure I agree with the way Fried develops this thesis in the following pages (pp. 343–46). Though I have borrowed Fried's notion of *facingness*, in the end I think I will give it a slightly different meaning.

17 Not to be equipped is unfortunately no excuse. I have recently attempted to disentangle the political from the religious in the context of today's 'society of the spectacle' and the confusion that has ensued for art. The occasion was given to me by Doreet LeVitte Harten, who invited me to contribute an essay to the catalogue of an exhibition she curated, whose theme was the return of the religious in contemporary art and its possible critique. See Thierry de Duve, 'Come on, Humans, One More Stab at Becoming Post-Christians', in *Heaven* (Kunsthalle, Düsseldorf – Tate Gallery, Liverpool, 1999).

Notes to Chapter 11

1 D. N. Rodowick, 'Reading the Figural', *Camera Obscura*, 24, p. 35.

2 Peter Wollen, *Signs and Meaning in the Cinema* (London, Secker and Warburg, 1969). Republished by the British Film Institute, London, 1998, p. 84.

3 Roland Barthes, *Camera Lucida* (London, Vintage 1993) p. 5.

4 Andre Bazin: 'The Ontology of the Photographic Image' in *What is Cinema?* (University of California Press, Berkeley, 1967) p. 15.

5 *Ibid.*, p. 13.

6 *Ibid.*, p. 14.

7 Barthes, *Camera Lucida*, p. 77.

8 Ann Banfield, '*L'Imparfait de l'objectif*: the Imperfect of the Object Glass', *Camera Obscura*, 24, p. 75.

9 *Ibid.*, p 76.

10 Bazin, 'Ontology of the Photographic Image', p. 10.

11 Barthes, *Camera Lucida*, p. 86.

12 Raymond Bellour, 'The Film Stilled', *Camera Obscura*, 24, p. 108.

13 Ernst Jentsch, 'On the Psychology of the Uncanny', *Angelaki* 2:1, p. 11. Quoted in S. Freud, 'The Uncanny' (Standard Edition, vol. XVII) (London, Hogarth Press, 1955), p. 226.

14 Jentsch, 'On the Psychology of the Uncanny', p. 12.

15 Freud, 'The Uncanny', pp. 247–8.

16 *Ibid.*, p. 242.

17 *Ibid.*, p. 247.
18 Tom Gunning, 'Phantom Images and Modern Manifestations: Spirit Photography, Magic Theatre, Trick Film and the Photograph's Uncanny' in Patrice Petro (ed.), *Fugitive Images* (Bloomington and Indianapolis, Indiana University Press 1995) pp. 46–7.
19 Bazin, 'The Ontology of the Photographic Image', p. 16.
20 Barthes, *Camera Lucida*, p. 82.
21 Wollen, *Signs and Meaning in the Cinema*, p. 92.
22 Barthes, *Camera Lucida*, p. 88.
23 Ann Banfield, *'L'Imparfait de l'Objectif*, p. 81.
24 *Ibid.*, p. 84. Citing *Camera Lucida*, p. 119.
25 Helmut Gernsheim, *Creative Photography. Aesthetic Trends 1839–1960* (London, Faber and Faber 1962), p. 80. I would like to thank Peter Wollen for pointing this out to me.

Notes to Chapter 12

1 Johann Wolfgang von Goethe, 'Observations on the Laocoön', *Propyläen* 1, October 1798, lead article. English translator unknown, *Monthly Magazine* vii, 1799, London, pp. 349–52, 399–401. Reprinted in Gert Schiff (ed.), *German Essays on Art History*, The German Library; vol. 79 (New York, Continuum, 1988), pp. 41–52.
2 See Schiff, *German Essays*, 'Introduction', p. xxi.
3 Gotthold Ephraim Lessing, *Laokoön*, 1766. *Laocoön*, trans. William A. Steel, in Lessing: *Laocoön, Nathan the Wise, Minna von Barnhelm* (London, J. M. Dent & Sons, Everyman's Library, 1930), pp. 2–110.
4 Jonathan Crary, *Techniques of the Observer* (Cambridge, MA, MIT Press, 1990).
5 Lessing, *Laocoön*.
6 Stephen Bottomore, 'Shots in the Dark – The Real Origins of Film Editing' in Thomas Elsaesser (ed.), *Early Cinema* (London, BFI Publishing, 1990).
7 André Gaudreault, 'The Development of Cross Cutting', in Elsaesser (ed.), *Early Cinema*.
8 Jacques Aumont, 'Griffith – The Frame, the Figure', in Elsaesser (ed.), *Early Cinema*.
9 Janet Leigh, with Christopher Nickens, *Psycho, Behind the Scenes of the Classic Thriller* (New York, Harmony Books, 1995).
10 Alfred Hitchcock, 'The Enjoyment of Fear', first published in *Good Housekeeping* 128, February 1949, republished in Sidney Gottlieb (ed.), *Hitchcock on Hitchcock* (Berkeley, University of California Press, 1995).
11 Sigmund Freud, 'Beyond the Pleasure Principle', section II, first published in German 1920, re-published in James Strachey (ed.), *The Standard Edition of the Complete Psychological Works of Sigmund Freud*, vol. XVIII (London, The Hogarth Press and the Institute of Psycho-Analysis, 1955).
12 Bernard Comrie, *Aspect* (Cambridge, Cambridge University Press, 1975).
13 Talmy Givón, 'Tense-Aspect-Modality: The Creole Proto-Type and Beyond', in Paul J. Hopper (ed.), *Tense-Aspect: Between Semantics and Pragmatics* (Amsterdam/ Philadelphia, John Benjamins Publishing Company, 1982).
14 See Lev Kuleshov, 'In Maloi Gnezdikovsky Lane', 1967, re-published in Ronald Levaco (ed.), *Writings of Lev Kuleshov* (Berkeley, University of California Press, 1974). Kuleshov's experiment is described in a number of earlier accounts by other writers,

including the filmmaker and theorist Vsevolod Pudovkin. Despite disconcerting variations of detail, all agree on the main principle of the experiment, first announced in *Kino-Phot* no. 3, 1922 and further described by Kuleshov in *The Art of the Cinema [Iskusstvo Kino]*, (Moscow, Tea-kino Pechyat, 1929).

15 Johann Joachim Winckelmann, *On The Imitation of the Painting and Sculpture of the Greeks*, 1755, trans. Henry Fuseli, re-published in David Irwin (ed.), *Winckelmann: Writings on Art* (London, Phaidon Press, 1972) and subsequently in Schiff, *German Essays*.

Notes to Chapter 13

1 *Proust and Signs*, trans. Richard Howard (New York, Braziller, 1972). The French edition was originally published in 1962, but republished in 1970 and 1972 with two new essays appended in the final version, '*Antilogos, ou la machine littéraire*' and '*L'araignée*'. Only the first of these is included in the translation, with the entirety of the 1962 text. It is significant that the two appended essays were written after Deleuze's encounter with Félix Guattari, to whom he refers, and whose concept of *transversality* he adopts.

2 The project might be summarised by a reformulation of Claire Ropars-Wuilleumier's account of Deleuze on cinema: 'In the pages that follow one should not look for a systematic account of the book that [Proust] led Gilles Deleuze to write … It seems much more in keeping with the spirit of this work to divert its course and instead to outline several theoretical options and points of uncertainty whereby a reflection on [Proust] becomes a philosopher's machine for reflection.' Marie-Claire Ropars-Wuilleumier, 'The Cinema: Reader of Gilles Deleuze' in Constantin V. Boundas and Dorothea Olkowksi (eds) *Deleuze and the Theater of Philosophy* (London, Routledge, 1994), p. 255.

3 Gilles Deleuze, *The Fold: Leibniz and the Baroque,* trans. Tom Conley (Minneapolis, Minnesota University Press, 1993).

4 Gilles Deleuze, *Cinema 2: The Time-Image,* trans. Hugh Tomlinson and Robert Galeta (London, Athlone, 1994).

5 Marcel Proust, *Time Regained,* trans. Terence Kilmartin and Andreas Mayor (London, Vintage, 1996), p. 224.

6 *Ibid.*

7 Deleuze, *Proust and Signs*, p. 16.

8 Cf. Samuel Beckett, *Proust & Three Dialogues* (London, John Calder, 1965), p. 72.

9 Deleuze, *Proust and Signs*, p. 46.

10 *Ibid.*, p. 47.

11 Proust, *Time Regained*, p. 221 'sealed vessels'.

12 *Ibid.*, p. 223.

13 Deleuze, *Proust and Signs*, p. 57.

14 Proust, *Time Regained*, p. 224.

15 *Illuminations*, trans. Harry Zohn (London, Fontana, 1992), p. 157.

16 Jean-François Lyotard, *Heidegger and the 'jews',* trans. Andreas Michel and Mark S. Roberts (Minneapolis, Minnesota University Press, 1990).

17 Lyotard locates Deleuze's work as an exploration of that 'other metaphysics' which does not rely on the vision of a subject or a 'philosophy of consciousness', but explores the

'general mechanics' or 'system of forces' which Freud's metapsychology opens up. From this perspective, it is not a question of the 'haunting' of a subject, but of a dynamic of forces in a differential temporality (*ibid.*, pp. 11–12).

18 *Ibid.*, p. 12.

19 *Ibid.*, p. 16.

20 Jacques Derrida, *Specters of Marx*, trans. Peggy Kamuf (London, Routledge, 1994).

21 The potential (but problematic) congruence between Deleuze's Bergsonian theorisation of time and Derrida's 'disjunctive' temporality in *Specters of Marx* is suggested by Deleuze's citation (again unattributed) of the phrase 'The time is out of joint' from *Hamlet*, which Derrida comments extensively in the book on Marx. Cf. Deleuze, *Cinema 2, The Time-Image*, p. 41.

22 Cf. *L'être et l'événement*, Paris, Seuil, 1988 and Slavoj Zizek's commentary on it in *The Ticklish Subject*, London, Verso, 1999.

23 Lyotard, *Heidegger and the 'jews'*, p. 17.

24 Deleuze quotes from Schefer's *L'homme ordinaire du cinéma* (Gallimard/Cahiers du cinéma, 1997).

25 Deleuze, *Cinema 2*, p. 37.

26 Lyotard, *Heidegger and the 'jews'*, p. 20.

27 *Ibid.*, p. 41.

28 Why not see Hamad Butt's 'sculpture', *Familiars Part I: Substance Sublimation Unit*, exhibited at the show *Rites of Passage: Art for the End of the Twentieth Century* (Tate Gallery, 1995) as a contemporary correlate of these sealed vessels? The sculpture consists of iodine under vaccuum in hermetically sealed glass globes suspended from wire from the ceiling.

29 Deleuze, *Proust and Signs*, pp. 44–5.

30 In *Proust and Signs* Deleuze mentions 'Certain Platonists'. In *The Fold* he refers to Proclus's *Elements of Theology* as one of Leibniz's sources, and to Bruno as the philosopher who brought the system of monads to its point of 'universal complication' (pp. 23–4).

31 The *crible*, for Whitehead (in Deleuze's chapter 'What is an Event?' in *The Fold*) is what intervenes to enable singularity to emerge from a pure multiplicity. Following Deleuze's description of it, which I cite below, it seems possible to draw a parallel with the cinematic apparatus – camera or projector, or more accurately, with the phenomenological experience of the cinema, the emergence of colours against the background of 'shadows without end', especially due to the contingency of the translation, here, of *crible*, by *screen*: 'Following a physical approximation, chaos would amount to depthless shadows, but the screen disengages its dark backdrop, the "fuscum subnigrum" that, however, little it differs from black, nonetheless contains all colours: the screen is like the infinitely refined machine that is the basis of Nature' (p. 77).

32 Deleuze, *The Fold*, p. 80.

33 *Ibid.*

34 Deleuze, *Proust and Signs*, p. 60.

35 Deleuze, *Cinema 2*, p. 17.

36 *Ibid.*, p. 35, p. 38.

37 *Ibid.*, p. 37.

38 It is also interesting to note the role of the magic lantern – a kind of prototype cinematic apparatus – in Marcel's bedroom in Combray: it marks a first distinguishing of

'the world' from the dark and indistinct cavern of maternal, habitual space. It is the first disturbance of 'habit' (lack of experience), the first deferral.

39 Deleuze, *Cinema 2*, p. 68.
40 *Ibid.*, p. 70.
41 *Ibid.*, p. 68.
42 *Ibid.*, p. 74.
43 *Ibid.*, p. 78.
44 *Ibid.*, p. 79.
45 *Ibid.*
46 *Ibid.*, p. 80.
47 Deleuze, *Cinema 2*, p. 81.
48 *Ibid.*
49 *Ibid.*, p. 82.
50 *Ibid.*
51 Such a fragment is Vinteuil's 'little phrase', and it might also be possible to extend this following of Proust's traces across the text via Deleuze's footnotes in *Proust and Signs* and *Cinema 2*, where he first of all refers to Félix Guattari as the originator of the notion of the 'crystal of time' ('Félix Guattari produced this idea of "crystal of time"', Deleuze, *The Time-Image*, p. 295), and then to Guattari's commentary on the '"ritornello": or "little phrase" in Proust's terms' (*ibid.*, p. 296; the text in question is Guattari's *L'inconscient machinique*). The crystal of time can also be realised in music, in the 'ritornello'; Vinteuil's 'little phrase' is thus named as a crystal-image. A different but related analysis is included in the commentary of Vinteuil's *little phrase* in Deleuze and Guattari's *Thousand Plateaux* (trans. Brian Massumi, Athlone, London, 1987), in which the *refrain* or *ritornello contains* a landscape – much in the same way that the monad contains a world. Deleuze and Guattari write there that: 'It is not by chance that the apprenticeship of the *Recherche* pursues an analogous discovery in relation to Vinteuil's little phrases: they do not refer to a landscape, they carry and develop within themselves landscapes that do not exist on the outside …' (p. 319). Thus the *ritornello*, which in cinema is *the smallest internal circuit,* linked to the crystal image, like the monad or the hermetically sealed vessel – contains a world, envelops an essence, marks out a territory.
52 Deleuze and Guattari, *A Thousand Plateaux*, p. 4.
53 Deleuze, *Cinema 2*, p. 39.
54 Proust, *Time Regained*, p. 237.

Notes to Chapter 14

1 S. Beckett, *Molloy, Malone Dies, The Unnamable* (London, Calder & Boyars, 1959), p. 418. See also S. Beckett, *L'Innommable* (Paris, Minuit, 1959), p. 262.
2 L. Hill, *Beckett's Fiction: In Different Words* (Cambridge, Cambridge University Press, 1990), ch. 3, 'The trilogy translated'.
3 G. Apollinaire, *Alcools*, in *Œuvres poétiques* (eds), M. Adéma and M. Décaudin (Paris, Bibliothèque de la Pléïade, 1965). See also *Apollinaire: Selected Poems*, trans. and intro. by O. Bernard (London, Anvil Press, 1986).
4 Works discussed here by R. Delaunay, S. Delaunay-Terk, and S. Delaunay-Terk with B. Cendrars are reproduced in V. Spate, *Orphism. The Evolution of Non-Figurative Painting in Paris 1910–1914* (Oxford, Clarendon Press, 1979).

5 B. Cendrars, *Prose du Transsibérien et de la Petite Jehanne de France*, in *Blaise Cendrars. Complete Poems*, trans. by R. Padgett, intro. by J. Bochner (Berkley, University of California Press, 1992). This volume includes the poems in the original French.

6 B. Cendrars, *Moravagine* (Paris, Bernard Grasset, 1926). All quotations from this work are taken from the readily available English translation by A. Brown (London, Penguin Books, 1979). Page references to this volume will henceforth be given in the text.

7 S. Freud, *Civilization and its Discontents*, in *Civilization, Society and Religion* (London, Penguin Books, The Pelican Freud Library, vol. XII), pp. 243–340.

8 A. Breton, *Nadja* (Paris, Éditions Gallimard, 1928). See also R. Cardinal, *Breton, Nadja* (London, Grant and Cutler, 1986).

9 T. Brennan, *History after Lacan* (London, Routledge, 1993), ch. 2.

10 See, for example, T. de Duve, *Résonances du readymade: Duchamp entre avant-garde et tradition* (Nîmes, Éditions Jacqueline Chambon, 1989), pp. 7–20, and pp. 36–7.

11 S. Freud, *Beyond the Pleasure Principle*, in *On Metapsychology. The Theory of Psychoanalysis* (London, Penguin Books, The Pelican Freud Library, vol. IX), pp. 269–338.

12 *La Peinture après l'abstraction, 1955–1975. Martin Barré, Jean Degottex, Raymond Hains, Simon Hantaï, Jacques Villeglé* (Paris, Musée d'art moderne de la ville de Paris, 1999).

Index

Note: Page numbers given in *italic* refer to illustrations.